The Egyptian Mummies and Coffins
of the Denver Museum of Nature & Science

The Egyptian Mummies and Coffins
of the Denver Museum of Nature & Science

HISTORY, TECHNICAL ANALYSIS, AND CONSERVATION

Edited by

Michele L. Koons and Caroline Arbuckle MacLeod

UNIVERSITY PRESS OF COLORADO
Louisville

Published by University Press of Colorado
245 Century Circle, Suite 202
Louisville, Colorado 80027

 The University Press of Colorado is a proud member of the Association of University Presses.

The University Press of Colorado is a cooperative publishing enterprise supported, in part, by Adams State University, Colorado State University, Fort Lewis College, Metropolitan State University of Denver, Regis University, University of Colorado, University of Northern Colorado, University of Wyoming, Utah State University, and Western Colorado University.

∞ This paper meets the requirements of the ANSI/NISO Z39.48-1992 (Permanence of Paper)

ISBN: 978-1-64642-136-7 (hardcover)
ISBN: 978-1-64642-137-4 (paperback)
ISBN: 978-1-64642-138-1 (ebook)
https://doi.org/10.5876/9781646421381

Library of Congress Cataloging-in-Publication Data

Names: Koons, Michele L., editor. | MacLeod, Caroline Arbuckle, editor. | Denver Museum of Nature and Science, host institution.
Title: The Egyptian mummies and coffins of the Denver Museum of Nature & Science : history, technical analysis, and conservation / edited by Michele L. Koons and Caroline Arbuckle MacLeod.
Description: Louisville : University Press of Colorado, [2021] | Includes bibliographical references and index. | Summary: "In the 1980s, Denver Museum of Nature & Science acquired two ancient Egyptian mummies and coffins. The mummies are from an unknown locale and have been subject of unpublished scientific and unscientific analyses. The DMNS staff scientists decided to reexamine the mummies and coffins using new and innovative techniques"— Provided by publisher.
Identifiers: LCCN 2020051276 (print) | LCCN 2020051277 (ebook) | ISBN9781646421367 (hardcover) | ISBN 9781646421374 (paperback) | ISBN 9781646421381 (ebook)
Subjects: LCSH: Denver Museum of Nature and Science—Archaeological collections. | Mummies—Egypt—History. | Mummies—Analysis. | Mummies—Radiography. | Mummies—Conservation and restoration. | Mummy cases—Egypt—History. | Mummy cases—Analysis. | Mummy cases—Conservation and restoration. | Egyptology—Colorado—Denver. | Egypt—Antiquities.
Classification: LCC DT59.D464 E34 2021 (print) | LCC DT59.D464 (ebook) | DDC 932.0074/78883—dc23
LC record available at https://lccn.loc.gov/2020051276
LC ebook record available at https://lccn.loc.gov/2020051277

The University Press of Colorado gratefully acknowledges the support provided by the Denver Museum of Nature & Science toward the publication of this book.

There are many people to thank for getting this project off the ground and seeing it to completion. First, we thank Deb Darrow and the Rosemount Museum for permission to analyze the mummies and coffins. At the Denver Museum of Nature & Science, Melissa Bechhoefer, Bethany Williams, Jeff Phegley, Jude Southward, Steve Nash, Andrew Doll, Jodi Schoemer, Frances Kruger, Salle Tulchin, Dave Pachuta, Todd Norlin, Chad Swiercinsky, Victor Muñoz, Megan Fisher, Rick Wicker, Jess Wellington, Greg Koronowicz, Maura O'Neal, René O'Connell, Courtney Scheskie, and Lindsay Dougan made the project possible. Special thanks to the Colorado Flight for Life team for driving the mummies and coffins to Children's Hospital Colorado in their ambulance. We thank the dedicated staff at Children's Hospital Colorado for donating time and energy to this project, especially Kari Hayes and Jason Weinman. The team at National Jewish Health, led by Stephen Humphries, was critical in visualizing the CT scans. We thank Bob Pickering and David Rubenstein for insights from the previous CT scanning projects in the 1990s. Thanks to Edoardo Guzzon for the translation of Mes's coffin and information on where and when it was found. Thanks to Caroline Cartwright, senior scientist at the British Museum, for comments and insights on wood analysis. Thanks to Erin Baxter, Kathlyn Cooney, and the two reviewers for helpful comments on earlier drafts. We also thank all the authors of the chapters in this volume for their work on this project.

The Egyptian Mummies and Coffins
of the Denver Museum of Nature & Science

1

Napoleon Bonaparte is often credited as the causal factor in the worldwide interest in mummy studies. During his 1789 invasion of Egypt, the emperor brought with him 100 scientists to document Egyptian society. Accounts from these studies, along with the discovery of the Rosetta Stone, fueled enthusiasm in the Western world for all things Egyptian and catalyzed an interest in artifact and mummy collecting. A corollary of this zeal was the development of the fashionable entertainment practice of "unrolling" ancient Egyptian mummies in the early 1800s. Thankfully, by the 1830s this practice was eclipsed by the more scientifically minded, such as medical doctors and burgeoning Egyptologists. These scientists continued "unrolling" but for the purpose of documenting anatomy, paleopathology, and mummification techniques (Dawson 1938; Moodie 1923; Murray 1910; Pettigrew 1834; Ruffer and Moodie 1921; Smith 2000 [1912]).

Two mummies and three coffins—the primary focus of the volume—emerged from these murky antiquarian practices; through a series of extraordinary events, archival research, and new technological applications, they stand prepared to tell and retell their stories.

Relatively little was known about the two women who now reside at the Denver Museum of Nature & Science (DMNS). They lived in ancient Egypt, died in their thirties, were mummified and interred. We do not know where they lived or died, but by the early 1900s both the mummies and their associated coffins, as well

Old Friends, New Tales

The Mummies and Coffins of the Denver Museum of Nature & Science

Michele L. Koons

DOI: 10.5876/9781646421381.c001

as a third coffin lid (EX1997-24.5), had made it to Cairo. Sometime in 1905 they were purchased by Andrew McClelland, a Colorado entrepreneur, and shipped to his home in Pueblo. Nicknamed the "Poor Mummy" and the "Rich Mummy" (among other unfortunate names) over the next century, the two mummies were subject to a variety of scientific and unscientific analyses, none of which were published. By the early 1980s, both the mummies and three coffins had been moved again to the DMNS, where they reside today.

During preparations for updating the Egyptian Hall at DMNS in 2016, scientists at DMNS and affiliate institutions recognized the understudied nature of the mummies and coffins and elected to undertake a series of technologically advanced analyses, both as a supplement to prior work and to take advantage of innovative new analyses. Among initial analyses conducted on the mummies—now known as EX1997-24.1 and associated coffin EX1997-24.2 and mummy EX1997-24.3 and associated coffin EX1997-24.4—were new AMS radiocarbon dates. These data were the first in a series of newly acquired information that enabled a variety of researchers from numerous backgrounds to view the two mummies with new eyes. Additional analyses included pigment analysis of the paints on the coffins using X-ray florescence; analysis of the coffin wood; coffin style and decoration analysis; analysis of varnish and resin samples from one mummy and two coffins with gas chromatography, X-ray diffraction (XRD), and other destructive and non-destructive methods; isotope analysis of tissue from one mummy; linen analysis; and updated conservation efforts.

This volume organizes and presents this work in nine subsequent chapters. Each describes different analytical techniques and how they were employed. The techniques are relatively inexpensive and readily accessible. This volume is intended to serve as a guide for other institutions or individuals who wish to perform holistic studies on extant museum collections of varying material types but specifically Egyptian mummies and coffins. It also adds to the corpus of what we know about Egyptian mummies and coffins.

Chapter 2 discusses in more detail the history of the two mummies and coffins in terms of the context of their discovery and movements (as far as they can be traced) to Colorado. It details previous research on the mummies (e.g., X-rays, basic analyses, historical photos) and presents new radiocarbon dates on the mummies and their coffins. Also provided in chapter 2 is a description of the mummification and coffin manufacture practices of different periods in Egyptian history. Finally, there is a discussion of the political situation in Egypt during the Third Intermediate Period, which is relevant to analyses presented in subsequent chapters.

Chapter 3 is a look at the conservation efforts and techniques employed over the years. It also presents an account of the new treatments performed in 2016. This chapter, written by DMNS conservators Southward and Fletcher, highlights best practices when conserving coffins and discusses which treatments are preferable.

Chapter 4 by Hayes, Weinman, Humphries, Rubinstein, and Koons explores the history of paleoradiography in Colorado and presents the results of updated computed tomography (CT) scans. Although the mummies had been CT scanned in the past, sparse notes on the results were left in the DMNS archives, prompting us to re-scan the mummies with the latest technology available.

Chapter 5 by Arbuckle MacLeod highlights the creation and construction of coffin EX1997-24.4, which is from the early Third Intermediate Period. CT scans of this coffin reveal hidden features, which are explored in their historical context. She also examines material choices and construction techniques in relation to the religious significance of coffins from this era.

Chapter 6 outlines the work of Arbuckle MacLeod, Baisan, and Creasman, who extracted wood samples from the coffins for analysis. Here, the different types of woods used for the different parts of the coffins are explored. The samples will ultimately contribute to an ancient Egyptian tree-ring database, which is currently in its infancy.

Chapter 7 details the pigments used on the coffins as assessed by Cundiff, Clark, and Miller with portable X-ray fluorescence (pXRF) and scanning electron microscopy (SEM). They found examples of Egyptian blue, that the color yellow is highly variable and can be made from various materials, and that although there are some drawbacks, overall pXRF is a good tool for assessing coffin pigments in a non-invasive manner.

Chapter 8 by Price, Muros, and Barnard discusses non-destructive and destructive techniques employed to understand the composition of the black substance found on mummy EX1997-24.1 as well as the composition of pigments and varnishes from the coffins. These techniques include using UV light, pXRF, XRD, polarized light microscopy, and gas chromatography–mass spectrometry (GC/MS).

Chapter 9 by Howley, Arbuckle MacLeod, and Creasman presents an artistic and textual analysis of the decoration and inscriptions on the coffins. They provide updated translations of two of the coffins (EX1997-24.2 and EX1997-24.5) and a stylistic analysis of a third coffin (EX1997-24.4), where a black substance obscures the text. Although translations were done before, no record of them exists in the DMNS archives, making this chapter an invaluable resource for those studying and interested in inscribed coffins.

Chapter 10 presents Koons and Arbuckle MacLeod's final reflections on the studies presented in this volume.

ARCHAEOLOGICAL SCIENCE AND EGYPTIAN MUSEUM COLLECTIONS

What makes studies of this nature possible is that the field of archaeological science has rapidly grown since the early twenty-first century (Killick 2015). New and more affordable analytical techniques have greatly expanded the kinds of questions archaeologists and other specialists studying archaeological materials can ask and the methods they can employ. These questions range from an expansion of field techniques such as photogrammetry for creating 3D models of the terrain, excavated features, and artifacts (Peng et al. 2017; Sapirstein and Murray 2017) to advanced lab techniques such as ancient dental calculus extraction to understand the ancient human microbiome (Warinner et al. 2015). Advances in microanalysis include minimally invasive techniques that require the slight alteration of the object and non-invasive techniques, which do not alter the object. This increased wave of applied analytical tools to archaeological research has also moved into the museum realm where new technologies are breathing new life into old collections (Bewes et al. 2016; Forster and Grave 2012; Giachi et al. 2016; Gostner et al. 2013; Lattanzi and Stinchcomb 2015; Siano et al. 2006). Since the intrigue engendered by the Bonaparte era, this is especially true for Egyptian collections held in museums throughout the world, which includes the application of various analytic techniques to the study of mummified human remains and coffins.

Shortly after the discovery of X-rays by Wilhelm Conrad Roentgen in 1895, the technique was applied to mummy studies (König 1896). However, it was not until computed tomography (CT scan) developed in the 1970s that scientific mummy imaging became common practice (Aufderheide 2011). Human and animal mummies stored in many museums throughout the world today have been investigated with CT scanning, mainly because of the ability to see inside the wrappings without adversely affecting the contents (Bewes et al. 2016; Cox 2015; David 2008; Hawass and Saleem 2016; Hoffman et al. 2002; McKnight et al. 2015; Zesch et al. 2016). Most of these studies are undertaken to understand an individual mummy or mummies in a particular institution. These case studies often conclude that CT scanning is a significant non-invasive tool that can help us better understand what is inside the wrappings. Despite this fact, no standards have been adopted for the parameters used for CT scanners, and there is insufficient consistency on how results are

reported. Cox (2015) cautions that although it is likely that over 100 mummies have been scanned and reported on, the lack of standards makes it difficult, if not impossible, for comparative studies to be undertaken. Thus there has been little synthesis of the mummies that have been scanned to better understand patterns of ancient Egyptian life and death. This is beginning to change with databases such as IMPACT Radiological Mummy Database (Nelson and Wade 2015; Wade and Nelson 2013a, 2013b) and the University of Pennsylvania Museum's Open Research Scan Archive (ORSA), which are attempting to compile known CT data of mummies to make accessible to researchers. The CT scans from this study are available through IMPACT's website, https://www.impactdb.uwo.ca/IMPACTdb/Index.html.

Recent publications raise the bar on what information can be extracted from CT scans and how they can be used to reinterpret and better understand mummy specimens. Studies using the radiological density and structure, measured in Hounsfield units, of foreign objects inside mummy wrappings allow us to discern what materials comprise the jewelry, amulets, and other objects buried with a person (Gostner et al. 2013; Saleem and Hawass 2014). Although Cox (2015) notes that we cannot yet reliably identify postmortem taphonomic changes and effects on the body from mummification from antemortem pathologies, recent work by Bewes and colleagues (2016) shows that dual-energy CT and effective atomic number imaging can help discriminate between different soft tissues and deteriorated bone. Studies like these, coupled with more synthetic research, are helping to pave the way for future noninvasive mummy studies that go beyond simplistic identification.

In addition to CT scanning, other analytical techniques help us to understand ancient mummification practices and Egyptian life (Nicholson and Shaw 2009). Gas chromatography (GC), GC/MS, and nuclear magnetic resonance (NMR) are consistently used to identify the composition of resins, varnishes, and bitumen found in and on mummies (Nicholson et al. 2011). When organic matter such as skin or bone is exposed, samples can be extracted to perform stable isotope analysis to reconstruct diet (Macko et al. 1999; Turner et al. 2010). Radiocarbon dating of linens and exposed tissue can determine the period of mummification. Analysis of the linen tells us about the quality and manufacturing techniques. Finally, ancient DNA studies, although not consistently reliable as of yet, are beginning to advance our understanding of the royal families and population in general (Hawass and Saleem 2016; Schuenemann et al. 2017).

As a supplement to research on mummies, this volume examines the coffins associated with the human remains. Coffin research, although popular for decades, has traditionally been based on paleography and art historical

approaches. Only recently has the scientific analysis of coffin materiality gained academic attention. A number of scientific studies were recently discussed at the Second Vatican Coffin Conference in Rome (2017) and in the published proceedings of the previous meeting (Amenta and Guichard 2017). In *Death on the Nile: Uncovering the Afterlife of Ancient Egypt* (Strudwick and Dawson 2016), the authors describe the manufacture of coffins in an exhibition at the Fitzwilliam Museum at the University of Cambridge to highlight the value of material analysis and the use of CT scans for coffins as well. Pigment and resin analyses from cartonnage and coffins have also increased recently (Calza et al. 2007; Dawson et al. 2010; Scott et al. 2009; Serpico 2000). These analyses demonstrate the value of such investigations for understanding ancient Egyptian technologies and access to foreign materials.

Holistic studies of mummies have been difficult since the days of the unwrapping parties. Although the number and efficacy of scientific techniques has skyrocketed, our abilities to use these tools are limited to cost and available access to mummified remains. A priority of any museum is the preservation of the collection. The analyses presented in this volume were designed to be minimally invasive or non-invasive in an effort to maintain the integrity of the mummies and coffins and not cause unnecessary harm. Because of this, certain studies such as DNA extraction, which is still not perfected or easily performed, were omitted.

With the growing body of inexpensive and minimally to non-invasive technologies, museum collections are no longer silent. These time capsules are beginning to reveal their stories through the numerous tools and techniques available to modern science. Through these advancements, we are now able to tell and retell the stories of people and objects in more holistic and humanistic ways. The women featured in this volume did not choose to reside in Denver, Colorado. We acknowledge the colonialist circumstances under which the DMNS became their caretaker. As beloved friends of the DMNS visitor experience, we owe it to their legacy to tell their stories in the most appropriate and accurate manner. This volume presents various methods that are the first steps in unlocking their secrets. As science continues to advance, the studies of these mummies and coffins will continue to be refined, and their stories will keep unraveling.

REFERENCES

Amenta, Alessia, and Hélène Guichard, eds. 2017. *Proceedings First Vatican Coffin Conference: 19–22 June 2013.* The Vatican: Vatican Museums.

Aufderheide, Arthur C. 2011. *The Scientific Study of Mummies*. Reissue ed. Cambridge: Cambridge University Press.

Bewes, James M., Antony Morphett, F. Donald Pate, Maciej Henneberg, Andrew J. Low, Lars Kruse, Barry Craig, Aphrodite Hindson, and Eleanor Adams. 2016. "Imaging Ancient and Mummified Specimens: Dual-Energy CT with Effective Atomic Number Imaging of Two Ancient Egyptian Cat Mummies." *Journal of Archaeological Science: Reports* 8 (Supplement C): 173–77.

Calza, Cristiane Ferreira, Marcelino Dos Anjos, Sheila Mendonça F.M. de Souza, Antonio Brancaglion, and Ricardo T. Lopes. 2007. "X-Ray Microfluorescence Analysis of Pigments in Decorative Paintings from the Sarcophagus Cartonnage of an Egyptian Mummy." *Nuclear Instruments and Methods in Physics Research Section B: Beam Interactions with Materials and Atoms* 263 (1): 249–52.

Cox, Samantha L. 2015. "A Critical Look at Mummy CT Scanning." *Anatomical Record* 298 (6): 1099–1110.

David, Rosalie, ed. 2008. *Egyptian Mummies and Modern Science*. Cambridge: Cambridge University Press.

Dawson, Julie, Christina Rozeik, Margot M. Wright, and Lisa Bruno, eds. 2010. *Decorated Surfaces on Ancient Egyptian Objects: Technology, Deterioration, and Conservation; Proceedings of a Conference Held in Cambridge, UK on 7–8 September 2007*. London: Archetype.

Dawson, Warren Royal. 1938. *Sir Grafton Elliot Smith*. London: Cape.

Forster, Nicola, and Peter Grave. 2012. "Non-Destructive PXRF Analysis of Museum-Curated Obsidian from the Near East." *Journal of Archaeological Science* 39 (3): 728–36.

Gianna, Maria Cristina Guidotti, Simona Lazzeri, Lorena Sozzi, and Nicola Macchioni. 2016. "Wood Identification of the Headrests from the Collection of the Egyptian Museum in Florence." *Journal of Archaeological Science: Reports* 9 (Supplement C): 340–46.

Gostner, Paul, Marco Bonelli, Patrizia Pernter, Angela Graefen, and Albert Zink. 2013. "New Radiological Approach for Analysis and Identification of Foreign Objects in Ancient and Historic Mummies." *Journal of Archaeological Science* 40 (2): 1003–11.

Hawass, Zahi, and Sahar Saleem. 2016. *Scanning the Pharaohs: CT Imaging of the New Kingdom Royal Mummies*. Cairo, Egypt: American University in Cairo Press.

Hoffman, Heidi, William E. Torres, and Randy D. Ernst. 2002. "Paleoradiology: Advanced CT in the Evaluation of Nine Egyptian Mummies." *RadioGraphics* 22 (2): 377–85.

Killick, David. 2015. "The Awkward Adolescence of Archaeological Science." *Journal of Archaeological Science*, Special Issue: Scoping the Future of Archaeological Science: Papers in Honour of Richard Klein 56 (Supplement C): 242–47.

König, Carl Georg Waltèr. 1896. *14 Photographien mit Röntgen-Strahlen, aufgenommen im Physikalischen Verein.* Frankfurt A.M. Leipzig: J. A. Barth.

Lattanzi, Gregory D., and Gary E. Stinchcomb. 2015. "Isotopic Analysis of Museum-Archived Soil Samples from Archeological Sites: A Case-Study Using the Abbott Farm National Historic Landmark, USA." *Journal of Archaeological Science: Reports* 4 (Supplement C): 86–94.

Macko, Stephen A., Michael H. Engel, Vladimir Andrusevich, Gert Lubec, Tamsin C. O'Connell, and Robert E.M. Hedges. 1999. "Documenting the Diet in Ancient Human Populations through Stable Isotope Analysis of Hair." *Philosophical Transactions: Biological Sciences* 354 (1379): 65–76.

McKnight, Lidija M., Judith E. Adams, Andrew Chamberlain, Stephanie D. Atherton-Woolham, and Richard Bibb. 2015. "Application of Clinical Imaging and 3D Printing to the Identification of Anomalies in an Ancient Egyptian Animal Mummy." *Journal of Archaeological Science: Reports* 3 (Supplement C): 328–32.

Moodie, Roy Lee. 1923. *Paleopathology: An Introduction to the Study of Ancient Evidences of Disease.* Champaign: University of Illinois Press.

Murray, Margaret Alice. 1910. *The Tomb of Two Brothers.* Manchester, UK: Sherratt and Hughes.

Nelson, Andrew John, and Andrew David Wade. 2015. "Impact: Development of a Radiological Mummy Database." *Anatomical Record* 298 (6): 941–48.

Nicholson, Paul T., and Ian Shaw, eds. 2009. *Ancient Egyptian Materials and Technology.* Cambridge: Cambridge University Press.

Nicholson, Tim M., Manuela Gradl, Beatrix Welte, Michael Metzger, Carsten M. Pusch, and Klaus Albert. 2011. "Enlightening the Past: Analytical Proof for the Use of Pistacia Exudates in Ancient Egyptian Embalming Resins." *Journal of Separation Science* 34 (23): 3364–71.

Peng, Fei, Sam C. Lin, Jialong Guo, Huimin Wang, and Xing Gao. 2017. "The Application of SfM Photogrammetry Software for Extracting Artifact Provenience from Palaeolithic Excavation Surfaces." *Journal of Field Archaeology* 42 (4): 326–36.

Pettigrew, Thomas Joseph. 1834. *A History of Egyptian Mummies, and an Account of the Worship and Embalming of the Sacred Animals by the Egyptians; with Remarks on the Funeral Ceremonies of Different Nations, and Observations on the Mummies of the Canary Islands, of the Ancient Peruvians, Burman Priests, &c.* London: Longman, Rees, Orme, Brown, Green, and Longman.

Ruffer, Marc Armand, and Roy Lee Moodie. 1921. *Studies in the Palaeopathology of Egypt.* Chicago: University of Chicago Press.

Saleem, Sahar N., and Zahi Hawass. 2014. "Multidetector Computed Tomographic Study of Amulets, Jewelry, and Other Foreign Objects in Royal Egyptian Mummies Dated from the 18th to 20th Dynasties." *Journal of Computer Assisted Tomography* 38 (2): 153–58.

Sapirstein, Philip, and Sarah Murray. 2017. "Establishing Best Practices for Photogrammetric Recording during Archaeological Fieldwork." *Journal of Field Archaeology* 42 (4): 337–50.

Schuenemann, Verena J., Alexander Peltzer, Beatrix Welte, W. Paul Van Pelt, Martyna Molak, Chuan-chao Wang, Anja Furtwängler, Christian Urban, Ella Reiter, Kay Nieselt et al. 2017. "Ancient Egyptian Mummy Genomes Suggest an Increase of Sub-Saharan African Ancestry in Post-Roman Periods." *Nature Communications: London* 8 (15694): 1–11.

Scott, David A., Sebastian Warmlander, Joy Mazurek, and Stephen Quirke. 2009. "Examination of Some Pigments, Grounds, and Media from Egyptian Cartonnage Fragments in the Petrie Museum, University College London." *Journal of Archaeological Science* 36 (3): 923–32.

Serpico, Margaret. 2000. "Resins, Amber, and Bitumen." In *Ancient Egyptian Materials and Technology*, edited by Paul T. Nicholson and Ian Shaw, 430–74. Cambridge: Cambridge University Press.

Siano, Salvatore, Laura Bartoli, Javier R. Santisteban, Winfried Kockelmann, Mark R. Daymond, Marcello Miccio, and Giuliano De Marinis. 2006. "Non-Destructive Investigation of Bronze Artefacts from the Marches National Museum of Archaeology Using Neutron Diffraction." *Archaeometry* 48 (1): 77–96.

Smith, G. Elliot. 2000 [1912]. *The Royal Mummies*. New York: Bloomsbury Academic.

Strudwick, Helen, and Julie Dawson, eds. 2016. *Death on the Nile: Uncovering the Afterlife of Ancient Egypt*. London: Fitzwilliam Museum and D. Giles Ltd.

Turner, Bethany L., John D. Kingston, and George J. Armelagos. 2010. "Variation in Dietary Histories among the Immigrants of Machu Picchu: Carbon and Nitrogen Isotope Evidence / Variación en Historias Dietéticas Entre los Inmigrantes de Machu Picchu: Evidencia de Isótopos de Carbono y Nitrógeno." *Chungara: Revista de Antropología Chilena* 42 (2): 515–34.

Wade, Andrew D., and Andrew J. Nelson. 2013a. "Evisceration and Excerebration in the Egyptian Mummification Tradition." *Journal of Archaeological Science* 40 (12): 4198–4206.

Wade, Andrew D., and Andrew J. Nelson. 2013b. "Radiological Evaluation of the Evisceration Tradition in Ancient Egyptian Mummies." *HOMO: Journal of Comparative Human Biology* 64 (1): 1–28.

Warinner, Christina, Camilla Speller, Matthew J. Collins, and Cecil M. Lewis. 2015. "Ancient Human Microbiomes." *Journal of Human Evolution*, Special Issue: *Ancient DNA and Human Evolution* 79 (Supplement C): 125–36.

Zesch, Stephanie, Stephanie Panzer, Wilfried Rosendahl, John W. Nance, Stefan O. Schönberg, and Thomas Henzler. 2016. "From First to Latest Imaging Technology: Revisiting the First Mummy Investigated with X-Ray in 1896 by Using Dual-Source Computed Tomography." *European Journal of Radiology Open* 3 (July): 172–81.

2

The study and display of ancient Egyptian coffins and mummies have delighted and intrigued audiences for millennia. In the last century, scholars have studied the texts and art of the Egyptians to better understand the religion and society that created them. As methods such as advanced CT scanning develop and become more affordable, the archaeologist's toolkit expands and allows for more thorough analysis of artifacts and less invasive studies of mummified human remains. The field of archaeological science is currently flourishing in museums, where various techniques can be applied to investigate extant collections in new ways. In this volume, we present the methods and results of the investigation of two Egyptian mummies and three coffins housed at the Denver Museum of Nature & Science (DMNS). The two mummies, both on permanent loan from the Rosemount Museum in Pueblo, Colorado, have been the subjects of a variety of past research projects. New tests in 2016 included updated CT scans of the mummies, CT scans of one of the coffins, radiocarbon dating, pigment analysis of the paints on the coffins, analysis of the coffin wood, analysis of the style and decoration of the coffins, gas chromatography of the resins, linen analysis, isotope analysis of the skin/muscle of one mummy, and updated conservation efforts. This combination of material analyses and traditional art historical approaches highlights the different methods that can now be applied to mummies and coffins to gain a thorough understanding of their

Contextualizing the Denver Museum of Nature & Science Mummies and Coffins

A History of Research and Exploring New Narratives

Michele L. Koons and Caroline Arbuckle MacLeod

DOI: 10.5876/9781646421381.c002

production and the society in which they were created. This chapter highlights the history of these two women, their coffins, and a third coffin lid. It explores what is known from archival records and previous studies. It also presents new radiocarbon dates that help build new narratives on the lives and deaths of these two women and the coffins in which they currently reside.

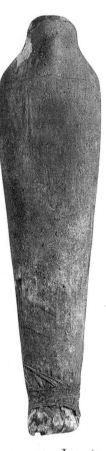

FIGURE 2.1. *Mummy EX1997-24.1 at the Denver Museum of Nature & Science. This mummy is coated in a black substance and was formerly known as Rich Mummy, Mummy 1, Bess, and Suzy/Susie.*

BACKGROUND ON THE MUMMIES AT THE DENVER MUSEUM OF NATURE & SCIENCE

The two mummies and coffins at DMNS began their journey to Colorado in 1905 when Andrew McClelland, an entrepreneur, miller, and businessman from Pueblo, Colorado, visited Egypt as a tourist. It was fashionable at the time for wealthy tourists to purchase mummies to bring back home, both for unwrapping parties and to display in local museums. The two mummies and three coffins at DMNS, and another mummy and coffin at the Rosemount Museum in Pueblo, made their way to Pueblo and were on display in the McClelland library for many years. In 1967, with the McClelland collection under threat of removal from the library, the Pueblo Metropolitan Museum Association (PMMA) formed and the collection was relocated to the John A. Thatcher residence, "Rosemount," in 1968.

In 1971, one mummy and coffin from the Rosemount collection moved to DMNS. Now known as EX1997-24.1 (human remains) (figure 2.1) and 24.2 (coffin—the base is 24.2B and the coffin lid is 24.2A) (figure 2.2), the mummy was formerly known as the "Rich Mummy," "Mummy 1," "Bess," and/or "Suzy/Susie."[1] The ventral side of the mummy is coated in a black substance

1. EX1997-24.1 and 24.2 were originally given Rosemount number E-13, which is still written on the coffin. At some point the mummy and coffin were given the DMNS accession number A88.1A-C, even though they are on permanent loan from the Rosemount Museum and should never have been accessioned into the DMNS collection. The nickname Suzy was given after a DMNS staff person at the time.

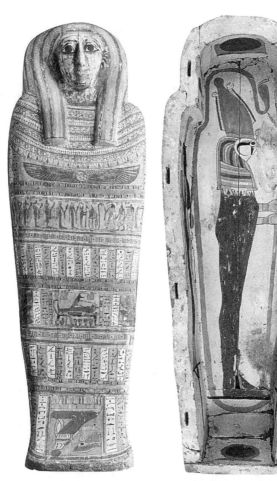

FIGURE 2.2. *Coffin EX1997-24.2B (lid) and A (base) at the Denver Museum of Nature & Science. According to the hieroglyphs on the surface, this coffin once belonged to a man named Mes.*

discussed in chapters 7 and 8. A second mummy at DMNS, now known as EX1997-24.3 (mummy) (figure 2.3) and 24.4 (coffin—the base is 24.4B and the lid is 24.4A) (figure 2.4), has an exposed face. This mummy was formerly known as "Poor Mummy," "Mummy 2," and/or "Porgy" and was called "Mes" by the Rosemount Museum. This mummy came to DMNS in 1985 by way of the University of Colorado Museum, where it was loaned by the Rosemount

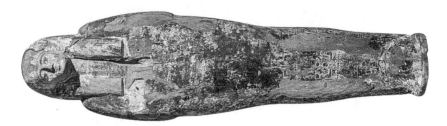

FIGURE 2.3. *Mummy EX1997-24.3 inside coffin EX1997-24.4A (base). The mummy is very fragile and was not removed from the coffin for these analyses.*

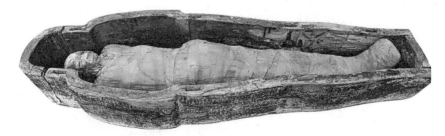

FIGURE 2.4. *Coffin EX1997-24.4B (lid).*

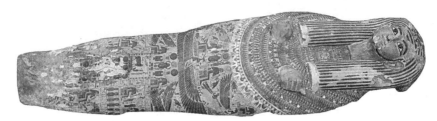

FIGURE 2.5. *Coffin EX1997-24.5. This is just a lid and is not associated with any mummy.*

Museum in 1982.[2] Coffin lid EX1997-24.5, originally E22, also came to DMNS in 1985 (figure 2.5).

2. Unfortunately, sometime between 1985 and 1991 the records for these two mummies were mixed up. From that time forward the name Mes and the number 1982-24 were used to refer to the mummy with the black varnish and A88.1A-C was used to refer to the mummy with the exposed face. The mummies were renamed again in 2016 to try to ameliorate the confusion. They were given numbers associated with the loan from the Rosemount Museum, EX1997-24.

In 1998, the DMNS opened the first Egyptian Hall, and the main attraction was the two mummies. The exhibit and the mummies were moved to their current location in 2000. Early X-rays and CT scans indicated that both mummies were females and died between the ages of thirty and forty. The scans also showed that EX1997-24.1 was treated well during mummification, which is apparent from her various amulets and lots of packing to make her more lifelike. The other mummy (EX1997-24.3) was in worse shape. Her wrappings are thinner, and there were no immediately identifiable amulets. The early scan led researchers in the 1990s to conclude that EX1997-24.1 was rich and EX1997-24.3 was poor, and the entire exhibit focused on this juxtaposition. We know now from new research that this is too simplistic a narrative. Our new findings show that their distinctions may have been based less on their economic status and more on their place in the history of Egyptian mummification. In 2017, the Egyptian Hall was updated to reflect a new understanding of the lives and deaths of these women, based on the analyses highlighted in this volume. Our hope is that this comprehensive study can help to reassert the status of these mummies as human remains, after a long history of commidification.

DMNS re-scanned the mummies again in 2016 at Children's Hospital Colorado with the assistance of radiologists Kari Hayes and Jason Weinman and a large support team. The re-scanning was necessary in part because no digital record of the scans was left at the museum, only film. Technology has also increased dramatically over the last twenty-plus years, and we knew we could create new 3D models and learn more about the women's lives. Stephen Humphries of National Jewish Health assisted with creating 3D models of the scans. A touch table where visitors can virtually unwrap and explore the mummies was created based off the results of the scans and in collaboration with Interspectral™. It was installed in the updated Egyptian Mummies Hall at DMNS in 2017.

In addition to CT scans, a few other analyses were performed prior to 2016. In 1994, the Egyptian Study Society of the DMNS created an accurate replica of EX1997-24.4. The group took exact measurements and dimensions and researched and used the proper wood, plasters, and paint. They also re-created and utilized the different kinds of tools that would have originally been used to construct the coffin (Kullman 1993). This replica coffin is still in the Egyptian Hall today. Other previous studies include the decipherment of coffins EX1997-24.2 and EX1997-24.5, as well as scanning electron microscopy (SEM) of the pigments from coffins EX1997-24.2 and EX1997-24.4. None of the results of these analyses were previously published, so what could be reconstructed from notes in the archives is incorporated in this volume.

TABLE 2.1. Radiocarbon dates for DMNS mummies and coffins

UCLAMS #	Sample ID	Material	δ_{13} C	Fraction Modern pMC	±	$14C$ age BP	r-sig error (±)	Calibrated Date bce 68.20%	Calibrated Date bce 95.40%	Egyptian Dynasty	Egyptian Period
EX1997-24.1 (mummy)											
173527	1997-24.1	Linen	-24.1	0.7137	0.00164	2710	20	894–825	901–815	22nd	Third Intermediate Period
173528	1997-24.1.1	Linen	-24.0	0.7136	0.00166	2710	20	894–825	901–815	22nd	Third Intermediate Period
EX1997-24.2 (Mes's coffin)											
173522	1997-24.2.A	Wood—core from base		0.7323	0.0016	2500	20	764–556	775–542	25th–26th	Third Intermediate Period–Late Period
173521	1997-24.2.B	Wood—tenon from lid		0.7301	0.00168	2525	20	787–591	791–550	25th–26th	Third Intermediate Period–Late Period
173523	1997-24.2.B.1	Wood—core from lid		0.7320	0.00163	2505	20	768–558	778–543	25th–26th	Third Intermediate Period–Late Period
EX1997-24.3 (mummy)											
174465	1997-24.3	Skin from hip	-20.3	0.7535	0.002	2275	25	396–260	400–231	28th–Ptolemaic	Late Period–Ptolemaic Period
173526	1997-24.3.1	Linen from neck	-23.7	0.7508	0.00172	2300	20	398–379	405–361	28th–30th	Late Period

continued on next page

TABLE 2.1—*continued*

UCIAMS #	Sample ID	Material	δ_{13}C	Fraction Modern pMC	±	14C age BP	1-sig error (±)	Calibrated Date bce	Calibrated Date bce	Egyptian Dynasty	Egyptian Period
EX1997-24.4 (coffin)											
173520	1997-24.4.A	Wood—dowel from base		0.7106	0.00164	2745	20	909–844	927–831	21st–22nd	Third Intermediate Period
173525	1997-24.4.B	Wood—tenon from lid		0.7123	0.00164	2725	20	895–837	911–822	21st–22nd	Third Intermediate Period
173524	1997-24.4.B.1	Wood—lid sample		0.7026	0.0017	2835	20	1016–936	1047–925	21st–22nd	Third Intermediate Period

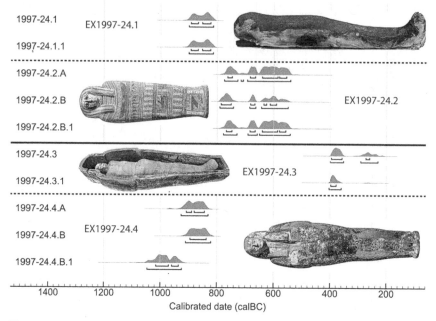

FIGURE 2.6. *Radiocarbon dates of the mummies and coffins at the Denver Museum of Nature & Science. The black bracket bars immediately below the probability distribution curve represents 1 σ probability rate (68.2%) and the bars below this represent the 2 σ, or 95.4 percent, rate.*

RADIOCARBON DATING AND OTHER ANALYSES OF THE MUMMIES AND COFFINS

Radiocarbon dating of the mummies and coffins was undertaken in 2016 (table 2.1, figure 2.6). Samples of linen, tissue, and coffin wood were sent to the Keck Laboratory at the University of California Irvine. The text here presents the 68.2 percent, or 1 σ probability, rate for each range of dates. The 2 σ, or 95.4 percent rate, is alongside the 1 σ dates in table 2.1. By looking at these dates, we can determine that neither mummy belongs with the coffin with which she is now associated (see also Cockitt and David 2007). The dates also allow us to better situate each mummy and coffin in time. Additional evidence from the CT scans also helps contextualize the time period of mummification. Although the CT scans and coffins are discussed in detail in the following chapters, below is a brief description of each mummy and coffin with particular attention paid to the radiocarbon dates and other information not covered elsewhere.

Mummy EX1997-24.1

This mummy is a female around thirty years old. The upper, outer surface of this mummy is coated in a thick black substance explored in chapters 7 and 8. Radiocarbon dates from 894–825 calBCE and details of the mummification practice identified in the CT scans, such as the reinsertion of the organs in linen bundles into the body cavity, indicate that she was mummified during the Third Intermediate Period, probably during the Twenty-second Dynasty. The details of the scans are presented in chapter 4.

An analysis of the linen by DMNS volunteers Peggy Whitehead and Dale Zitek shows that it is a warp-faced plain weave. The cloth was made from well-processed, S-spun, single-ply fine linen and measures 80 ends per inch (EPI) on the warp and 24 EPI on the weft. Whitehead and Zitek suggest that this is fine linen made for a wealthy person. Overall, she received very good treatment and was likely a member of the elite class.

Coffin EX1997-24.2

Coffin EX1997-24.2 is currently associated with mummy EX1997-24.1. Prior to this round of analysis there was speculation that the coffin did not belong to the associated mummy, since it is too large for a roughly 5-foot-tall individual. Between 1985 and 1991, text on the coffin was first translated, which confirmed that, indeed, the two were not originally together. Unfortunately, it remains unclear from where the translation was obtained, since the original is not present at DMNS. However, we know that the translation identified that this coffin was that of a man named Mes or Mose, and it is of a style dating from the 25th to 26th Dynasties (ca. 760–525 BCE). Although it is puzzling that this woman is now in a man's coffin, it was not uncommon for such substitutions to occur. It was a common practice in the early 1900s to pair "nice" mummies and "nice" coffins and sell them as a set to tourists. The two were likely sold together to McClelland in 1905. However, we note that reusing coffins was a common practice in antiquity. Since mummy EX1997-24.1 predates Mes's coffin, it is possible that she was placed in this coffin by priests as they reorganized burials, but it is impossible to know for certain. We may never know what happened to the mummy of Mes; nor will we ever know about the original coffin of the woman now associated with his coffin.

To further confuse the story, the other mummy (EX1997-24.3) was originally given the nickname Mes by the Rosemount Museum. We speculate that DMNS started referring to mummy EX1997-24.1 as Mes sometime in the late 1980s or early 1990s after the coffin was translated. This could be a

pure coincidence, but since both mummies were at the Rosemount Museum until 1971 when EX1997-24.1 came to DMNS, at some point the translation may have been deciphered on the one coffin and the name mistakenly given to the other mummy. Based on the radiocarbon dates, it is also possible that the mummies could have been switched at some point in the recent past, probably while still at the Rosemount Museum. The dates show that mummy EX1997-24.1 (black coating) and the other coffin (EX1997-24.4) (table 2.1, figure 2.5) are from the same time period. It is also possible that the mummies were never originally associated with coffins and this was done sometime before 1971, either in preparation for the DMNS loan or before. We will probably never know, but it has caused confusion in the DMNS archives.

Recently, Edoardo Guzzon from the Museo Egizio (Egyptian Museum) in Turin provided a new translation (see chapter 9) and new clues on the origin of this coffin. According to Guzzon, the coffin did indeed belong to a man named Mes and was discovered by Italian Egyptologist and former director of the Museo Egizio in Turin, Ernesto Schiaparelli, in the Valley of the Queens in 1903. The coffin was found in the reused tomb of Khaemwaset, a son of Ramses III. Forty other coffins were also found in this tomb at the same time. Schiaparelli did not publish the corpus of coffins from this tomb until 1923, and what he did publish was quite limited. Since 2010, Guzzon (2017) has revisited Schiaparelli's work with the plan of producing a more complete manuscript. In his studies, Guzzon realized that the coffin at DMNS was one of five left by Schiaparelli in the Cairo Museum to give to "some American museums." In a photograph from the Italian expedition, Mes's coffin can be seen (figure 2.7).

Guzzon notes that Mes was the brother of Hor (B), S. 5225, whose coffin is in Turin. Hor (B)'s coffin has a decoration dating to 730/720 BCE. According to Guzzon, this date is early in comparison with those of the other coffins found in Rameses III's reused tomb. He suggests that Mes's coffin may be a bit later than Hor (B)'s, since "some new details are included like the Ptah-Sokar-Osiris image on the bottom wall of the box, the background colour of the written columns, and by the philological proofs (like the Osiris names)" (Edoardo Guzzon, personal communication, 2016). According to Guzzon, all of this information indicates that Mes's coffin dates to the years immediately following 715 BCE. This would place the coffin in the 25th (ca. 746–653 BCE) Dynasty rather than the 26th (ca. 664–525 BCE).

Three radiocarbon dates were obtained from this coffin: one from a core from the base, one from a core from the lid, and one from a tenon from the lid

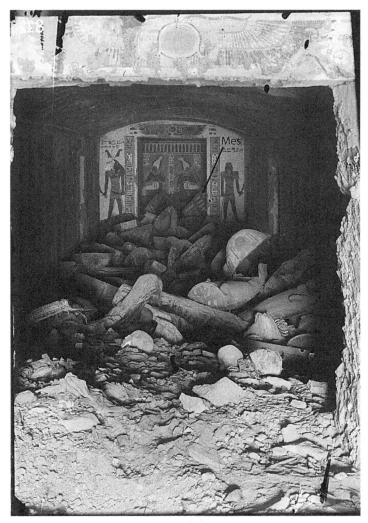

Figure 2.7. *Photograph from the reused tomb of Khaemwaset, a son of Ramses III, taken by the Ernesto Schiaparelli expedition in the Valley of the Queens in 1903. An arrow points to the bottom half of Mes's coffin, visible in the door jamb on the right side of the photograph.* Courtesy, *Archivio Museo Egizio, Turin, Italy.*

(table 2.1, figure 2.6). Collectively, they show that the wood dates from 787–556 calBCE, which would agree with Guzzon's assertion. Analysis of the wood and construction of the coffin is detailed in chapter 6.

Mummy EX1997-24.3

Mummy EX1997-24.3 is also a female about thirty years of age. The details of the CT scans are presented in chapter 4. According to records from the University of Colorado Boulder (CU), where she was housed prior to her move to DMNS, she lived during the 26th Dynasty and was buried in the El Qurna region of Upper Egypt near the Valley of the Kings in an area across the Nile from Karnak and Luxor (*University of Colorado Boulder News*, February 10, 1983). Another source says she came from the Goornah region (an alternative spelling of El Qurna) about 2,750 years ago (*Denver Post*, May 22, 1982). Where this information originated is unclear, as the records at DMNS, the CU Museum, and the Rosemount Museum consist mainly of old newspaper clippings and no original notes or scholarly materials. Although the region of origin may be correct, recent radiocarbon dating and analyses of this mummy and her coffin contradict these dates.

Radiocarbon dating of the linens and a small sample of her tissue indicate that this woman was from the Late Period into the Ptolemaic Period (398–260 calBCE) (table 2.1, figure 2.6) and was mummified during a time when the practice was on the decline. The intact organs visible in the CT scans and outlined in chapter 4 also attest to her Late Period–Ptolemaic Period mummification. At that time, the outer appearance of the mummy was more important than the internal preservation (David 2008). Beautiful cartonnages were often placed over the face and upper body. Conservation notes from 1985 indicate that she was partially unwrapped sometime in the past. The fact that her face is exposed and the wrapping in the CT scans is quite scant also suggests that there were more layers once bundling her. She may have received the finest mummification treatment of the time, but since she was partially unwrapped and potentially had her cartonnage removed, we will never know.

Linen analysis by Peggy Whitehead and Dale Zitek shows that she was wrapped in plain weave, warp-faced, S-spun, single-ply linen. The linens were well processed and have 54 EPI on the weft and 25 EPI on the warp. They were not as fine as the linens of the other mummy, which could indicate that the other mummy was wealthier.

Since her wrappings were so thin, a sample of her tissue could be removed and analyzed for carbon and nitrogen isotope ratios. The d13C values are suggestive of a diet primarily composed of C3 plants such as wheat, barley, and acacia beans (Beauchesne et al. 2008; Tieszen 1991; White and Schwarcz 1994). The d15N value is quite high. This could suggest that she may have been consuming a high proportion of marine fish in her diet. However, if this were the case, a higher (less negative) d13c value would be expected. The high d15N

values are likely due to the fact that plants that grow in arid regions typically have abnormally high d15N values because of high d15N in desert soils (Beauchesne et al. 2008; Schwarcz et al. 1999). In addition, animals (including humans) in arid environments tend to excrete d15N-depleted urea, which leads to enriched values in their tissues.

Coffin EX1997-24.4

The coffin with which this mummy is currently associated was not originally hers. The coffin stylistically dates to the 21st or 22nd Dynasty (1077–943 calBCE). Three radiocarbon samples were taken from this coffin for dating: one from a dowel in the base, one from a tenon from the lid, and one from the wood that made up the lid. The dates for the dowel and the tenon are similar and range from 909 to 837 calBCE. The coffin wood dates to 1016–936 calBCE. The wood is sycomore fig, a slow-growing tree, and the date may reflect the long time it takes for these trees to mature (see chapter 6). However, the earlier date for the coffin wood versus the tenon and dowel may also indicate that this coffin was constructed of previously used wood, perhaps from architecture, since wood was in high demand at the time. The overall construction of this coffin is poor but the decoration is rather high quality, including the use of highly regarded Egyptian blue paint (chapters 7 and 8). This suggests that the family of the deceased or the carpenters did not expect the coffin to last a particularly long time, but it still required the correct decorations to ensure that the deceased was able to pass on to the afterlife (see chapter 5). The lower-quality construction is likely due to the known high levels of tomb robbery during this time and the belief that, because of this, the coffin would not last. This was ultimately the case, as this coffin is now associated with a woman who died roughly 600 years later.

Unfortunately, the black coating on the coffin and the deteriorated state of the painting make it difficult to decipher personal details, such as the original name of the person buried in the coffin. However, some information can be gleaned, and it is presented in chapter 9. Infrared and UV photography (see chapter 3) do show some more details, but this information needs to be evaluated further. It is possible that mummy EX1997-24.3 was buried in this coffin in antiquity, since it was common to rob tombs even in ancient times to find quality coffins, but it is also possible that she was placed in this much older coffin for the tourist market in the early 1900s. It is also possible that the other mummy (EX1997-24.1) may have actually been buried in the coffin with EX1997-24.3 and switched in Pueblo, Colorado. Both mummy EX1997-24.1 and this coffin (EX1997-24.4) are covered with a thick black substance, and both are from around the same time period.

EX1997-24.4 is slightly too long and narrow for mummy EX1997-24.1, but she would fit. Unfortunately, we may never know if the two were an original pair.

Coffin EX1997-24.5

This coffin lid came to DMNS from the Rosemount Museum in 1985. Over the years it has suffered some damage around the edges and the feet, but the designs and hieroglyphs are in remarkably good shape. Because of this, we know it belonged to Ankhefenkhonsu, Priest of Amun at Karnak, who died during the 21st Dynasty. A complete translation and analysis of the decoration is provided in chapter 9.

MUMMIFICATION IN ANCIENT EGYPT

Mummification has a long history in Egypt. To appreciate what CT scans and other technological tests can reveal, it is necessary to understand the changing nature of mummification over the centuries it was practiced. The majority of the descriptions of mummification practices are by Egyptologists (Brier 1996; David 2008; Ikram 2015) and are based on firsthand accounts especially by Herodotus (1988 [ca. 440 BCE]) and Diodorus Siculus (1933 [ca. 50 BCE]). Recently, CT scans of mummies have begun to show that there is a great deal of variability in what is thought to be the standard practices based on these accounts (Wade and Nelson 2013a, 2013b). Nelson and Wade (2015) call for scholars to be more accepting of this variability to show that mummification was much more dynamic than is traditionally believed. The building of the CT scan corpus through studies like this one helps to better define the range of possibilities. Nonetheless, the traditional views of mummification practices through time are presented here as a benchmark for this study.

It was once believed that Predynastic (6000–3150 BCE) burials only contained naturally desiccated individuals in shallow pits. Because of the environmental conditions in Egypt, the bodies would preserve, which led to the development of more advanced mummification techniques through time. However, recent excavations suggest that already in this period there were early efforts to preserve bodies by wrapping them in linen (Ikram 2015: 59). Nonetheless, the idea for mummification and the related religious connection to preserving the body for eternal life still may have developed from observing the way the desert preserved dead bodies.

As early as the 2nd Dynasty (ca. 2890–2686 BCE), natron—a mixture of naturally occurring sodium carbonate, sodium bicarbonate, sodium chloride, and

sodium sulfate—was used to desiccate the body. The removal of the organs began around the 4th Dynasty (ca. 2613–2494 BCE), and canopic chests were first used to contain the viscera. These were rarely inscribed and had plain lids. By the Middle Kingdom (ca. 2055–1650 BCE) there was sporadic removal of the brain, but this did not become standard practice until the New Kingdom (ca. 1570–1069 BCE). Canopic jars in the Middle Kingdom had lids in the form of human heads. Amulets began to be consistently placed on the body within the wrappings around the 13th Dynasty (ca. 1803–1649 BCE). The amulets were charms with magical powers that protected the mummy from evil. They could be used for healing, luck, or protection. Heart scarabs were some of the most important amulets, as they helped protect the heart during the final judgment and could be a substitute if the real heart was destroyed (Ikram 2015: 98; Wade and Nelson 2013a). Mummification became more popular during the Middle Kingdom and was available to non-royal individuals. However, less care was taken in regard to the preparation of the body during this period and more attention was paid to the outward appearance (Brier 1996; David 2008; Ikram 2015). The mummification techniques that are the best known began during the New Kingdom, which spanned the 18th–20th Dynasties. Some of the most famous pharaohs lived during this time, including King Tutankhamun and Ramesses II.

Many royal and non-royal mummies have been found that date to this time, which give us some suggestions of how class differences were manifest in mummification. Royal mummies were prepared with more expensive oils and linens and more amulets than the non-royal mummies. Royal individuals had their arms crossed over their chests. Non-royal females' arms were placed along the sides of the bodies with the hands on the thighs, and men had their hands over their genitals. The organs were removed from all people and placed in canopic jars. By the 19th Dynasty the lids of the canopic jars represented one of the Four Sons of Horus. Hapi, the baboon, contained the lungs and was protected by the goddess Nephthys. Duamutef, the jackal, contained the stomach and was protected by the goddess Neith. Imseti, the human, was associated with the goddess Isis and protected the liver, and Qebehsenuef, the falcon, housed the intestines and was protected by the goddess Serqet. It was during this time period that increased efforts were made to make the body look more lifelike. Bodies were stuffed with linen, sawdust, grease, and/or lichen to maintain the natural shape (David 2008: 16). False linen eyes were placed over the eye sockets.

Mummification peaked during the 21st Dynasty (ca. 1070–945 BCE) of the Third Intermediate Period (ca. 1070–664 BCE). This is when mummies were

made to closely resemble the living body. As in the previous period, the body was packed with mud, sand, resin, and/or sawdust; at this time mummies were also painted. The faces of male mummies were often painted red and the faces of female mummies were painted yellow (Brier 1996). The eye sockets were packed with resin and glass, or stone eyes were placed over the orbitals. False hair extensions were often used for beautification. Instead of placing the organs in canopic jars, they were now inserted back into the body in individually wrapped linen packets. Sometimes the packets were accompanied by a wax figurine of one of the Four Sons of Horus that served the same purpose as the canopic jars in the New Kingdom. This was done because looting during the New Kingdom had become a big problem, and mummies were getting separated from their organs. In order to pass into the afterlife, it was necessary for the organs to be with the body, so during the Third Intermediate Period reinsertion of the viscera bundles became common practice (David 2008).

After the Third Intermediate Period, mummification began to decline. In the Late Period (ca. 664–332 BCE), painting the skin and packing the body cavity became less common. When the viscera were removed, they were often placed between the legs and not back inside the body. Sometimes the organs were not completely removed. By the Ptolemaic Period (ca. 332–30 BCE), the process of mummification became more commercial and less religious. With the influx of foreigners, the external appearance was more important than the internal preservation of the body. Beautifully decorated cartonnage masks made of papyrus or linen and resin became desirable. Many of these masks are now in museums without their accompanying mummy. This trend lasted into the Roman Period (30 BCE–CE sixth century) and persisted when Egypt adopted Christianity. However, although natron and other oils and resins continued to be used, the body was no longer eviscerated. Mummification continued to decline throughout the Christian period and had ceased altogether by the time of the introduction of Islam in Egypt after AD 641 (David 2008: 17; Ikram 2015: 72–73).

COFFIN MANUFACTURE IN ANCIENT EGYPT

The style of Egyptian coffins changed throughout Egypt's history, along with construction techniques. During the Third Intermediate Period, which is when the coffins in the present discussion were created (see below), most coffins were anthropoid, or human-shaped. Often, they were placed in nested sets and could include an outer coffin, inner coffin, and a mummy board—a carved and decorated board that was placed directly over the mummy. Occasionally, these inner coffins were also placed in an outer rectangular coffin. This was

most common in the 25th Dynasty and later, at which time the box coffin often had a vaulted lid with four corner posts (Taylor 1989: 42, 56).

Most coffins in all periods were built from local Egyptian wood, such as sycomore fig, acacia, and tamarisk. These trees, however, tend to grow rather twisted and full of faults. When the economy was strong and trade was flourishing, the best coffins were therefore built out of imported timbers such as Lebanese cedar, which grows straight and produces high-quality construction materials (Gale et al. 2000). These trees were chopped down with axes and laid out to dry, or season, for a number of months or even years. They would then usually be sawn into workable planks from which to create the coffins. The woodworking tools used by the ancient Egyptians are surprisingly similar to those used today for objects made by hand. They included the axe, saw, mallet, drill, chisel, awl, adze, and sandstone blocks to smooth the surface of the wood and remove visible tool marks. The carpenters would use these tools to join the wood, selecting from a number of joining techniques, such as mitre or dovetail joints. Patches of wood or large amounts of plaster were often required to fill gaps in construction, particularly for coffins made of local wood (Dawson et al. 2016; Killen 1994; see chapters 5 and 6).

After construction, the coffin was usually covered in plaster or, more technically, a calcium-based preparation layer. Sometimes a layer or multiple layers of linen were then placed on top, and another layer of plaster or paste was added to prepare a smooth working surface. The polychrome inscriptions and figures could be painted on top of this layer, or a background color could first be applied. Pigments were often created from yellow or red ochres, yellow orpiment, Egyptian blue and green, and carbon black (Dawson et al. 2016: 94–99). During the 21st and early 22nd Dynasties, many coffins had a yellow background. This was either applied directly, or the white background was colored yellow due to the application of varnish. Coffins were often covered in a clear or yellow varnish, usually made from pistacia resin. Finally, a black substance often consisting of darkened pistacia resin or bitumen might be applied to the exterior in varying amounts (Stacey 2016; see chapters 7 and 8).

THE THIRD INTERMEDIATE PERIOD IN EGYPT

The coffins and one of the mummies in this publication date to what Egyptologists refer to as the *Third Intermediate Period*. This is an era toward the end of Egypt's pharaonic history, before the rule of Greece and Rome, when multiple leaders controlled different areas of Egypt. Although its extent is debated, it is generally seen to cover the Twenty-first through Twenty-fifth Dynasties,

or approximately the years 1069–664 BCE. The breakdown in control that began this period was caused by a combination of factors. Libyans from the west had been moving into Egypt for generations, with a number of families becoming very powerful (Dodson 2012: 6–9; Taylor 2000: 332–345). Groups of seafaring peoples, referred to collectively as the "Sea Peoples," were also traveling down the coast and at least contributed to the collapse of a number of the settlements in the eastern Mediterranean. Egypt therefore lost a number of Levantine trading partners and also battled with these groups directly.[3] This put significant strain on society and the economy, and the Egyptians began to experience grain shortages as well. After the death of Ramesses XI (ca. 1069 BCE), rule of Egypt was split between the succeeding Egyptian kings of the 21st Dynasty in the north and powerful families of high priests in the south. These priests may have nominally been under the control of the pharaoh, but in reality they were "virtually independent" (Taylor 2010: 220).

In the following period, powerful Libyan families that had slowly been gaining power took control of the Delta, becoming the 22nd Dynasty around 946 BCE. They placed their sons as high priests in the south, ensuring better control of Egypt as a whole (Taylor 2000: 329); however, in the Delta, other lineages began to compete for power, with some individuals claiming the title of kingship. Toward the end of Dynasty 22, the kings of the 23rd and 24th Dynasties seem to also have been ruling concurrently in this area, though the identity of these men is a debated and complicated issue (see Dodson 2012: 113–38). Meanwhile, in the south, the Kushite kings in Nubia were also beginning to look to the north. Eventually, they were able to invade Egypt and consolidate their rule as the 25th Dynasty (Taylor 2000: 347).

When the Kushite rulers took power, they renewed sites and temples around Egypt, particularly those dedicated to the god Amun. Texts from this period discuss a desire to return Egypt to its former state of prosperity, and the monuments and artwork created under Kushite reign connect to traditional motifs and styles that had been popular in older periods of Egyptian history (Taylor 2000: 360–61). These practices of archaism remained popular into the following period, when the Assyrians took control of Egypt, ending the Third Intermediate Period.

During the earlier Third Intermediate Period, particularly the 21st and early 22nd Dynasties, with the Egyptian economy failing and resources harder to come by, many objects and materials had to be reused in greater numbers than

3. For an overview of the various factors in the transformation of the Mediterranean powers at this time, see Broodbank (2013: 445–505).

was previously common. This included coffins and funerary equipment. Tombs were opened, and even kings were removed from their burials so their golden objects could be melted down and their wooden coffins could be reused for new owners (Cooney 2007, 2011, 2014). As tomb robberies were occurring with increasing frequency, the Egyptian people were no longer confident that their burials would last for eternity. They started opting for group burials, perhaps in the hope of greater shared security. The burial assemblage was also frequently simplified down to the necessities, which often consisted of just the mummy and a coffin. For those of more substantial means, the assemblage was limited to the mummy, coffins, canopic containers, shabtis, an Osiris figure, funerary papyri, and a stela (Cooney 2011: 16–18; Richards 2005: 85; Taylor 2010: 234). With the loss of decorated tomb walls, images and spells were condensed and incorporated into coffin decoration (Taylor 2010: 235). As noted above, more focus was also placed on mummification, as the body could not be reused.

During the 22nd Dynasty, Egypt seems to have recovered somewhat economically, and funerary objects were again crafted from fresh materials for their owners (Taylor 2003). This prosperity lasted into the 25th Dynasty, when many of the traditional motifs returned as part of coffin decoration, though in entirely new ways. As noted, many of the developments that occurred during this last dynasty of the Third Intermediate were carried on into later periods as well.

CHANGING NARRATIVES AND NEW DIRECTIONS

From the 1991 and 1998 scans, EX1997-24.1 was nicknamed Rich Mummy, and EX1997-24.2 was nicknamed Poor Mummy. When the *Egyptian Mummies* exhibit at DMNS was opened in 2000, the theme centered on the class differences in the treatment of these two women in death because it was assumed they were from the same time period—the 19th or 20th Dynasty. As discussed, new radiocarbon dates indicate that these women lived over 500 years apart, and mummification practices changed dramatically over this time. Although class was important in Egypt and discernible in the mummification of these women to some degree, when they died played a larger role in the treatment the women received. This book explores the different methods employed to re-examine and ultimately change the narrative of these two mummies and their associated coffins.

The combination of these scientific, anthropological, and art historical analyses provides a complete and in-depth study of these Egyptian mummies and coffins. The combined results correct the mistaken assumptions made regarding the status of the women while adding significant information to our

knowledge of ancient Egyptian materials, technologies, and religious practices. The study as a whole demonstrates the value of such multidisciplinary projects, in the hope that these methods will be integrated into future studies to provide more thorough investigation of objects as witnesses of life in the ancient world.

REFERENCES

Beauchesne, Patrick, Ian Colquhoun, Alan Cross, Janet Gardner, Fred Longstaffe, Laura Marciano, Jessica Metcalfe, Andrew J. Nelson, Andrew Pawlowski, Sandra Wheeler, Christine D. White, and Lana Williams. 2008. "Lady Hudson and Mummy Studies at the University of Western Ontario." In *Mummies and Science, World Mummies Research: Proceedings of the VI World Congress on Mummy Studies*, edited by Pablo Atoche Peña, Conrado Rodriguez Martin, Angeles Ramirez Rodriguez, and Arthur C Aufderheide, 637–40. Santa Cruz de Tenerife: Academia Canaria de la Historia.

Brier, Bob. 1996. *Egyptian Mummies: Unraveling the Secrets of an Ancient Art*. New York: Harper Perennial.

Broodbank, Cyprian. 2013. *The Making of the Middle Sea: A History of the Mediterranean from the Beginning to the Emergence of the Classical World*. Oxford: Oxford University Press.

Cockitt, Jenefer A., and Rosalie David. 2007. "The Radiocarbon Dating of Ancient Egyptian Mummies and Their Associated Artefacts: Implications for Egyptology." In *Current Research in Egyptology 2006: Proceedings of the Seventh Annual Symposium*, edited by Maria Cannata, 43–53. Oxford: Oxbow Books.

Cooney, Kathlyn M. 2007. *The Cost of Death: The Social and Economic Value of Ancient Egyptian Funerary Art in the Ramesside Period*. Egyptologische Uitgaven 22. Leiden: Nederlands Inst. voor het Nabije Oosten.

Cooney, Kathlyn M. 2011. "Changing Burial Practices at the End of the New Kingdom: Defensive Adaptations in Tomb Commissions, Coffin Commissions, Coffin Decoration, and Mummification." *Journal of the American Research Center in Egypt* 47: 3–44.

Cooney, Kathlyn M. 2014. "Ancient Egyptian Funerary Arts as Social Documents: Social Place, Reuse, and Working towards a New Typology of 21st Dynasty Coffins." In *Body, Cosmos, and Eternity: New Research Trends in the Iconography and Symbolism of Ancient Egyptian Coffins*, edited by Rogério Sousa, 45–66. Oxford: Archeopress Archaeology.

David, Rosalie, ed. 2008. *Egyptian Mummies and Modern Science*. Cambridge: Cambridge University Press.

Dawson, Julie, Jennifer Marchant, and Eleanor von Aderkas. 2016. "Egyptian Coffins: Materials, Construction, and Decoration." In *Death on the Nile: Uncovering the Afterlife of Ancient Egypt*, edited by Helen Strudwick and Julie Dawson, 75–111. London: Fitzwilliam Museum and D. Giles Ltd.

Diodorus Siculus. 1933. *Library of History*, vol. 1: *Books 1–2.34*. Translated by Charles Henry Oldfather. Loeb Classical Library 279. Cambridge, MA: Harvard University Press.

Dodson, Aidan. 2012. *Afterglow of Empire: Egypt from the Fall of the New Kingdom to the Saite Renaissance*. Cairo, Egypt: American University in Cairo Press.

Gale, Rowena, Peter Gasson, F. Nigel Hepper, and Geoffrey Killen, 2000. "Wood." In *Ancient Egyptian Materials and Technology*, edited by Paul T. Nicholson and Ian Shaw, 334–71. Cambridge: Cambridge University Press.

Guzzon, Edoardo. 2017. "The Wooden Coffins of the Late Third Intermediate Period and Late Period Found by Schiaparelli in the Valley of the Queens (QV 43 and QV 44)." In *Proceedings First Vatican Coffin Conference 19–22 June 2013*, vol. 2, edited by Alessia Ameta and Helene Guichard, 191–98. The Vatican: Vatican Museum.

Herodotus. 1988. *Herodotus: The History*. Translated by David Grene. Chicago: University of Chicago Press.

Ikram, Salima. 2015. *Death and Burial in Ancient Egypt*. Reprint ed. Cairo, Egypt: American University in Cairo Press.

Killen, Geoffrey. 1994. *Egyptian Woodworking and Furniture*. Shire Egyptology 21. Princes Risborough, UK: Shire.

Kullman, Jack. 1993. "Construction and Plastering of Wood Coffins." *The Ostracon: Egyptian Study Society* 4 (2): 1–4.

Nelson, Andrew John, and Andrew David Wade. 2015. "Impact: Development of a Radiological Mummy Database." *Anatomical Record* 298 (6): 941–48.

Richards, Janet. 2005. *Society and Death in Ancient Egypt: Mortuary Landscapes of the Middle Kingdom*. Cambridge: Cambridge University Press.

Schwarcz, Henry P., Tosha L. Dupras, and Scott I. Fairgrieve. 1999. "15N Enrichment in the Sahara: In Search of a Global Relationship." *Journal of Archaeological Science* 26 (6): 629–36.

Stacey, Rebecca. 2016. "Resins and Varnishes Used on Coffins." In *Death on the Nile: Uncovering the Afterlife of Ancient Egypt*, edited by Julie Dawson and Helen Strudwick, 99. Cambridge: Fitzwilliam Museum and D. Giles Ltd.

Taylor, John H. 1989. *Egyptian Coffins*. Shire Egyptology 11. Aylesbury, UK: Shire.

Taylor, John H. 2000. "The Third Intermediate Period." In *The Oxford History of Ancient Egypt*, edited by Ian Shaw, 324–63. Oxford: Oxford University Press.

Taylor, John H. 2003. "Theban Coffins from the Twenty-second to the Twenty-sixth Dynasty: Dating and Synthesis of Development." In *The Theban Necropolis: Past,*

Present, and Future, edited by Nigel Strudwick and John H. Taylor, 95–121. London: British Museum Press.

Taylor, John H. 2010. "Changes in the Afterlife." In *Egyptian Archaeology*, edited by Willeke Wendrich, 220–40. Chichester, UK: Wiley-Blackwell.

Tieszen, Larry L. 1991. "Natural Variations in the Carbon Isotope Values of Plants: Implications for Archaeology, Ecology, and Paleoecology." *Journal of Archaeological Science* 18 (3): 227–48.

Wade, Andrew D., and Andrew J. Nelson. 2013a. "Evisceration and Excerebration in the Egyptian Mummification Tradition." *Journal of Archaeological Science* 40 (12): 4198–4206.

Wade, Andrew D., and Andrew J. Nelson. 2013b. "Radiological Evaluation of the Evisceration Tradition in Ancient Egyptian Mummies." *HOMO—Journal of Comparative Human Biology* 64 (1): 1–28.

White, Christine D., and Henry P. Schwarcz. 1994. "Temporal Trends in Stable Isotopes for Nubian Mummy Tissues." *American Journal of Physical Anthropology* 93 (2): 165–87.

3

The *Egyptian Mummies* exhibition at the Denver Museum of Nature & Science (DMNS) underwent renovation in April 2016. While the gallery was closed, two mummies, two complete wooden coffins, and a single wooden coffin lid were brought to the Avenir Conservation Center at DMNS for conservation treatment. The goal of this three-week treatment was to secure any loose surface and structural elements on the mummies and coffins prior to their transport to Children's Hospital Colorado to undergo computed tomography (CT) scanning and then for subsequent long-term exhibition reinstallation. DMNS conservators evaluated the objects' stability to guide the selection and implementation of a treatment strategy. Included in the 2016 evaluation were empirical observations and a review of thirty-four years of historical treatment documentation from work completed at a regional conservation center in 1982 and 1985 and at DMNS in 1998. Other chapters in this book address the history, construction techniques, and materials used for the group of mummies and coffins. This chapter presents the results of the conservation work completed for the 2016 case study project.

Understanding the Current Condition of a Group of Egyptian Coffins and Mummies by Examining the Past

A Case Study on Four Decades of Conservation Treatment

Judith A. Southward and
Jessica M. Fletcher

GENERAL CONSERVATION
METHODS AND MATERIALS

Conservation as a profession strives to preserve cultural property for the future while at the same time

DOI: 10.5876/9781646421381.c003

maintaining the integrity of the property (AIC 1994). Conservators typically approach this goal through careful examination and documentation of the current condition of an artifact, followed by development of a preservation strategy that may include steps such as preventive care and stabilization treatment. They are initially guided in their choice of methods and materials for a treatment by the type and cause of deterioration. A further factor may include the location where the conservation work is to be performed (for example, *in situ* in the gallery or in a fully ventilated purpose-built laboratory facility). Conservators consider available aging data and working properties of their materials and incorporate best practices at the time in an evolving field. Success of a past treatment can be evaluated by examining the current appearance of repairs and noting any failure, such as loss of structural integrity, loss of adhesion, brittleness, and any dimensional changes such as shrinking, slumping, or warping. Conservators also evaluate whether the repair materials caused any staining from application and if they yellowed or darkened with age.

Ultimately, empirical observations and the examination of historical treatments strongly influenced the 2016 treatment strategy. DMNS conservators chose to follow methods and materials used in 1998 because of their good working properties and performance over time. The methods and materials of all the documented treatments (1982, 1985, 1998, and 2016) are summarized in tables 3.1–3.3.

CONSERVATION TREATMENT HISTORY OF THE MUMMIES AND COFFINS

The mummies and coffins that are the subject of this case study are on long-term loan to DMNS from the Rosemount Museum in Pueblo, Colorado. The reader is referred to chapter 2, as well as to the other chapters in this book, for a complete discussion of the loan history of these artifacts at DMNS and recently completed research. The majority of conservation work undertaken through the past thirty-four years primarily involved securing loose areas in the decorative surface layers that cover the wood of the coffins. The decorative surface layers include the polychrome paint and ground layers on both coffins and the single coffin lid, as well as the black layer on the black-coated coffin. Previous treatment of the coffins also included gap-filling of some wooden structural elements. The 2016 condition assessment and both past and present treatments are outlined below.

Figure 3.1. *Areas of suspected pre-1982 treatment on the black-coated mummy (EX1997-24.1), shown in 2016 under normal illumination (A) and flourescing turquoise blue under UVA (320–400 nanometers) illumination (B). Rick Wicker photos, © Denver Museum of Nature & Science.*

Mummy EX1997-24.1 (black-coated mummy)

Description: Female mummy EX1997-24.1 is wrapped in linen and is coated on the front half with a black substance. This mummy is hereafter referred to in this chapter as the black-coated mummy. Radiocarbon analysis dates the mummy to the Third Intermediate Period (chapter 2). Though the black-coated mummy was grouped with Mes's coffin (described below) in the original Rosemount Museum loan and has subsequently been displayed adjacent to the coffin, research has shown that this was not her original housing (chapter 2).

Current Condition and Historical Treatments: The linen wrapping is brittle and darkened, and the thick black substance is cracked along the edges with some losses. Extensive examination with ultraviolet illumination (UVA at 320–400 nanometers) in 2016 revealed previous treatment associated with the black coating that fluoresced a bright turquoise blue (figure 3.1). The fluorescing material was probably applied prior to 1982 to secure cracks and losses in the black coating. Records on file for the mummy indicate that no treatment was performed in 1982. Literature sources (Grant 2000; Measday 2017; Unruh et al. 2005) and the authors' previous experience suggest a wide range of materials that fluoresce blue, from paraffin wax to polyvinyl acetate adhesives and other synthetic resins. Further analytical testing is recommended to identify this material. In 1998, dust was removed from the surface of the black layer using soft bristle brushes directed toward vacuum suction. No surface dust was noted in 2016 because the mummies and coffins had been exhibited in well-sealed cases.

2016 Treatment: No changes were noted to the black-coated mummy in 2016 and no treatment was undertaken except for bagging several small slivers of linen found on the exhibition mount platform that had detached during handling and transport from the gallery to the Avenir Conservation Center.

Coffin EX1997-24.2 (Mes's Coffin)

Description: Coffin EX1997-24.2 (A base and B lid) is anthropoid in shape and has a white background with polychrome decoration. Rough wood surfaces are covered with a white ground layer over which the polychrome paint has been applied. Inscriptions indicate that the coffin was originally built for a male named Mes, and hereafter the coffin is referred to in this chapter as Mes's coffin. Radiocarbon dating places the coffin in the 25th Dynasty (chapter 2).

Current Condition and Historical Treatments: The structure of Mes's coffin is largely intact, though a hole at the chin on the lid suggests the original presence of a false beard (see chapter 9). Decorative surface layers still cover the majority of the wooden structure, both interior and exterior, with scattered areas of damage and loss. Tide-line stains corresponding to the placement of a mummy can be seen on the interior of the coffin. A tide line is a demarcation line usually distinguished by significant color difference between the edge of a stain and the material on which it is located (AIC 2015). Tide lines can occur when solid materials, such as pigment or dirt, are carried to a new location by a liquid or when a colored liquid dries with a higher concentration of the coloring agent at the edges. Future forensic testing could help determine if these stains are the result of decomposition fluids.

Stabilization campaigns from 1982 using gelatin and polyvinyl acetate adhesive (unspecified brand) and from 1998 using a mixture of Lascaux 498HV and Rhoplex AC-234 (acrylic polymer emulsions) are generally holding. Structural fills from 1998 of Paraloid B-72 (ethyl methacrylate copolymer in acetone) bulked with glass microspheres and dry pigments are also still secure. Saturation of exposed wood and ground was noted in 1998 adjacent to some areas treated in 1982. Drip marks and dark stains from the application or aging of restoration materials, as well as additional visible structural repairs, were also noted in 1998 in areas that did not correspond to 1982 treatment reports. These areas are suspected to have been treated pre-1982 (figure 3.2).

New areas of concern in 2016 included three loose slivers of wood at the head of the coffin base and sixteen small lifting or loose areas of the decorative surface layers on the base and lid. A small area of minor saturation of the

FIGURE 3.2. *Drip marks in area of suspected pre-1982 treatment on Mes's coffin (EX1997-24.2A), visible in the 1982 treatment image (A), and in 2016 under normal illumination (B) and flourescing yellow under UVA (320–400 nanometers) illumination (C). A © Denver Museum of Nature & Science, B and C Rick Wicker photos, © Denver Museum of Nature & Science.*

pale blue paint at the foot of the lid was also noted in 2016, resulting from the 1998 treatment.

2016 Treatment: Loose areas of the decorative surface layers and small slivers of lifting structural coffin wood were secured with a 70 percent to 30 percent ratio mixture of Lascaux 498HV and Rhoplex AC-2235M (acrylic polymer emulsions). This adhesive mixture, similar to that used in 1998, was chosen for several reasons. Primarily, examination of the repairs made eighteen years previously showed that the adhesive was still holding well, with good aging characteristics (Down 2015; Down et al. 1996). In addition, the working properties of the adhesive mixture were well suited for stabilizing the flaking decorative layers on the largely vertical surfaces, with minimal visual disruption. The adhesive mixture was applied under loose surface areas and structural slivers using either a fine syringe or brush after pre-wetting with ethanol. The ethanol allowed the adhesive to wick more smoothly under the target area. To avoid staining, care was taken to use only enough adhesive to secure the target area while not overflowing onto adjacent porous surfaces.

In 1998 at DMNS, the treatment documentation included 8 inch × 10 inch black-and-white photographs covered with Mylar (polyester film). The treatment locations from 1982, 1985, and 1998 were recorded using different-colored Sharpie permanent markers. The conservators chose to add all 2016 treatment locations to the 1998 Mylar overlays for continuity. Marking the 2016 locations alongside those from previous treatments made it readily apparent where new damage had occurred versus failure of previous stabilization.

TABLE 3.1. Treatment history of mummy EX1997-24.1 and coffin EX1997-24.2A and B

DMNS Catalog #	Treatment Dates	Treatment Summary
EX1997-24.1 Black-coated mummy	Pre-1982	• Black layer secured with unspecified turquoise-blue–fluorescing adhesive.
	1982	• Mount recommendations only.
	1998	• Surface cleaned with soft-bristle brush toward a vacuum nozzle.
	2016	• No treatment.
EX1997-24.2A Mes's coffin base	Pre-1982	• Unknown structural repairs and consolidation, including turquoise-blue–fluorescing adhesive.
	1982	• Loose areas of the decorative surface layers were secured with gelatin or PVA emulsion (polyvinyl acetate, unspecified).
	1998	• Surface cleaned with soft-bristle brush toward a vacuum nozzle. • Structural gap filling using 40 percent Paraloid B-72 (ethyl methacrylate copolymer) in acetone, bulked with glass microspheres and dry pigments. • Loose areas of the decorative surface layers were secured with mixture of Lascaux 498HV and Rhoplex AC-234 (aqueous acrylic adhesives), pre-wet with ethanol. • Minimal inpainting with Liquitex acrylic paints. • Mount improvements.
	2016	• Loose areas of the decorative surface layers and small slivers of lifting wood were secured with a 70 percent to 30 percent mixture of Lascaux 498HV and Rhoplex AC-2235M (aqueous acrylic adhesives), pre-wet with ethanol.
EX1997-24.2B Mes's coffin lid	Pre-1982	• Unknown structural repairs and consolidation.
	1982	• Loose areas of the decorative surface layers were secured with gelatin or PVA emulsion (polyvinyl acetate, unspecified).
	1998	• Surface cleaned with a soft-bristle brush toward a vacuum nozzle. • Structural gap filling using 40 percent Paraloid B-72 (ethyl methacrylate copolymer) in acetone, bulked with glass microspheres and dry pigments. • Loose areas of the decorative surface layers were secured with mixture of Lascaux 498HV and Rhoplex AC-234 (aqueous acrylic adhesives), pre-wet with ethanol. • Minimal inpainting with Liquitex acrylic paints. • Mount improvements.
	2016	• Loose areas of the decorative surface layers and small slivers of lifting wood were secured with a 70 percent to 30 percent mixture of Lascaux 498HV and Rhoplex AC-2235M (aqueous acrylic adhesives), pre-wet with ethanol.

Mummy EX1997-24.3

Description: Female mummy EX1997-24.3 was partially unwrapped at the head and face at some point in history and is hereafter referred to in this chapter as the mummy with exposed face. CT scans and radiocarbon dating show that the mummy died within the time frame of the Late Period to the Ptolemaic Period (chapter 2). Although this mummy was grouped with the black-coated coffin, research has shown that this was not the original coffin (chapter 2).

Current Condition and Historical Treatments: This mummy is particularly fragile and was left *in situ* on a Plexiglas support in the coffin during examination and subsequent treatment of the wooden coffin. The linen wrappings do not cover the face, exposing eyebrows, eyelashes, and teeth that are all reasonably intact. The body has some deformation, particularly in the hips. The head is loose at the neck and the feet are loose at the ankles. There are holes in the skin of the head that indicate previous insect damage. The linen wrappings are yellowed, brown, and brittle, with numerous tears and losses. Impressions of the original textile remain visible in the facial skin.

The 1985 treatment report from the regional conservation center describes using strips of nylon net to stabilize the fragile linen. These were wrapped around vulnerable areas and stitched to a larger piece of net that was placed underneath the mummy. In 1998, it was deemed that more comprehensive support of the fragile linen was needed. The 1985 net was removed and new light-brown nylon-net strips (approx. 3 inches wide) were wrapped around the mummy, beginning at the feet and ending at the neck. In 2016, the net did not appear to have physically shifted in position or visually altered in color (compared to samples retained from 1998). The net continues to support loose areas of the linen.

2016 Treatment: No changes were noted to the mummy in 2016, and no treatment was undertaken.

Coffin EX1997-24.4 (black-coated coffin)

Description: Coffin EX1997-24.4 (A base and B lid) is also anthropoid in shape and has a yellow background with polychrome decoration (figure 3.3). The wood surface is covered with a ground layer over which the decorative polychrome paint has been applied. A black substance is present over much of the exterior surface, obscuring the polychrome below. Hereafter, the coffin is referred to in this chapter as the black-coated coffin. Using radiocarbon dating and stylistic analysis, this coffin was determined to have been constructed in the 21st or 22nd Dynasty for a female occupant (chapter 2).

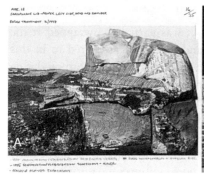
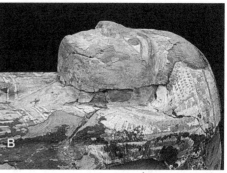

FIGURE 3.3. *The black-coated coffin lid (EX1997-24.4B) in a 1998 Mylar-covered black-and-white photo with treatment campaigns identified (A), and the coffin in 2016 under normal illumination (B). A © Denver Museum of Nature & Science, B Rick Wicker photo, © Denver Museum of Nature & Science.*

Current Condition and Historical Treatments: The structure of the black-coated coffin is largely intact, although carved hands are missing from where they would have attached to the chest (see chapter 9). Decorative surface layers still cover the majority of the wooden structure, both interior and exterior, with scattered areas of damage and loss. Heavy stains with tide lines corresponding to the placement of a mummy can be seen on the interior of the coffin, obscuring much of the interior polychrome. Infrared photographs taken in 2016 provide some enhancement of the obscured interior painting but were not helpful for examining the black-coated exterior.

Stabilization campaigns from 1985 using rabbit-skin glue and Vinamul polyvinyl acetate and from 1998 using the mixture of Lascaux 498HV and Rhoplex AC-234 are holding well. Slight saturation of exposed wood and ground was noted in 1998 adjacent to some areas treated in 1985. Dark stains in the yellow polychrome on the face are suspected to be the result of the application or aging of restoration materials from pre-1985 stabilization attempts.

Areas of concern for this coffin in 2016 included two partly detached slivers of wood at the foot exterior of the base and approximately twenty-five small areas of lifting decorative surface layers across both the base and the lid. These areas were mostly 1 centimeter or less in size, and only a few were 2 centimeters in size. Structural fills of toned Paraloid B-72 and glass microspheres from the 1998 treatment showed some outward bulging and distortion, possibly

TABLE 3.2. Treatment history of mummy EX1997-24.3 and coffin EX1997-24.4A and B

DMNS Catalog #	Treatment Dates	Treatment Summary
EX1997-24.3 Mummy with exposed face	Pre-1985	• Unknown.
	1985	• Surface cleaned with a soft-bristle brush toward a vacuum nozzle. • Detached pieces placed in original locations, as possible. • Linen wrappings straightened and creases removed with small weights. • Nylon net strips wrapped over original linen where stabilization needed. • Supportive mount made.
	1998	• Nylon net wrapped over entire body except for head and neck. • Mount improvements.
	2016	• No treatment.
EX1997-24.4A Black-coated coffin base	Pre-1985	• Unknown previous consolidation.
	1985	• Tape and glue residues removed with xylenes. • Surface cleaned with soft-bristle brush toward a vacuum nozzle. • Loose areas of the decorative surface layers were secured with rabbit-skin glue and Vinamul PVA (polyvinyl acetate).
	1998	• Surface cleaned with a soft-bristle brush toward a vacuum nozzle. • Structural gap filling using 40 percent Paraloid B-72 (ethyl methacrylate copolymer) in acetone, bulked with glass microspheres and dry pigments. • Loose areas of the decorative surface layers were secured with mixture of Lascaux 498HV and Rhoplex AC-234 (aqueous acrylic adhesives), pre-wet with ethanol. • Minimal inpainting with Liquitex acrylic paints. • Mount improvements.
	2016	• Loose areas of the decorative surface layers and small slivers of lifting wood were secured with a 70 percent to 30 percent mixture of Lascaux 498HV and Rhoplex AC-2235M (aqueous acrylic adhesives), pre-wet with ethanol. • Slumped previous (1998) Paraloid B-72 (ethyl methacrylate copolymer) and glass microsphere structural fills were reshaped with scalpel and/or acetone on cotton swabs.

continued on next page

TABLE 3.2—*continued*

DMNS Catalog #	Treatment Dates	Treatment Summary
EX1997-24.4B Black-coated coffin lid	Pre-1985	• Unknown previous consolidation.
	1985	• Surface cleaned with soft-bristle brush toward a vacuum nozzle. • Nail holes in chest area filled with Fine Surface Polyfilla spackling compound and inpainted with Magna Colour in xylenes. • Loose areas of the decorative surface layers were secured with rabbit-skin glue and Vinamul PVA (polyvinyl acetate).
	1998	• Surface cleaned with a soft-bristle brush toward a vacuum nozzle. • Structural gap filling using 40 percent Paraloid B-72 (ethyl methacrylate copolymer) in acetone, bulked with glass microspheres and dry pigments. • Loose areas of the decorative surface layers were secured with mixture of Lascaux 498HV and Rhoplex AC-234 (aqueous acrylic adhesives), pre-wet with ethanol. • Minimal inpainting with Liquitex acrylic paints. • Mount improvements.
	2016	• Loose areas of the decorative surface layers were secured with a 70 percent to 30 percent mixture of Lascaux 498HV and Rhoplex AC-2235M (aqueous acrylic adhesives), pre-wet with ethanol. • Slumped previous (1998) Paraloid B-72 (ethyl methacrylate copolymer) and glass microsphere structural fills were reshaped with scalpel and/or acetone on cotton swabs.

caused by movement in the wood. In addition, examination with ultraviolet illumination (UVA at 320–400 nanometers) in 2016 showed that a yellow-fluorescing coating was applied to the face at some point in history. Further analytical testing is recommended to identify this material.

2016 Treatment: The small slivers of lifting wood and loose areas of the decorative surface layers were secured with the 70 percent to 30 percent ratio mixture of Lascaux 498HV and Rhoplex AC-2235M. Adhesive was applied under the flakes using either a fine syringe or brush after pre-wetting with ethanol. Bulging Paraloid B-72 and glass microsphere structural fills from 1998 were reshaped using a surgical scalpel, followed by acetone on cotton swabs, where necessary.

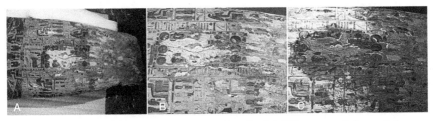

FIGURE 3.4. *Water-damaged areas on the single coffin lid (EX1997-24.5) shown before consolidation with Paraloid B-72 in 1985 (A) and in 2016 under normal illumination (B) and UVA illumination (C). A © Denver Museum of Nature & Science, B and C Rick Wicker photos, © Denver Museum of Nature & Science.*

COFFIN LID EX1997-24.5

Description: The single coffin lid EX1997-24.5 is anthropoid in shape and has a yellow background with polychrome decoration. As with the complete coffins, rough wood surfaces are covered with a ground layer, over which the decorative surface layers are applied. According to the stylistic analysis (see chapter 9), the modeled ears and clenched hands suggest a male owner, Ankhefenkhonsu, and the lid can be dated to the 21st Dynasty.

Current Condition and Historical Treatments: The coffin lid is missing the lower section (approximately 3 inches) of the proper left side. This loss continues around the lid to include missing feet and the lower section on the proper right side until a point close to the knees. The decorative surface layers are still largely intact on the torso and head portion of the lid. What appears to be water damage has caused significant disruption to the leg area, with loss of material and blurring of the remaining decorative surface layers. In 2016, five new 1–3 millimeter-sized loose flakes of paint were found on the lid and the exhibition mount, dislocated from their original locations in the water-damaged leg area. These were bagged for sampling purposes.

With the exception of the five loose flakes, previous stabilization efforts still appear to be intact, with no obvious changes in appearance. In 1985, the regional conservation center secured loose decorative layers using dilute rabbit-skin glue. Slight saturation of exposed wood and ground was noted in 1998 adjacent to some of the 1985 locations. Water-damaged areas in the leg portion of the lid were also consolidated in 1985 with two applications of 5 percent Paraloid B-72 in xylenes (figure 3.4). Thirteen years later, in 1998, the mixture of Lascaux 498HV and Rhoplex AC-234 was injected behind additional areas of insecurity. Paraloid B-72 and glass microspheres structural fills, toned with dry pigments, were also added in 1998.

TABLE 3.3. Treatment history of the single coffin lid EX1997-24.5

DMNS Catalog #	Treatment Dates	Treatment Summary
EX1997-24.5 Single coffin lid	Pre-1985	• Unknown.
	1985	• Solubility testing of painted surfaces: soluble in organic solvents and with heavy use of aqueous solvents. • Surface dust removed (unknown method). • Further cleaning with swabs dampened in 2 percent TSP (trisodium phosphate) followed by swabs of de-ionized water. • Loose areas of the decorative surface layers were secured with rabbit-skin glue. • Water-damaged areas on lower portion of lid were consolidated with two applications of 5 percent B-72 (ethyl methacrylate copolymer) in xylenes. • Adhesive tape residue on chest removed with xylenes.
	1998	• Surface cleaned with soft-bristle brush toward a vacuum nozzle. • Structural gap filling using 40 percent Paraloid B-72 (ethyl methacrylate copolymer) in acetone, bulked with glass microspheres and dry pigments. • Loose areas of the decorative surface layers were secured with mixture of Lascaux 498HV and Rhoplex AC-234 (aqueous acrylic adhesives), pre-wet with ethanol. • Minimal inpainting with Liquitex acrylic paints. • Mount improvements.
	2016	• No treatment.

2016 Treatment: With the exception of the five dislocated paint flakes, no change in condition was noted and no treatment was undertaken.

DISCUSSION

During the 2016 renovation of the *Egyptian Mummies* exhibition, DMNS conservators evaluated the stability of at least thirty-four years of previous conservation treatments for a group of coffins and mummies to inform their understanding of the current condition of these artifacts and subsequently guide the 2016 treatment. It was initially difficult to access curatorial, loan, and conservation information, as there were many different numbering systems for both the artifacts themselves and their associated documentation, a problem

described in more detail in chapter 2. In addition, the 1982 and 1985 treatments were completed before centralized conservation and registration departments were established at DMNS, and while most of the treatment documentation was stored in the Conservation Department, some records and images were stored in Anthropology and Archives.

Examination of the historical treatment documentation alerted DMNS conservators to the extensive level of previous surface stabilization from 1982, 1985, and especially 1998. The ability of these fragile surfaces to withstand vibrations from transport to a local hospital for CT scanning was a primary concern during 2016. Thus the conservators paid particular attention to evaluating the success of the past surface treatments, as well as locating any new areas of damage.

To determine stability, the DMNS conservators initially used the end of a wooden skewer to gently tap and probe the extent of loose or lifting polychrome paint and ground layers. This technique, combined with close visual examination, showed the surfaces of the coffins to be largely stable after four decades of documented treatments. Specifically, very little new damage on the coffins was noted in the surface layers in 2016, just forty-five small areas of loose, lifting, or detached insecurities. This number can be compared with the large areas that required over 500 injections of adhesive in 1998. Furthermore, examination of marked areas on the Mylar-covered black-and-white photographs from all known and likely earlier treatments showed that only nine of these newly identified insecurities overlapped with previously stabilized areas. The authors feel this represents a very small failure rate of the adhesives. The new areas of loose or lifting insecurities were largely along existing cracks in the coffins and may have resulted from dimensional incompatibility between the wood and the decorative surface layers caused by small fluctuations in relative humidity in the gallery since 1998. The *Egyptian Mummies* exhibition is in an older area of the museum that has temperature control but no relative humidity control.

The most common adverse result observed from previous treatment was staining on the decorative surface layers and areas of exposed wood. This staining was minimal, but it did influence the choice of materials and techniques in 2016. Staining from saturation can occur when an area becomes imbued with an adhesive or consolidant. A consolidant is a binding material that is applied to loose or friable media to improve cohesion (AIC 2018). This can result in visual alteration, such as intensification of colors, increased shine, and/or increased transparency. Saturation is related to the working properties of an adhesive and the nature of the corresponding substrate and can occur

immediately when an adhesive is applied to a porous surface, such as matte paint, ground layers, and wood. Staining can also result from the application of a non-clear material or can develop over time as an adhesive or consolidant yellows or darkens with age.

The conservators also evaluated the structural stability of the coffins. As with the decorative surface layers, the structure of the coffins was largely stable. Areas of concern included a few new lifting slivers of wood and some distortion of the 1998 fills on the black-coated coffin. While maintaining their adhesion and structural integrity, some of these fills were noted to have bulged slightly outward. It is unclear why this was observed on only one coffin. It is possible that slight movements in the wood could have put pressure on the fills, resulting in distortion. Another possibility is that there was a different variation in the consistency of the fill mixture at the time of application.

Though not treated in 2016, the mummies were examined and compared to the previous available documentation. Nylon-net strips wrapped around the linen on the mummy with the exposed face in 1998 continued to support fragile areas and showed no visible change in color or positioning. The black-coated mummy showed no new signs of insecurity.

Ultimately, this review and empirical evaluation of previous treatments strongly influenced the conservation materials and methods chosen in 2016 to stabilize the decorative surface layers on the coffins. For this project and these particular artifacts, a mixture of acrylic polymer emulsions similar to those used in 1998 continued to be a good choice. In 1998, the aqueous mixture had been chosen for three main reasons. First, at that time, the conservation laboratory at DMNS did not have extraction trunks to evacuate the considerable fumes that would be generated from treating large surface areas with a solvent-based adhesive. A solvent-based system was only employed for localized areas of gap filling where acetone was involved, and a portable extraction unit was sufficient to manage the minimal fumes in those cases. Second, the acrylic polymers chosen for the mixture were documented in the literature as having good aging properties (Down 2015; Down et al. 1996). Finally, the adhesive mixture in 1998 was also chosen because the working properties of the adhesive mixture were well suited for stabilizing flaking decorative layers on the largely vertical surfaces, with minimal visual disruption.

All of these reasons for using the aqueous mixture were again considered in 2016, with the added advantage of demonstrable positive performance on the coffins over eighteen years. Although fume extraction trunks were now integral to the new Avenir Conservation Center, the trunks were not long enough to reach all coffin bases and lids simultaneously. By using an aqueous

mixture, the conservators were able to easily switch between working on each coffin or lid without repositioning them. This procedure was efficient in the short three-week time frame and reduced additional movement of the fragile, vibration-sensitive surfaces.

When preparing for the conservation project in 2016, it became apparent that the Lascaux product used in 1998 (498HV) was still widely available, but Rhoplex AC-234 had been discontinued. Another product with similar properties, Rhoplex AC-2235M, was researched and chosen. Therefore, a 70 percent to 30 percent ratio mixture of Lascaux 498HV and Rhoplex AC-2235M was tested for workability before being used (samples of the adhesive mixture are retained for future observation). Utilizing controlled hand techniques as described previously, the conservators made certain that the adhesive was targeted behind the loose flakes in an amount designed not to overflow. The mixture was successfully applied behind all insecure areas with no saturation or other visual disruption to the surface. After spending three weeks in the Avenir Conservation Center, the mummies and coffins were able to travel through the museum, in an ambulance to the local hospital, and back into the newly refurbished exhibit gallery with no new damage.

CONCLUSION

The conservation project completed during the 2016 *Egyptian Mummies* exhibition renovation at DMNS highlights the importance of reviewing previous treatments to understand the current condition of an artifact and to implement a treatment strategy. Historical treatment documentation for the mummies and coffins spans thirty-four years (1982, 1985, and 1998). Examining past documentation was initially challenging. Now that numbering issues have been resolved and the treatment information is gathered in one place, it will be much easier in the future to review the complete history of each mummy or coffin. During this project the DMNS conservators compiled tables 3.1–3.3, which provide accessible summaries of the treatment histories. The treatments for the decorative polychrome paint and ground layers draw attention to a surface that is vulnerable to handling, vibration, and movement of the wooden structure below from fluctuations in the environment.

The importance of accurate treatment location documentation cannot be overstated. Conservators in 1998 placed Mylar over black-and-white photographs and recorded past and present treatment locations using different-colored Sharpie markers. These visual maps of past treatments helped the conservators in 2016 easily locate particularly vulnerable areas, evaluate the

efficacy of past treatments, and determine locations for future testing. Today, damage and treatment mapping are often done in digital format.

The conservators used information gained from the 1998 Mylar overlays and the other historical treatment documentation to help determine the best methods and materials to use for the 2016 stabilization. Adhesives were chosen that were similar to those employed in 1998, as they had performed well over time and would provide ease of application on both flat and vertical surfaces. Having access to the treatment histories gave the conservators advantages when undertaking the 2016 project, both in reducing the time required for testing and choosing from the broad selection of available adhesives and by providing confidence in the long-term efficacy of the final choices.

The data review and conservation treatment steps undertaken for the 2016 project were used for a specific group of artifacts, but there are broader applications for other projects. It is critical to have complete and accessible records for the stewardship of any artifact or specimen. Steps could include resolving inconsistent numbering conventions, tracking down records stored in disparate places, referencing and/or scanning old printed records into a current database, and printing out electronic records for a hard file. Reviewing a complete and accessible set of records, in conjunction with close visual inspection, allows conservators, curators, collection care specialists, and researchers to make the best determination of the current condition of an artifact or specimen, to understand what has happened to it in the past, and how best to protect it for the future.

ACKNOWLEDGMENTS

The authors would like to thank Michele Koons, Melissa Bechhoefer, Bethany Williams, Jeff Phegley, Rick Wicker, James Squires, Jodi Schoemer, Victor Muñoz, Chad Swiercinsky, Todd Norlin, Dave Pachuta, and Kathryn Reusch for their help on this project.

REFERENCES

AIC (American Institute for Conservation of Historic and Artistic Works). *Code of Ethics and Guidelines for Practice*. Revised 1994. http://www.conservation-us.org /our-organizations/association-(aic)/governance/code-of-ethics-and-guidelines -for-practice/code-of-ethics-and-guidelines-for-practice-(html)#.WpIgEoPwbIUd.
AIC (American Institute for Conservation of Historic and Artistic Works). Wiki page definition of tide lines. 2015. http://www.conservation-wiki.com/wiki/Tide

_line. AIC (American Institute for Conservation of Historic and Artistic Works). Wiki page about consolidation, fixing, and facing. 2018. http://www.conservation-wiki.com/wiki/Consolidation/Fixing/Facing#23.2_Factors_to_consider.

Down, Jane L. 2015. *Adhesive Compendium for Conservation*. Ottawa: Government of Canada, Canadian Conservation Institute.

Down, Jane L., Maureen A. MacDonald, Jean Tétreault, and R. Scott Williams. 1996. "Adhesive Testing at the Canadian Conservation Institute: An Evaluation of Selected Poly (vinyl acetate) and Acrylic Adhesives." *Studies in Conservation* 41 (1): 19–44.

Grant, Martha Simpson. 2000. "The Use of Ultraviolet Induced Visible-Fluorescence in the Examination of Museum Objects, Part II." *Conserve O Gram 1/10*. Washington, DC: National Park Service.

Measday, Danielle. 2017. "A Summary of Ultra-Violet Fluorescent Materials Relevant to Conservation." *Australian Institute for the Conservation of Cultural Materials National Newsletter* 137 (March). https://aiccm.org.au/national-news/summary-ultra-violet-fluorescent-materials-relevent-conservation.

Unruh, Julie, Tara Hornung, and Stephanie Ratcliffe. 2005. "The Documentation of Adhesives in the Whole Vessel Pottery Collection at the Arizona State Museum." In *Objects Specialty Group Postprints, American Institute for Conservation 33rd Meeting, Minneapolis, vol. 12*, compiled by Virginia Greene and Patricia Griffin, 62–75. Washington, DC: American Institute for Conservation of Historic and Artistic Works.

4

Evolution of Paleoradiology in Colorado

The Experience of Two Egyptian Mummies

KARI L. HAYES,
JASON WEINMAN,
STEPHEN HUMPHRIES,
DAVID RUBENSTEIN, AND
MICHELE L. KOONS

At Children's Hospital Colorado in 2016, we re-scanned two Egyptian mummies currently on display at the Denver Museum of Nature & Science using the latest advances in computed tomography (CT) imaging. This study enabled us to uncover new information and preserve digital data in a medical-grade digital archive. In this chapter we explore the history of paleoradiography—defined as imaging archaeological or historical remains—and how it enriches our understanding of the role of these two mummies. We review the methods employed and present a summary of our findings. Data from the new scans, along with other information presented in this volume, add to a new narrative about two women—once called "Rich Mummy" and "Poor Mummy"— who lived and died over 500 years apart.

Radiological evaluation of the human body has evolved significantly over the past century. Non-invasive evaluation of anatomy began in 1895 with Wilhelm Conrad Roentgen's discovery of X-rays and their ability to "see" inside the human body. X-rays are taken from a single angle and produce two-dimensional (2D) images on film. There are pros and cons to this technique: Radio opaque materials such as bone and metal attenuate and are easily identifiable; soft tissue and muscle, however, are less clear. Months after its initial discovery, in 1896, this new technology was used to investigate the mummified remains of an Egyptian child (Zesch et al. 2016).

DOI: 10.5876/9781646421381.c004

Paleoradiology gained popularity among Egyptologists over the course of the twentieth century because of the non-invasive, non-destructive analytic techniques that reveal what is inside mummy wrappings. The earliest uses focused on authenticating mummies and identifying amulets and jewelry inside the wrappings (Hawass and Saleem 2015; Zesch et al. 2016).

CT scanning, developed in the 1970s, provided an additional analytic tool to the study of specimens (Harwood-Nash 1979). CT uses the same technology as X-rays but images a specimen at multiple angles (Hoffman et al. 2002). Early CT scans were relatively unsophisticated, and specimens were subject to only a few images from limited angles. Technological advances now allow CTs to acquire hundreds or thousands of thin cross-sections (slices) at multiple angles, which can be combined into a much more sophisticated and detailed volumetric, or 3D, dataset of the study specimen. Pixel intensity values in a CT scan are expressed on the Hounsfield unit (HU) scale, which is linearly related to physical density (Hounsfield 1973). Modern CT scans are therefore non-invasive maps of internal density that are used to virtually visualize the inner makings of a specimen, such as a mummy, and to measure different densities inside that correspond to air, soft tissues, bones, wrappings, and artifacts (Hoffman et al. 2002; Sydler et al. 2015).

HISTORY OF PALEORADIOLOGY AND THE DMNS MUMMIES

Paleoradiology first began in Colorado at Denver General Hospital in 1971 with the X-ray of one of the mummies now housed at the Denver Museum of Nature & Science (DMNS) (EX1997-24.1). This mummy was X-rayed again in 1982 at Valley View Hospital. No records of these studies exist aside from a few newspaper clippings (*Rocky Mountain News*, December 7, 1982) and accession notes. The first known CT scans of mummy EX1997-24.3 were acquired in 1982 at the University of Colorado Health Science Center (UCHSC) in Denver (*Silver and Gold Record*, February 27, 1983).

Both mummies at DMNS were re-CT scanned in 1991 at UCHSC under the direction of the curator of archaeology at the time, Robert Pickering, and radiologists David Rubinstein, Jan Durham, Ed Hendricks, and Michael Manco-Johnson. Image acquisition took over forty-eight hours on a first-generation Toshiba 900S CT scanner. Scanners of this era acquired axial images one at a time, with the patient translated through the scanner after each image. This limited high-resolution reconstruction to the acquired plane. Approximately 1,000 images were generated in the axial plane; some were printed on film, as digital imaging workstations were not yet available. Five

millimeter-thick slices were acquired through the bodies and 1 mm-thick slices through the head and neck. The prolonged scanning time was due to the CT tube overheating and necessitating time to cool, as CT scanners of this era were limited in the number of images they could take in one acquisition.

In 1998, mummy EX1997-24.1 was re-scanned at UCHSC using a GE 9800 helical CT scanner. The re-scan was performed mainly because the 1991 scans of the lower half went missing and the museum wanted to create 3D models for the new *Egyptian Mummies* exhibit that opened in 2000. Helical scanning consists of the X-ray tube and detector rotating continuously while the specimen, in this case the mummy, moves through the gantry. This acquires a dataset that, like a continuous peel of an apple, can be reconstructed in any plane or as a 3D image. With advances in CT, the 1998 scan was performed in less than four hours, again, with tube-cooling remaining a major factor in the time required to obtain the scan. Between 1,400 and 1,500 1.0 mm-thick slices were obtained from the apex of the skull to the base of the feet of the mummy. With about 100 images left to acquire in the scan, the image-viewing monitor on the scanning console broke. Rebooting the scanner would have eliminated the image registration, so the team continued scanning and sent the images to a workstation to tell when the scanning was complete. The images produced from the CT scans in 1991 and 1998 were printed on sheets of film. The digital data were saved, but the equipment necessary to read the magnetic tape of the 1991 scans and the optical discs from the 1998 scans became obsolete and is no longer available.

Three-dimensional reconstructions were just beginning to be incorporated into medical imaging in 1998. While most images were still printed on film, the data could be reformatted into multi-planar reconstructions on freestanding computer workstations. The late 1990s also saw improved evaluation of internal artifacts due to the utilization of Hounsfield units to differentiate the densities of the artifacts. The DMNS exhibit on the mummies that opened in 2000 incorporated 3D images of the mummies and the identification of some of the internal amulets.

The exhibit emphasized the narrative that one mummy had been rich and the other poor. This narrative was based on details revealed in the scans—for example, one mummy has amulets and the other does not. Thanks to radiocarbon dating, we now know that the women lived over 500 years apart, and differences in mummification have more to do with temporal disparity and less to do with the wealth of the women. This revised narrative, as well as new details revealed in the new CT scans, is presented in an updated exhibit that opened in 2017. The new details of these scans are presented below.

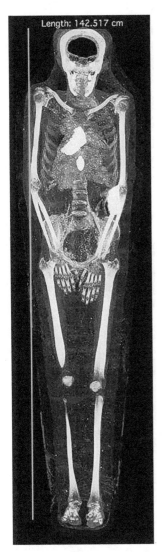

Length: 142.517 cm

FIGURE 4.1. *Full-length maximum-intensity projection CT image of mummy EX1997-24.1. Absent brain matter, dense artifacts over eyes, two metallic artifacts overlying the mid-chest and one overlying the left abdomen.*

CT SCANNING TODAY

In 2016, Children's Hospital of Colorado CT re-scanned the mummies with a dual-source SOMATOM® Definition Flash CT scanner, by Siemens Healthineers. Advances in CT scanner technology over the last twenty years allow for thinner section imaging with higher resolution, less image degradation, and faster acquisition. Improved scanner speed allows for faster rotation of the gantry and faster translation of specimens through the scanner, which permits detectors to acquire up to 128 image slices simultaneously. Each mummy was scanned using several different techniques; including thin-section imaging, imaging at different energy levels, and dual-energy imaging, which is the near simultaneous acquisition of images at two different energy levels (Coursey et al. 2010). These techniques, as well as advances in computer power and reconstruction software, allow for greater detailed reconstructions.

Both mummies were transported and scanned on a custom-constructed acrylic carrier designed by DMNS staff to fit in the scanner. EX1997-24.1 was scanned directly on the acrylic carrier. Mummy EX1997-24.3 was scanned in the coffin base (EX1997-24.4A) that was placed on top of the carrier (figures 4.1 and 4.2). Coffin lid EX1997-24.4B was also scanned. Data from the scans of the coffins are presented in chapter 5.

To optimize this opportunity to scan such rare specimens, each mummy was scanned multiple times. Single-energy whole-body acquisitions of each mummy were obtained from the apex of the skull through the entire lower extremities at 80kV/214 mA and

120kV/271 mA. These were done with a pitch of 0.7 (table movement in one rotation of the scanner divided by total detector width) and collimation of 38.4 mm (64 detector with a width of 0.6 mm per detector). The first complete acquisition obtained 2,564 0.6 mm-thick images in fifty-seven seconds from head to toe.

Because of her fragile nature, as mentioned, EX1997-24.3 was scanned in the coffin base. Unfortunately, the coffin was longer than the Z-axis of the scanner; therefore, single-energy images at each kilovolt (kV) were obtained in two passes. The first was from the top/head of the coffin through the mid-calf region. The second scan started at the mummy's skull apex and captured through the distal end of the coffin. Single-energy images were also obtained for the coffin lid EX1997-24.4B, again in two passes.

In addition, data were acquired using a dual-energy protocol in which two different tubes at different energies and two different sets of detectors acquire images nearly simultaneously. This allowed for optimal reconstruction techniques that are based on the composition of different tissues and artifacts. Dual-energy acquisitions of both mummies were obtained from the skull apex through the mid-calf. The lower calves, feet, and ankles had to be scanned separately due to a limitation in the length of a scan in dual-energy mode. Dual-energy scans were obtained with 80 kV/254 mA and 140Sn/98mA, with a pitch of 1.0 and collimation of 12 mm (20 detectors per energy with a width of 0.6 mm per detector). We performed mixed-energy reconstructions.

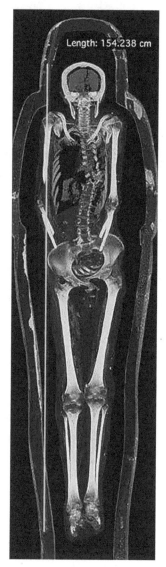

Length: 154.238 cm

FIGURE 4.2. *Full-length maximum intensity projection CT image of mummy EX1997-24.3. Image shows retained brain matter, no metal artifacts, and joint disruptions postmortem.*

Reconstructions weighted toward a higher kilovolt provided better detail of the metallic artifacts, and reconstructions weighted toward a lower kilovolt showed better detail of soft tissue structures. We also executed monochromatic reconstructions at a high kilovolt (176 keV) to emphasize detail in metallic artifacts. In total, 112,829 images were generated for mummy EX1997-24.3 (and coffin EX1997-24.4) and 70,660 images for mummy EX1997-24.1. This count includes the multiple acquisitions for each mummy, as well as extensive reconstructions of the acquired data.

Advanced image analysis software was utilized to generate volume and surface-rendered reconstructions, and it allowed us to virtually peel away the layers of wrapping to examine the internal remains. Using TeraRecon software, preliminary volume renderings were available within minutes of CT acquisition. Volume rendering is a digital visualization technique in which a variety of colors and opacities are selectively assigned to voxels (the 3D analogue of 2D image pixels) based on their density values (in HU) (table 4.1). This makes it possible to create virtual 3D representations in which wrappings, skin, and tissue appear translucent while dense interior structures, such as bone and amulets, appear solid and are represented with different colors. Additional filters, cropping, and lighting effects can enhance the 3D appearance to highlight subtle structures that may be difficult to identify in 2D image slices.

We also undertook additional post-processing using semiautomatic segmentation to delineate the boundaries of individual artifacts (figure 4.3). Objects of similar density—for example, recently identified wax artifacts and their surrounding wrappings (detailed below)—are difficult to separate automatically using global density thresholds. These structures required manual delineation of edges for accurate segmentation (ITK-Snap) (Yushkevich et al. 2006). Using these techniques, we produced 3D volume- and surface-rendered images with a near limitless ability to manipulate the data. This enabled us to perform a virtual autopsy with unprecedented detail and to 3D print objects found inside the bundles (McKnight et al. 2015).

Visualization techniques for volumetric medical imaging continue to advance. Siemens Healthineers has developed software termed "cinematic rendering" that employs methods utilized in the film industry. This technique is still in the early stages but uses complex lighting and shading methods to produce photo-realistic images similar to computer-generated special effects used in movies. The software displays exquisite anatomic detail of Mummy EX1997-24.1 and is able to virtually remove layers of external wrappings to reveal the underlying bones, soft tissues, and associated artifacts (figure 4.4).

TABLE 4.1. Hounsfield units of various organs, tissues, and objects found in the human body and DMNS mummies. The Hounsfield units for the coffin wood are also noted.

Tissue/Object	Hounsfield unit 80kV	Hounsfield unit 120kV
Air	-1,000	-1,000
Lung	-300	-300
Liver	40–60	40–60
Fat	-100	-100
Water	0	0
Muscle	10–40	10–40
Blood	60–80	60–80
Bone	1,000	1,000
Wax figures in EX1997-24.1	-93	-64
Wood lid in EX1997.24.4B	-651	-600
Wood peg in EX1997.24.4B	-296	-290
Benu bird in EX1997-24.1	-35	-21
Heart scarab in EX1997-24.1	2,585	2,120
Winged scarab/jewelry in EX1997-24.1	3,070	3,070
Metal foil in EX1997-24.1	3,069	2,923
False eyes in EX1997-24.1	2,466	2,069

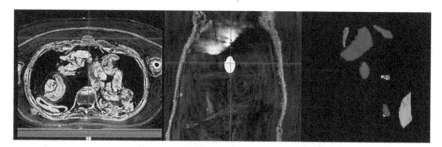

FIGURE 4.3. *Axial (left) and coronal (middle) CT images through the lower chest demonstrate multiple layers of wrapped linens surrounding the chest and arms of Mummy EX1997-24.1. The blue crosshairs triangulate the artifact external to the chest wall. The image on the right shows 3D surface-rendered images of internal and external artifacts that were virtually removed from the mummy and its wrappings. The artifact in red is a scarab external to the chest wall. The artifact in green is located on the mummy's left flank and matches the Eye of Horus as seen in figure 4.7. The blue image resembles wings of metallic jewelry, and the four smaller artifacts are the Four Sons of Horus (figures 4.9–4.12).*

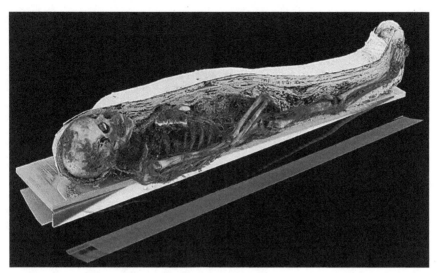

Figure 4.4. *Using CT data, Siemens Healthineers used cinematic rendering to virtually re-create the remains of Mummy EX1997-24.1. The multiple layers of wrappings are well visualized and separated from the artifacts, bones, and remaining soft tissue.*

RESULTS

Mummy EX1997-24.1

Previous and new paleoradiology scans provide significant detail about the physical makeup and mummification of EX1997-24.1. The mummy was determined to be female, approximately 4 feet 9 inches tall and thirty to thirty-five years old. The scans did not detect notable trauma or pathologies on the remains; however, her teeth show a considerable amount of wear. This is a symptom found among many Egyptians possibly due to the high concentrations of inorganic materials—such as sand—in their food (figure 4.5) (Forshaw 2009).

The scans reveal many details of the mummification process. Upon death, her brain was removed through the nasal cavity, as demonstrated by missing portions of the ethmoid sinuses and nasal septum as well as perforation of the cribriform plate (figure 4.6) (Fanous and Couldwell 2012). It does not appear as though resin was poured into her cranial cavity. Her organs were removed through an incision on the left side of the abdomen. The incision was covered with a 7 cm × 7 cm metal foil. Using volume-rendering techniques, the foil was reconstructed, clearly identifying the symbol of the Eye of Horus on the surface (figure 4.7). Saleem and Hawass (2014) have suggested that the Eye of Horus was placed over a wound as a symbol of healing.

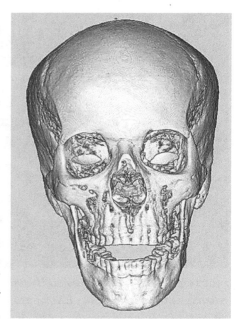

FIGURE 4.5. *3D volume-rendered CT image of EX1997-24.1 demonstrates occlusal flattening of the incisors, canines, and pre-molars of upper and lower dentition.*

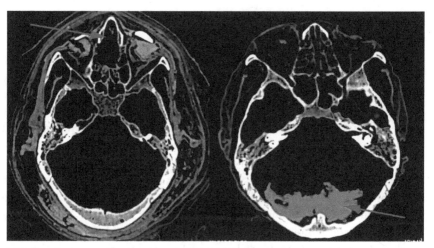

FIGURE 4.6. *Axial CT image of the skulls of EX1997-24.1 (left) and EX1997-24.3 (right). The arrow on the left image is demonstrating disruption of the anterior ethmoid sinuses and nasal septum as a pathway for excerebration. Also visible are dense "false eyes" covering the eye sockets and foreign material packing the sockets. No brain tissue is visible. The arrow in the right image of Mummy EX1997-24.3 points to the residual brain tissue. Intact ethmoid sinuses and septum are also notable in this image.*

FIGURE 4.7. *Metallic artifact from the left flank of Mummy EX1997-24.1 (A). The volume rendering revealed the image of the Eye of Horus (B).*

Once removed, the organs were wrapped in layers of linen and reinserted into the body cavity. The 2016 scans determined that each viscera bundle was associated with low-density figurines, probably made of wax (David 2008), with high-density calcific or metallic material affixed to one side (figure 4.8). These artifacts were segmented using semiautomatic techniques, which enabled them to be virtually extracted from the mummified remains and digitally manipulated separately (figure 4.3, figures 4.9–4.12). Axial, coronal, and 3D images indicated that they represented the Four Sons of Horus, each of which is associated with a particular organ. Although the organs themselves are too desiccated to be identified, the associated wax figures allow us to know the contents of each viscera bundle. In figure 4.9, the artifact found in the right upper quadrant of the mummy's abdomen clearly represents Hapi, a god who takes the form of a baboon and protects the lungs. Nearby is a figure of Qebehsenuef, a falcon god who protects the intestines (figure 4.10). In the left lower quadrant of the abdomen, a figure that resembles Duametef, a jackal god who looks after the stomach, was identified virtually (figure 4.11). A figurine of Imsety, who protects the liver, is found in the upper left quadrant of the mummy's abdomen (figure 4.12). Inclusion of wax figures of the Four Sons of Horus in the viscera bundles was common during the Third Intermediate Period, when radiocarbon dating indicates this woman died (see chapter 1).

Along with the Four Sons of Horus, there is also a fifth wax figure that appears to be a bennu bird inside her lower left abdomen, not far from the incision (figure 4.13). This bird is often linked to rebirth, the ultimate goal of the practice of mummification.

THE METROPOLITAN MUSEUM
OF ART 1925

FIGURE 4.8. *Beeswax figures of the Four Sons of Horus (*left to right: *Imsety, Hapi, Duametef, and Qebehsenuef) from the Third Intermediate Period. From Egypt, Upper Egypt, Thebes, Deir el-Bahri, Tomb MMA 60, Chamber B, Burial of Djedmutesankh (5), Metropolitan Museum of Art excavations, 1923–24. Metropolitan Museum of Art, New York, NY.*

The scans identified the pericardium and heart, which is small and desiccated but intact. Ancient Egyptians considered the heart to be the seat of wisdom and personality, and because of this it was commonly left in place (Ikram 2015; Ikram and Dodson 1998). However, there are noted cases where the heart was removed (Wade and Nelson 2013a, 2013b). In the final underworld judgment, the heart was weighed against the feather of Ma'at (truth, justice) to ensure it was pure and good—a requirement to proceed into the afterlife. If a person failed this test, they would be eaten by Ammit—a part lion, crocodile, and hippopotamus goddess. If they passed, they would journey into the afterlife. A heart scarab was placed on the chest of the deceased to protect the heart in the final judgment and to act as a substitute if the real heart was damaged or removed. It also ensured that the real heart would not speak against the

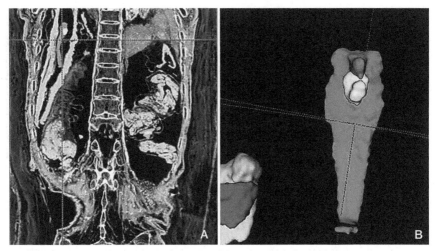

FIGURE 4.9. *Mummy EX1997-24.1. Coronal (A) and 3D image (B) of a figurine associated with desiccated soft tissue and linens in the upper right quadrant of the mummy's body. The figure resembles Hapi, baboon: god who looked after the lungs.*

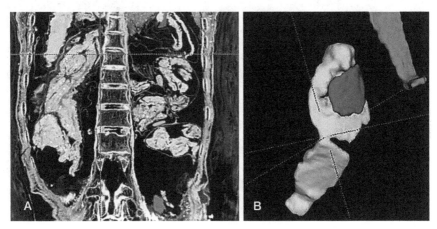

FIGURE 4.10. *Mummy EX1997-24.1. Coronal (A) and 3D image (B) of a figurine associated with desiccated soft tissue and linens in the upper right quadrant of the mummy's body. This figure resembles Qebehsenuef, a falcon god who protected the intestines.*

deceased during judgment (David 2008). A heart scarab was clearly identified in the scans of this mummy (figure 4.3).

The density of the heart scarab, measured in Hounsfield units, was compared to the densities of other scanned Egyptian artifacts in the DMNS

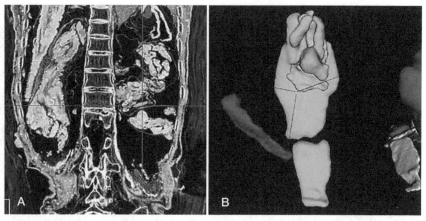

FIGURE 4.11. *Mummy EX1997-24.1. Coronal (A) and 3D image (B) of a figurine associated with desiccated soft tissue and linens in the lower left quadrant of the mummy's body. The figure resembles Duametef, jackal: god who looked after the stomach.*

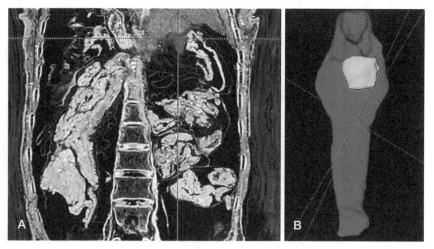

FIGURE 4.12. *Mummy EX1997-24.1. Coronal (A) and 3D image (B) of a figurine associated with desiccated soft tissue and linens in the upper left quadrant of the mummy's body. The figure resembles Imsety, human: god who looked after the liver.*

collection. Figure 4.14 demonstrates the nearly identical density of the heart scarab on the chest of Mummy EX1997-24.1 and a scarab bead from the collection. The similarity in density of both objects (the scarab in the mummy bundle and the bead) is an indicator that they are made of the same material.

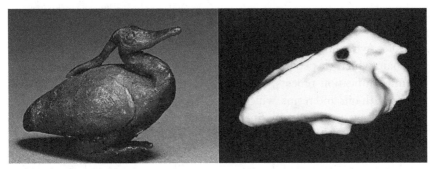

FIGURE 4.13. *Bennu bird, 1000–500 BCE wax figure from the Cleveland Art Museum, measures 3.2 cm (A). 3D surface-rendered image also measures 3.2 cm in size, located in left lower quadrant of Mummy EX1997-24.1 (B). The bennu is a deity linked with the sun, creation, and rebirth. Used with permission of the Cleveland Museum of Art, Cleveland, OH.*

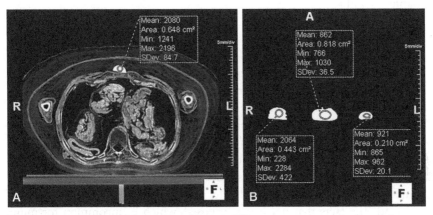

FIGURE 4.14. *Density of the scarab in Mummy EX1997-24.1 was measured at 2,080 Hounsfield Units (HU) and compared with other museum artifacts. It matches the density of the first artifact measuring 2,064 HU, suggesting a similar composition.*

The bead is made of limestone; thus it is possible to postulate that the heart scarab is also made of limestone.

Atop her chest and next to the heart scarab is another object that is possibly a winged scarab or a piece of jewelry (figure 4.3). The image pixel intensities for this object are at the maximum values typically stored in medical CT scans, indicating that this is metal with density much higher than bone or any tissue normally present in the human body (table 4.1) (Barrett and Keat 2004). X-ray

fluorescence may suggest that this metal object has a high zinc content (see chapter 7).

Prior to wrapping, her hair was braided. This could have been either her own hair, which was styled with a fat-based gel and then preserved during the mummification process, or a wig (McCreesh et al. 2011). Her skin was treated with oils and resins, which are visible in the CT scans. Her pelvis and upper neck were packed with linen and resin, which were used by priest practitioners of mummification to support the body in a way to make it retain its lifelike appearance even after desiccation (Ikram 2015). The scans also show that her eye sockets were filled with a resin-like substance and covered with glass or stone "false eyes," again to appear more lifelike. Her hands and legs were individually wrapped in linen bandages. Additional strips were used to swathe her entire body in many layers—up to forty in some areas. At the midpoint of the linen wrappings and atop the outer layer of linen is a thick black substance, possibly applied for preservation and further explored in chapters 7 and 8.

Mummy EX1997-24.3

Early scans were complicated by this mummy's relatively poor condition. It was ascertained that the mummy was female, approximately 5 feet tall, and thirty to forty years old. Her skeleton shows no pathologies. Many of the bones are misaligned and out of place, and her skeleton is no longer structurally intact (figure 4.2). Her ribs, spine, and pelvis have separated into small pieces, and three of her teeth have dislodged and fallen into the oropharynx. It is unclear if this disarticulation was caused peri-mortem, postmortem, or both. Some destruction likely occurred after mummification and since she was exhumed. The facts that her face is exposed, which is uncommon for mummies, and that the wrapping in the CT scans is quite scant suggest that there were once more layers bundling her (figure 4.15). Conservation notes from 1985 also indicate that she was partially unwrapped in the past, but it is unclear when this occurred and if it is directly related to the poor state of preservation of the body (see Gardner et al. 2004 for a similar discussion).

In contrast to Mummy EX1997-24.1, EX1997-24.3's internal organs were not removed and the abdominal cavity was not packed with linens. This promoted the postmortem collapse of the body cavity over time. Her nasal cavity is intact and brain matter is clearly visible in the back of her skull (figure 4.6). She had the same abrasive wear pattern on her teeth as EX1997-24.1, an indication of a similar diet, which included abrasive inorganic matter. The skin around her

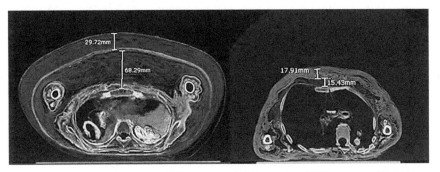

FIGURE 4.15. *Axial CT image of EX1997-24.1* (left image) *and EX1997-24.3* (right image) *demonstrates the increased thickness of numerous linen wrappings both internally and externally on 24.1. Intact desiccated heart and pericardium is present in both remains. Minimal internal packing allowed for collapse of the skeleton of 24.3.*

neck was folded and wrinkled, a phenomenon that led earlier researchers to postulate that she was heavy-set. Early scans also noted a beaded necklace near the neck, but this was not identified in 2016. Scans did show that she has some dense, possibly metal, amulets or jewelry in the wrappings. One is a thin, pin-like piece bent at a 90° angle, and there is an assortment of other small, hard, undifferentiated inclusions in the wrappings that may have been deliberately placed. A comparison of the internal components of mummies EX1997-24.1 and EX1997-24.3 is presented in table 4.2.

DISCUSSION

Advancements in paleoradiography, as well as new radiocarbon dates, have changed the way we understand the lives of these two women. Previously referred to as the "Rich Mummy" and the "Poor Mummy," we now know that this is inaccurate. The differences in mummification we see between these two women are a factor of when they died, not of their wealth or social status. Radiocarbon dating of the linens indicates that mummy EX1997-24.1 is from 901–815 BCE (see chapter 2). This places her burial date within the Third Intermediate Period (ca. 1070–664 BCE)—a time when mummification was at its apex in Egyptian society and mummies appeared the most lifelike (Ikram 2015). This is exemplified by the packing seen throughout her body to make her appear more lifelike and the removal and reinsertion of the viscera in bundles accompanied by one of the Four Sons of Horus. Other attributes, such as hair extensions and false eyes, are also noteworthy of this time. Linen and tissue

TABLE 4.2. Comparison of the virtual artifact and anatomic findings between mummies EX1997-24.1 and EX1997-24.3

	Mummy EX1997-24.1 894–825 calbce (1 σ probability) 22nd Dynasty Third Intermediate Period	Mummy EX1997-24.3 398–260 calbce (1 σ probability) 28th Dynasty–Ptolemaic Dynasty Late Period–Ptolemaic Period
Overall height	142.5 cm 4 ft 8 in	154.2 cm 5 ft 0 in
Artifacts inside the wrappings (outside body cavity)	Scarab on chest Artificial eyes Left flank Eye of Horus	Pin-like object; other small objects
Head	Brain tissue absent Transnasal excerebration	Brain tissue present No sign of surgery
Eyes	Artificial eyes overlying sockets Sockets filled with foreign substance	Normal sockets intact with little decay
Teeth	Occlusal surface worn	Occlusal surface worn (three teeth dislodged postmortem)
Heart	Intact—desiccated	Intact—desiccated
Abdomen	Organs (liver, stomach, lungs, intestines) removed and returned to the abdominal cavity with small sculptures of the Four Sons of Horus. Bennu bird figure present in lower abdomen.	Organs intact and desiccated; not easily identifiable
Skeleton	Structurally intact and well preserved	Multiple areas of separation that all appear postmortem; poor internal preservation

from mummy EX1997-24.3 indicate that she lived between 400 and 231 BCE. This straddles the Late Period (ca. 664–332 BCE) and the Ptolemaic Period (ca. 332–30 BCE), when mummification practices were on the decline. During this era, more focus was placed on the external appearance of the mummy rather than on the preservation of the internal body (Ikram 2015). This is exemplified by the fact that her internal organs, including her brain, were left in place and no packing was placed inside the body. Although she may not have been as well-to-do as the other mummy, the fact that she had the resources to be mummified indicates that she was not poor. Furthermore and unfortunately, since she was partially unwrapped, we will never know if she once had a painted cartonnage funerary mask, typical of the time and seen as an external form of beauty.

CONCLUSION

The DMNS mummies continue to play an important role in the development and application of paleoradiography to archaeological specimens—from the first X-rays in 1971 to advanced, multi-image CT scans. The resolution and slice thickness during image acquisition has improved identification of small but important irregularities. Both 2D and 3D reconstruction techniques allow us to visualize anatomic abnormalities and objects inside the mummy bundles.

Advances in digitization permit us to reinvestigate the stories of two mummies from two different eras. This new research clarified past findings, discovered new data points, and further elucidated their life histories in a digital, non-destructive way that is accessible to future researchers and shareable with the wider public. New scans confirm the age, sex, and overall health of the mummies and add new information on artifact types, locations, and materials. For example, advanced segmentation techniques revealed wax figures of the bennu bird and the Four Sons of Horus in association with viscera bundles. The Four Sons' presence allows us to identify the individual organs that were reinserted into the abdomen of mummy EX1997-24.1. In addition to new radiocarbon dates, the techniques used in the mummification process—such as incision type and removal and replacement of viscera versus leaving organs in place—and the thickness and techniques used for the wrappings help place these mummies in time and space. This new research contributes to a new narrative of the lives and deaths of these two women in ancient Egypt and adds to the growing corpus of knowledge on how to process, interpret, and manipulate CT scans of archaeological specimens.

REFERENCES

Barrett, Julia F., and Nicholas Keat. 2004. "Artifacts in CT: Recognition and Avoidance." *RadioGraphics* 24 (6): 1679–91.

Coursey, Courtney A., Rendon C. Nelson, Daniel T. Boll, Erik K. Paulson, Lisa M. Ho, Amy M. Neville, Daniele Marin, Rajan T. Gupta, and Sebastian T. Schindera. 2010. "Dual-Energy Multidetector CT: How Does It Work, What Can It Tell Us, and When Can We Use It in Abdominopelvic Imaging?" *RadioGraphics* 30 (4): 1037–55.

David, Rosalie, ed. 2008. *Egyptian Mummies and Modern Science*. Cambridge: Cambridge University Press.

Fanous, Andrew A., and William T. Couldwell. 2012. "Transnasal Excerebration Surgery in Ancient Egypt: Historical Vignette." *Journal of Neurosurgery* 116 (4): 743–48.

Forshaw, Roger J. 2009. "Dental Health and Disease in Ancient Egypt." *British Dental Journal* (London) 206 (8): 421–24.

Gardner, Janet C., Greg Garvin, Andrew J. Nelson, Gian Vascotto, and Gerald Conlogue. 2004. "Paleoradiology in Mummy Studies: The Sulman Mummy Project." *Canadian Association of Radiologists Journal (Montreal)* 55 (4): 228–34.

Harwood-Nash, Derek C. 1979. "Computed Tomography of Ancient Egyptian Mummies." *Journal of Computer Assisted Tomography* 3 (6): 768–73.

Hawass, Zahi, and Sahar Saleem. 2015. *Scanning the Pharaohs: CT Imaging of the New Kingdom Royal Mummies*. Cairo, Egypt: American University in Cairo Press.

Hoffman, Heidi, William E. Torres, and Randy D. Ernst. 2002. "Paleoradiology: Advanced CT in the Evaluation of Nine Egyptian Mummies." *RadioGraphics* 22 (2): 377–85.

Hounsfield, Godfrey N. 1973. "Computerized Transverse Axial Scanning (Tomography), Part 1: Description of System." *British Journal of Radiology* 46 (552): 1016–22.

Ikram, Salima. 2015. *Death and Burial in Ancient Egypt*. Reprint ed. Cairo, Egypt: American University in Cairo Press.

Ikram, Salima, and Aidan Dodson. 1998. *Mummy in Ancient Egypt: Equipping the Dead for Eternity*. New York: Thames and Hudson.

McCreesh, Natalie C., Andy P. Gize, and Rosalie David. 2011. "Ancient Egyptian Hair Gel: New Insight into Ancient Egyptian Mummification Procedures through Chemical Analysis." *Journal of Archaeological Science* 38 (12): 3432–34.

McKnight, Lidija M., Judith E. Adams, Andrew Chamberlain, Stephanie D. Atherton-Woolham, and Richard Bibb. 2015. "Application of Clinical Imaging and 3D Printing to the Identification of Anomalies in an Ancient Egyptian Animal Mummy." *Journal of Archaeological Science: Reports* 3 (Supplement C): 328–32.

Saleem, Sahar N., and Zahi Hawass. 2014. "Multidetector Computed Tomographic Study of Amulets, Jewelry, and Other Foreign Objects in Royal Egyptian Mummies Dated from the 18th to 20th Dynasties." *Journal of Computer Assisted Tomography* 38 (2): 153–58.

Siemens. https://www.healthcare.siemens.com/magazine/mso-cinematic-rendering.html.

Sydler, Christina, Lena Öhrström, Wilfried Rosendahl, Ulrich Woitek, and Frank Rühli. 2015. "CT-Based Assessment of Relative Soft-Tissue Alteration in Different Types of Ancient Mummies." *Anatomical Record* 298 (6): 1162–74.

Wade, Andrew D., and Andrew J. Nelson. 2013a. "Evisceration and Excerebration in the Egyptian Mummification Tradition." *Journal of Archaeological Science* 40 (12): 4198–4206.

Wade, Andrew D., and Andrew J. Nelson. 2013b. "Radiological Evaluation of the Evisceration Tradition in Ancient Egyptian Mummies." *HOMO: Journal of Comparative Human Biology* 64 (1): 1–28.

Winkler, Eike-Meinrad, and Harald Wilfing. 1991. *Tell el-Dab'a, Anthropologische Untersuchungen an den Skelettresten der Kampagnen 1966–69, 1975–80, 1985 VI.* Vienna: Verlag der Osterreichischen Akademie der Wissenschaften.

Yushkevich, Paul A., Joseph Piven, Heather Cody Hazlett, Rachel Gimpel Smith, Sean Ho, James C. Gee, and Guido Gerig. 2006. "User-Guided 3D Active Contour Segmentation of Anatomical Structures: Significantly Improved Efficiency and Reliability." *Neuroimage* 31 (3): 1116–28.

Zesch, Stephanie, Stephanie Panzer, Wilfried Rosendahl, John W. Nance, Stefan O. Schönberg, and Thomas Henzler. 2016. "From First to Latest Imaging Technology: Revisiting the First Mummy Investigated with X-Ray in 1896 by Using Dual-Source Computed Tomography." *European Journal of Radiology Open* 3 (July): 172–81.

5

The Creation of a Third Intermediate Period Coffin

Coffin EX1997-24.4 in the Denver Museum of Nature & Science

Caroline Arbuckle MacLeod

In the Third Intermediate Period, artists decorated coffins with thick layers of plaster, pastes, and paint, concealing the wood and structure of these funerary objects.[1] Any attempt to access these veiled features therefore requires detailed in-person analysis or CT scans. Perhaps due to these challenges, Egyptologists have only recently begun to include detailed analyses of construction in their discussions of coffins (see varied entries in Strudwick and Dawson 2019); nevertheless, when production is addressed, the discussion generally takes the form of short, step-by-step, passive instructions: "the short foot-board was attached" (Niwiński 1988: 59); "the frame is mortised and tenoned together" (Killen 1994: 23). This has the unintended effect of removing people from the picture and has caused scholars to overlook a number of potential socioeconomic inferences a close examination of coffin construction could provide. A particularly effective approach to the anthropological study of technologies is the *chaîne opératoire* concept developed by French sociologists. It is defined by Lemonnier (1992: 26) as the "series of operations

1. The author would like to thank Kathlyn Cooney and Pearce Paul Creasman for reading drafts of this chapter and making suggestions for improvement. An extensive discussion of the techniques and approaches described in this chapter and how the examples and their social significance fit into the broader context of Egyptian coffin construction throughout the pharaonic period is included as part of the author's doctoral dissertation (Arbuckle 2018).

DOI: 10.5876/9781646421381.c005

involved in any transformation of matter (including our own body) by human beings." Lemonnier emphasizes that it is important to include not only the general steps used for production but also each movement of the creator's body. Attempting to account for these movements and the decisions of craftspeople can provide a better understanding of the artifacts and their significance in society. This discussion of the construction of anonymous coffin EX1997-24.4 from the Denver Museum of Nature & Science attempts to take into consideration the choices and movements associated with its manufacture, from the selection of materials to its final decoration and religious activation. The mistakes, improvisations, and approaches unique to this particular coffin provide a realistic view of the technological process involved in its creation.[2]

To access this information, a combination of approaches is necessary. CT scans and close, visual analysis permit the examination of the main construction techniques. The value of computed tomography (CT) for use in archaeology, especially for coffins, is only beginning to be appreciated (cf. Strudwick and Dawson 2016). These scans are more frequently used for mummy analysis (see chapter 2), but the internal cross-sections they are able to provide also allow access to the details of coffin construction covered by decoration. In-person analysis is also necessary to view tool marks and to gain a better understanding of the quality of the construction.[3] This evidence, as demonstrated below, illustrates the movements of the carpenters and the care and attention, or lack of it, with which they worked. Interpretation of this evidence is based on work with modern carpenters and through my own experimentation, integrating methods from ethnoarchaeology and experimental archaeology (cf. Arbuckle 2018; Arbuckle MacLeod et al. 2016). The woodworking stages of construction must also be considered alongside the analysis of the wood and decorative materials, in addition to a stylistic and textual examination of the illustrations and inscriptions. While all of this is discussed in detail in chapters 6, 7, 8, and 9 of this volume, aspects of these results have been considered here in light of their significance for construction choices. Finally, as suggested by Lemonnier's approach, each construction and decoration choice must be

2. This level of detailed construction analysis could not be performed on the other two coffins discussed in this volume. Coffin EX1997-24.2 was too large to permit CT scanning, and the incomplete nature of lid EX1997-24.5 would provide only partial data.

3. In some cases the cracks in decoration are so substantial that significant construction details are visible from in-person analysis alone (see Parkes and Watkinson 2010). In these instances, however, investigators should acknowledge that there may be additional internal details that are not readily apparent. As shown in this chapter, a number of construction details would not have been visible without the use of CT scans.

considered within the historical context, as provided by decades of work by Egyptologists. What emerges from this holistic study is not only a detailed examination of the construction techniques used for a specific coffin but also a demonstration of the utility of such interdisciplinary projects to unravel the significant information about ancient peoples and societies that is encapsulated in the objects they leave behind.

HISTORICAL CONTEXT

To begin to understand the choices craftspeople made during each step of production, it is first necessary to understand the historical context in which they worked. As noted in the historical introduction (chapter 2) of this volume, the Third Intermediate Period, particularly the 21st–22nd Dynasties (ca. 1069–715 BCE), was a time of economic and political uncertainty. It was therefore difficult to gain access to fresh, high-quality materials. Imported Lebanese cedar, which was particularly valued as a coffin construction material, was now difficult to acquire. Even local timber seems to have been scarce. It may be that environmental issues and deforestation were partly responsible, but Cooney (2011: 32) has also suggested that the Egyptians may have required higher amounts of local wood to build ships and for supplies to fight the constant battles Egypt now faced. The reuse of materials, including coffin timbers, was practiced throughout Egyptian history (Creasman 2013), but due to the increased economic pressure at this time, the Egyptian people were forced to reuse funerary equipment to a much greater degree than was seen previously. Even before the beginning of the 21st Dynasty, there were a number of trials of suspected tomb robbers, recorded on scrolls in what are now referred to as the "Tomb Robbery Papyri" (Papyrus Leopold II, Papyrus Abbott; Capart, Gardiner, and van de Walle 1936; Peet 1930). The fact that so many of these texts survive shows the extent of this practice leading into the Third Intermediate Period. In light of this evidence, it is therefore not surprising that so many coffins from this era seem to be reused.

Cooney (2007, 2011, 2014) has discussed the multiple methods of coffin reuse. They include altering only the name of the coffin or transforming the gender of the depicted owner by exchanging female earrings, flat hands, and wigs for masculine ears, fists, and beards. In other instances the reuse is more extensive. The decoration has been scraped off of a number of coffins so painters could start anew with blank wood. Occasionally, the craftspeople simply plastered over the older paint and redecorated the piece for a new owner. In instances of more complete reuse, coffins or other wooden objects were broken down,

and the wood was reshaped and recombined to create an entirely new object (cf. Cooney 2014: 46–47).

Since the instances of tomb robbery and coffin reuse were so high, the Egyptians seem to have lost faith in the ability of the coffin to remain untouched for eternity. With the exception of objects made for the very high-ranking elite, craftspeople do not seem to have focused their attention on the detailed construction of the coffin. Painted decoration was fashionable at this time and would have hidden rushed work. Careful joints and preparation were only necessary if the object needed to last for generations. In addition, materials that could be reused, such as gold gilding or expensive inlays, were no longer frequently incorporated into the coffin. The attention instead went to the painted decoration and the application of spells. Turning to the specific construction of EX1997-24.4, it is clear that these considerations had an impact on this example as well.

SELECTION OF MATERIALS

The first step in the construction of a coffin is the selection of building materials. At the height of Egypt's wealth and political dominance, this was a relatively straightforward choice: the best timber available was cedar, imported from Lebanon. Only the wealthiest inhabitants of Egypt could afford this material. Those who did not have the means or influence to gain access to cedar had to select from local woods. Acacia, tamarisk, and sycomore fig were frequently selected for coffin production, of which sycomore fig was by far the most common (see chapter 6; Davies 1995; Gale et al. 2000). When Egypt was not stable and foreign politics were more complicated, as was clearly the case for much of the Third Intermediate Period, it was not possible to import large amounts of cedar to Thebes, the source of most surviving coffins from this era. In these instances, local used were used almost exclusively for new constructions, while imported woods were reused.

The anatomical analysis of samples taken from several areas of the lid of coffin EX1997-24.4 revealed that the larger planks were made of sycomore fig (*Ficus sycomorus*), while the tenons and dowels were made of acacia (*Vachellia nilotica*; see chapter 6). There is no clear evidence of reuse in the decoration of coffin EX1997-24.4, but scientific analyses complicate the interpretation. The carbon 14 analysis for the wood shows that the sycomore fig from the lid likely dates to between 1016 and 936 BCE, while the acacia from the lid dates to between 909 and 837 BCE (see chapters 2 and 6). At the very least, this suggests that the sycomore fig would have had to be cut and lie unused for 27 years

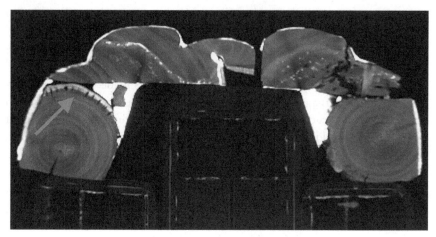

FIGURE 5.1. *CT scan of the lid (EX1997-24.4B). Arrow showing the bark left on worked logs.*

before being made into a coffin with the acacia dowels in 910 BCE, if we are to believe that these materials had not been used previously. If wood were as hard to come by as seems to be the case, then it is unlikely that it sat unused for over a decade. In addition, statistically, it is much more likely that the true dates of the timbers are closer to the middle of their respective C14 ranges, suggesting that the sycomore fig was actually cut closer to 100 years before the acacia, making a much stronger case for timber reuse (see chapter 6 for an in-depth discussion of the wood analysis).

The CT scans of the coffin do not reveal any redundant holes or mortises that would indicate it had been used for a previous coffin.[4] The scans do show, however, that the coffin was made out of thick branches or small tree trunks that had been reshaped as little as possible; some pieces still retained their bark (figure 5.1). Logs and thick branches such as these were frequently used as architectural implements, so they could have potentially been used for years without being substantially altered. They then could have easily been reused for this coffin.

The carpenters likely cut the acacia shortly before constructing the coffin. Since dowels and tenons are quite small, a single acacia tree could have been cut down and used to create numerous pieces. Acacia fragments could also have been selected for dowels from off-cuts—leftover scraps in the carpenter's workshop. Structurally, the use of dense woods for dowels, such as acacia and

4. See for comparison the clear evidence of reuse in the CT scans of the coffin of Nespawershefyt (Strudwick and Dawson 2016: 186, fig.96a); for more information on the radiological analysis used for this project, see chapter 3, this volume.

Christ's thorn (also known as sidder), was preferable to the softer sycomore fig. This would keep joints tighter and more secure for longer than the softer materials (Cartwright 2016). Acacia is therefore an appropriate choice for the dowels. The date range for the acacia, 909–837 BCE, lies within the late 21st Dynasty or early 22nd Dynasty, which is also the date of the final decoration of this coffin as suggested by the stylistic analysis (see chapter 9). It therefore seems likely that the sycomore fig was selected from previously used wood that was decades old at the time the acacia was cut, which took place shortly before the coffin was constructed and decorated.

STEPS OF CONSTRUCTION

With the wood selected, the carpenters could begin constructing the coffin. Thanks to the combination of ancient evidence with scientific analyses, ethno-archaeology, and experimental archaeology, we have access to a remarkable level of detail about the construction of coffin EX1997-24.4 and the people who made it. CT scans, in addition to close in-person visual analysis, were used to provide insight into the interior structure of the coffin. Extant ancient carpentry tools, alongside tomb paintings and models, help indicate the types of actions and steps available to the carpenters who constructed this coffin. The visual analysis of the tool marks then demonstrates which specific tools and techniques were selected. The tool assemblage stayed relatively consistent throughout the history of ancient Egypt until the Greco-Roman period. The full complement included axes, saws, adzes, chisels, awls, mallets, and bow-drills. Numerous straight edges, plumb lines, and measuring rods are also frequently found. For finishing and smoothing, the woodworkers rubbed abrasive sandstone blocks along the grain (Gale et al. 2000: 355–58; Killen 1994; Śliwa 1975).

Construction of the coffin would usually begin by sawing the selected timber into workable boards, a process referred to as milling. In the case of coffin EX1997-24.4, however, not all the pieces were completely processed. For the sidepieces on the lid, for instance, the carpenters simply squared off the ends of small logs or branches. The differences in highlighted areas visible in the CT scans show that the bark remains on the interior edges or in areas that were covered with substantial amounts of paste (as indicated by the arrow in figure 5.1). The pastes and ground layers used to prepare the surface of coffins are rarely identified scientifically but are usually referred to as "plaster." When analyzed, these materials have been identified as mud, clay, and calcite pastes. As the term *plaster* should be used for specific materials and techniques (Dawson et al. 2016: 91), the less problematic term *paste* has been used in this discussion.

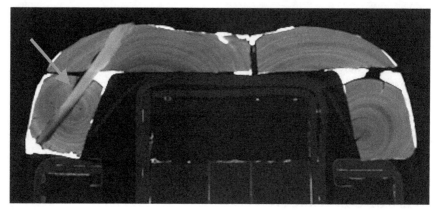

FIGURE 5.2. *CT scan of lid (EX1997-24.4B). Arrow indicates a large dowel used in a butt joint.*

Once the broad cuts were finished, the carpenters used axes and adzes to create a basic anthropoid shape for the coffin. The rough tool marks that remain on exposed areas of the wood demonstrate the absence of finishing processes. The only piece the woodworkers carved carefully with the use of chisels was the face. While some of the pieces would have been shaped before being fixed in place, the carpenters accomplished the subtler modeling of the body with the adze after the wood had been joined.

The Egyptians were very competent joiners. Local timbers tended to produce short or twisted planks, so throughout Egyptian history, craftspeople would often join smaller pieces of wood to make boards in the lengths required. While a number of sophisticated joining methods were known at this time, few were used in the creation of this coffin. Most of the joints used to construct EX1997-24.4 were simple butt joints, where the edges of the two pieces of wood simply abut and are held together with wooden dowels (figure 5.2).[5] Some of the relatively more complicated joints the carpenters used for this piece include edge joints for the longer planks, a stub tenon and mortise joint, a wedge joint to extend the lengths of boards on the sides, and half-dovetail joints to attach the footboard to the lid (cf. Gale et al. 2000: 358–66). These techniques require skill and knowledge of carpentry to complete, but the gaps left between the joints suggest that in this case they were executed quickly and without attention to detail. In addition, on other coffins, dowels are often

5. The terms for wood joinery vary widely. I have chosen to follow those provided by Killen (1994; Gale et al. 2000).

carefully shaped and placed into drilled holes. In the present case, the carpenters roughly shaped the dowels using chisels, leaving square edges instead of round, and placed these pieces into holes also created by chisels instead of drill holes. This process leaves spaces between the dowels and the wood into which they were inserted and may cause the joint to loosen over time. Interestingly, the carpenters also drilled additional, round holes in rows into the base of the case. As a mummy still lies in this coffin, these holes were only visible with CT scans. The purpose of this final action is discussed below.

CT scans help show that for the lid of the coffin, the carpenters joined together 10 large pieces of wood, with several smaller pieces to fill gaps. Two additional pieces would have been used for the hands that no longer remain. These sections were held in place with 4 tenons and approximately 41 dowels. The craftspeople constructed the case of the coffin from 12 larger pieces of wood and approximately 46 dowels, 7 of which were particularly long. Finally, another 8 tenons were used to attach the lid to the case. In total, including the now-absent hands, 24 large pieces of wood, 12 tenons, and approximately 87 dowels were used to complete this coffin. A diagram showing how these main pieces of wood fit together is provided as figure 5.3. When completed, the lid was 189.5 cm long and had a maximum width of 53 cm, and the footboard was 33 cm high. The case was 188.7 cm long and had a maximum width of 53 cm and a height of 25 cm.

MOVEMENTS OF THE CARPENTERS

CT scans can provide invaluable information about the steps used to create objects, but they do not provide access to the movements used by carpenters. The evidence for these actions is gathered through the examination of tool marks. Each type of tool leaves distinctive marks on objects during the crafting process that serve as a record of an individual's movements. Unfortunately for archaeologists and anthropologists, the finishing processes and decoration often erase these marks. Thick axe marks and the lines created by saws are usually smoothed away by craftspeople using sandstone rubbing blocks to produce beautifully finished surfaces that are then covered with pastes and paint. Occasionally, however, objects are not as carefully made, the paint and paste falls off, and tool marks can be seen—as is the case with coffin EX1997-24.4.

Tool marks are particularly easy to identify on the footboard of the coffin lid. Here, the paint has fallen away, and no finishing processes have been applied. To make each set of actions clear, the tool marks have been outlined in figure

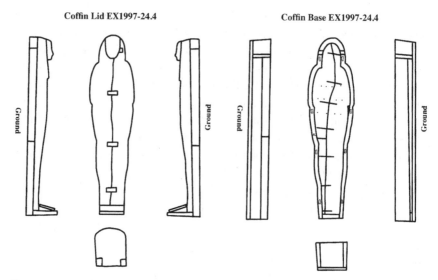

Coffin Lid EX1997-24.4

Coffin Base EX1997-24.4

Ground

Ground

Ground

Ground

FIGURE 5.3. *Construction diagram of coffin EX1997-24.4 (B and A). Image by the author.*

5.4. As noted, the carpenters would first saw the wood to create a plank that was appropriately thick for the footboard. The red lines show the long saw marks that are visible down the entire face of the board. The woodworker then shaped the board using axes and chisels, and the final shape has been outlined in yellow. When this piece was joined to the rest of the coffin, the woodworkers used dowels, which are outlined in blue. At some point the footboard cracked, and it was repaired with a pink, earthen paste. This patch has been marked in green. It is not possible to know how long after the initial construction this crack appeared, but the use of a paste similar to what was used for the decoration base layer suggests that this repair was accomplished in antiquity.

Moving to the body of the coffin, additional tool marks can be seen. In areas where the paint and pastes have fallen away, adze and axe marks are visible. After the initial sawing and joining of the planks, the carpenters used an adze to shape and partially smooth the body of the coffin (figure 5.5). At the shoulders of the coffin, axe marks are also visible. No further steps were applied to smooth the surface in either case.

To fully appreciate what these tool marks can relate about the coffin and craftspeople, it is necessary to compare them to a modern context. Ethnoarchaeology and experimental archaeology can help shed more light about the decisions and actions of the people who no longer exist (see further Arbuckle 2018; Graves-Brown 2015; Wendrich 1999). Experimenting with

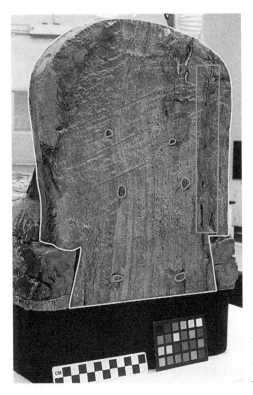

FIGURE 5.4. *Tool marks visible on the footboard of the coffin lid EX1997-24.4B.*

modern tools allows the scholar to better appreciate the choices the woodworkers had to make, as well as the challenges they had to overcome. From observing skilled carpenters using hand tools, differences in ability are also readily apparent. Through experimentation, it is clear that it takes a long time to master the seemingly simple task of sawing a piece of wood. The carpenter needs to keep a saw perfectly straight and at an exact angle to ensure that the tool does not snag and create faults. The whole body is also involved in the sawing process; to create a straight, even cut, the movements must flow together in a steady rhythm. Only after years of practice does the body know exactly how to position and move with the saw in order to cut wood smoothly and in a straight line. Using an adze to create even strokes is also surprisingly challenging and takes years of practice to perfect. This "mastery of dexterity, skill, and endurance" learned by the body after so many repetitions is referred to as *body knowledge* (Wendrich 2012: 13). Conversations with a number of woodworkers suggest that it can take up to six years of constant practice to develop adequate body knowledge to create quality objects out of wood.

FIGURE 5.5. *Adze marks on the front of the coffin lid EX1997-24.4B.*

The saw marks on this coffin are straight and evenly spaced. There is no sign that the saw snagged while moving through the wood, and the angles of the marks are largely consistent across the entire footboard. The adze marks are also uniform. This suggests that an experienced carpenter with *body knowledge* was at work. The piece, however, is quite obviously flawed. The footboard is not uniform in shape, and the dowels have not been formed and inserted carefully. If the break in the footboard did occur in antiquity, the carpenters should have replaced this piece instead of repairing it with paste. In addition, little attempt has been made to remove the tool marks through the additional finishing steps of sanding or rubbing the object.

The only area of the coffin the carpenters carefully carved was the face. The delicate contours of the cheeks, nose, lips, and eyes are chiseled into the wood. On the exposed areas of the cheeks, no rough tool marks remain, suggesting that here, care was taken to smooth out the wood and rub out the flaws. This combination of tool marks therefore suggests that an experienced carpenter or team of carpenters created this coffin, but they chose to work as quickly as possible, only taking their time during the production of the face. By comparing this approach to that used during the decoration of the coffin, it is possible to discuss the motivation behind these construction choices.

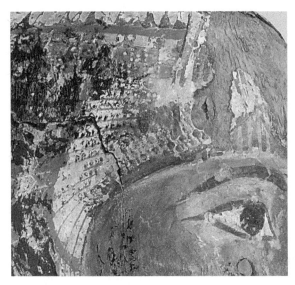

FIGURE 5.6. *Details of painting decoration seen on the coffin wig on lid EX1997-24.4B.*

MATERIAL ANALYSIS OF THE DECORATION

The preparation of the surface of the coffin for decoration begins with the addition of a paste layer. The craftspeople would use this material to cover any faults in the construction and create a flawless surface. As noted, the large gaps and recesses left in the carpentry work of coffin EX1997-24.4 necessitated copious amounts of paste, as is clearly visible on the CT scans (the bright-white areas in figures 5.1 and 5.2). For this coffin, a thick pinkish paste was used to fill up the large gaps, after which the artists covered the entire coffin with a finer layer of white paste. This causes the additional layers of color to appear brighter. In some areas of the coffin lid, particularly around the wig, the overlapping layers of pigment provide access to the steps used to apply the decoration (see figure 5.6).

Over the preparatory white layer, the painters applied a yellow background to the lid, which is characteristic of coffins from this period (for pigment analysis, see chapters 7 and 8; for a full image of this coffin, see chapter 2, figure 2.4). The painters then outlined the decorative details in red before adding the larger areas of blue, green, and black. Once the painters had finished the bold blocks of color, they added delicate details. The wig, for example, has dots of decoration in all colors, some just for decorative geometric patterns but others to add realistic details to the feathers of the headdress. Once the pigments were applied, the craftspeople would then coat the coffin in varnish.

Due to aging and the final black layers applied to this coffin, it is difficult to tell whether yellow varnish was applied to the entire object or just certain areas. The face has certainly been coated, and layers on the legs do seem to have undergone a similar treatment. The case of the coffin was decorated in a similar style to the lid and also seems to have received a layer of varnish.

The final element that was added to the coffin is a thick black layer of resinous material that seems to have been poured quite liberally on the top of the lid of the closed coffin while avoiding the face. It has no obvious structural function and badly obscures the rest of the decoration. Most scholars agree that it had a religious function (Niwiński 1992), which will be discussed below.

The smooth, even application of the paint, the precise execution of the figures, and the tiny added details show that in this case, the artist or team of artists was both experienced and put a lot of time and effort into the decoration of this coffin. The finished product, prior to the application of the thick black layers, would therefore have appeared to most viewers to be a carefully and beautifully constructed object.

UNDERSTANDING THE CONSTRUCTION AND DECORATION

Having analyzed all the steps of construction, it is now possible to interpret the choices made by the carpenters and painters while they constructed coffin EX1997-24.4. It is unlikely that there was much choice involved in the selection of the wood, as only local woods were available; however, the carpenters may have selected acacia for dowels and tenons due to its density. The craftspeople do not seem to have been concerned about the quality of the sycomore fig, whether fresh or, more likely, reused. The large pieces of wood have knots and twists that were usually avoided when possible. The carpenters did not properly prepare the pieces, leaving bark in some areas and shaping only what would be visible. There was also no concern taken to finish the wood or to fill many of the large spaces with smaller pieces. All faults were simply filled with paste or plaster during the decoration stages. When this much paste is used, especially without the added help of a preparatory layer of linen, the decoration is not likely to remain intact for long. Thick layers of paste applied directly to wood are more likely to crack and fall off the coffin, as is clearly seen on many areas of the lid, which received much more paste than the case. This suggests that the craftspeople were comfortable constructing a coffin that would not survive intact for more than a few generations; however, looking at the coffin when it was first completed, it would have been difficult to see these low-quality elements.

The abundant amounts of paste created a smooth, perfect form that could then be decorated. The stages of decoration demonstrate the care and attention to detail that was absent during the carpentry steps. In addition, Egyptian blues and greens, yellow orpiment, and varnish were expensive (Cooney 2011, 28) and were used in large quantities by the artists to create a coffin that was truly beautiful in appearance. The decorated coffin is therefore likely to have been relatively expensive. Although almost certainly less expensive than those belonging to the upper elite, coffin EX1997-24.4 likely belonged to an individual of some means. Indeed, anybody who was able to spend a considerable amount of his or her income on a coffin should be seen as belonging to at least the lower elite.[6] Unfortunately, no names or titles remain visible to help us with a more precise estimation of the rank of the owner, so we can only speculate about his or her possible status. It is clear, however, that high-ranking individuals such as Nespawershefyt or the high priest Pinudjem I and his family went to much greater lengths to create coffins that would survive the test of time (Daressy 1909, 59; Strudwick and Dawson 2016). Perhaps only individuals of this rank and status could imagine that it would be possible to afford the security necessary to keep their coffins from being reused soon after burial (though in reality this was not always the case). Seeing that tomb robbing and coffin reuse were frequent practices, those slightly lower-ranking individuals may only have been confident about the security of their group burials for a short period of time; therefore, they may have decided that it was better to purchase coffins that could be cheaply and quickly constructed from whatever wooden materials were available and spend the bulk of their investment on the coffins' decoration. The decoration would be seen and would afford owners an arena for social competition. This suggestion aligns with Cooney's (2011, 31) argument that at this time the Egyptians placed more emphasis on the use of objects in short-term ritual contexts than as eternal additions to the burial (see also Arbuckle MacLeod and Cooney 2019). An examination of the religious and ceremonial activation of this object may also reveal why the face of this coffin, and others, has received special attention.

6. Precise costs for coffins and their construction are not known for the Third Intermediate Period; however, during the Ramesside Period, the average price for a standard coffin was 31.57 deben (Cooney 2007, 87). The average wage for the workers at Deir el-Medina, who seem to have been paid much better than most, was approximately 4½ Khar per month, or approximately 9 deben (Janssen 1975, 460). Three months of total income was therefore necessary to buy a coffin, which would not have been possible for the majority of the population and would have been particularly difficult during the Third Intermediate Period, when an income seems to have been less reliable (Cooney 2011, 3).

RELIGIOUS ACTIVATION AND ITS EFFECT ON CONSTRUCTION

Before a coffin receives its ceremonies for religious activation, it is not complete; it is still a decorated, anthropoid-shaped body container, but it has no magical efficacy. These last few steps should therefore be seen as an essential part of the creation of the coffin. After the seventy-day mummification period, the body of the deceased was placed in the coffin and taken in a procession to the tomb. Here the coffin was placed upright and received a number of rituals, the most essential being the "Opening of the Mouth." In this ritual, an instrument called a *pesesh-kef*, or an adze, was touched to the mouth of the coffin to ensure that the deceased would have the ability to breathe in the afterlife or, in other words, to live in the afterlife (Seiler and Rühli 2015; Taylor 2010, 109). The coffin, having now been essentially enlivened as the reborn deceased, could receive food offerings that would sustain him or her eternally. As the focus of the Opening of the Mouth ceremony, the face may have been seen as the most important element of the coffin at this time. The knowledge that the rituals would be carried out on the face may have encouraged individuals to ensure that this part of the coffin was constructed as flawlessly as possible. This may be the reason the owner of coffin EX1997-24.4 ensured that the carpenters carved the details of the face and finished it carefully, while they were not nearly as concerned with the quality of the construction for the rest of the coffin. This may also be why, in the case of high-ranking coffins such as those belonging to Pinudjem I, when small pieces of cedar wood could be found, they were used for the face instead of any other area (Daressy 1909, 59). The increased importance of the face is also suggested by the fact that it was avoided during the application of the black layers.

This application was one of the last acts associated with the coffin that leaves clear physical evidence.[7] In earlier periods, this black layer was occasionally poured in the outer coffin, and the inner coffin was placed inside. In his analysis of the coffins of Henutmehyt from the 19th Dynasty, Taylor also found pieces of grain placed in the black viscous material. He therefore suggested that the added black layers might have been associated with "Osiris beds" (Taylor 1999, 62). Osiris beds and the later "corn mummies" were pieces of wood or boxes shaped into the image of Osiris and used as a planter for wheat or barley seeds to symbolize the rebirth of Osiris within the Osirian mysteries (Raven 1982, 7, 30–31). A similar interpretation may be appropriate

7. While black layers on coffins are frequently identified as bitumen, recent chemical analysis has shown that many examples are actually coated with blackened pistacia resin (Serpico 2000, 459–60). See also chapters 7 and 8, this volume.

for the black in this example as well. The black layer acts as a representation of the fertile soils of the Delta, from which life arose and from which the deceased as an Osiris would be reborn. The pouring of the black layer is likely to have occurred at the very end of the burial rites, just before the coffin was placed in the tomb. From the direction and movements of the black drips on coffin EX1997-24.4, the material was clearly poured while the coffin was closed and lying on its base. If the Opening of the Mouth rituals occurred first, this would have allowed those involved in the burial to see the decoration and perform the necessary ceremonies while the coffin was still standing upright. The black layers could then be applied after it was laid back down. This final action may have signified the moment the deceased was ready to connect to the fertile black soils of the Nile and be reborn as an Osiris in the afterlife. In addition, the covering of the yellow coffin with the black bitumen or resin has parallels in the main theme of funerary religion in this period: the uniting of the solar and Osiride elements, as seen in the figural decoration of this coffin (see chapter 9; Niwiński 1989). Covering the yellow with the black was likely a symbolic action showing the movement from the sunlit land of the living to the dark, Osirian afterlife.

The last mystery pertaining to this coffin is the purpose of the rows of holes drilled into the base of the coffin case (see figure 5.7). The holes were clearly drilled after the case was constructed, as these rows cover both of the larger planks used for construction. The holes are therefore intentional and not simply due to the reuse of an old piece of wood that had been drilled previously. A similar practice is found on several other coffins from this period, including a stola coffin from the Burke Museum of Natural History and Culture in Seattle (catalog 367) and on another stola coffin currently in the Penn Museum in Philadelphia (L-55-16A). The holes seem to appear exclusively on stola coffins, which date to the late 21st and early 22nd Dynasties. It is unlikely that these were present for drainage of the bodily fluids, as mummification was very advanced at this stage in Egypt's history (Ikram and Dodson 1998, 124–28), so little or no fluid would have been left in the body. It is possible that anointing oils and unguents were poured over the body after it was placed in the coffin in amounts that would have necessitated drainage; however, the decoration is intact on the floor of coffins that have holes, which is unlikely to be the case if these pieces were flooded with oils. Perhaps the carpenters thought that drilling holes might help preserve the coffin by allowing air to circulate in areas where the body would usually be pressed against the floor, but this seems unlikely. It is also possible that the purpose of the holes was ideological.

Eisenberg (2004, 82) relates how rows of holes are also occasionally drilled into the base of coffins belonging to individuals from certain Jewish denominations. According to this practice, the coffin is placed in damp earth, and the holes are seen to increase the rate of decomposition. These individuals believe the spirit is free to leave its confines and rejoin the earth only after the coffin has completely degraded (Eisenberg 2004, 82). There are therefore both functional and religious reasons for the holes. In the Egyptian context, coffins were usually placed in dry tombs, so the holes would not have assisted with the degradation of the coffin; however, they may have functioned conceptually to allow the spirit of the deceased to connect to the earth and then be reborn. This would reconnect the coffins once again to the concept of the Osiris bed. Osiris beds, which are, in essence, planters, had rows of holes drilled into the base to allow the water to move through and the planted wheat to grow (see the example found in the tomb of Tutankhamun, Carter 1923, plate 33). The holes in the coffin, then, might be a connection to the added black layers and act as an attempt to match the coffins more closely to the form of the Osiris beds to share in their religious link to Osiris and the conception of rebirth, even if they do not share the same practical function; however, it is necessary to search for

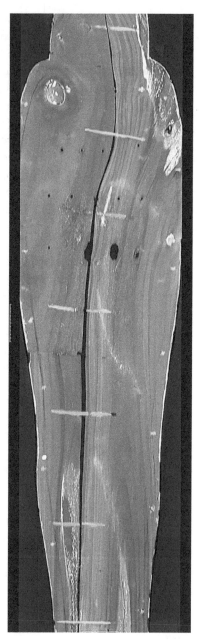

FIGURE 5.7. *CT scan showing holes drilled in the base of the coffin case EX1997-24.4A.*

these holes more actively, as some museums are under the impression that these holes are unique to their coffins or were drilled in the modern era for some unknown reason (Roundhill 2004, 96). Perhaps after more examples are found, we can be more certain about the correct interpretation. As there is no clear practical purpose, however, it is likely that these holes were an attempt to demonstrate some type of religious knowledge as a means of competitive display, which may have been the motivation behind the complicated decoration as well (see chapter 9).

CONCLUSION

The life of coffin EX1997-24.4 is long and complicated, beginning during a time of unrest and insecurity. In light of the uncertainty surrounding the futures of their funerary assemblages, owners and carpenters focused on the short-term ritual function of the coffin and not on the enduring burial. The limited timber resources, caused by environmental and political strain, also restricted the materials available to carpenters. The woodworkers were therefore constructing as quickly as possible with whatever materials became available, knowing that their work would be covered in thick pastes, painted, and likely reused in the future; nevertheless, the tool marks and joining techniques clearly indicate that the carpenters who created this coffin had enough experience to gain the body knowledge necessary to build quality objects, if that had been their goal. Their lack of care in this instance is therefore a choice and not indicative of the absence of experienced craftspeople from Egypt at this time. This is especially clear by the later 22nd Dynasty, when new leaders brought new trade opportunities and it again became fashionable to leave the wood of the coffin exposed, and careful and precise methods of coffin construction became the norm once more (Taylor 2003, 108).

This full, holistic analysis of coffin construction within the historical context demonstrates how large-scale political events can affect crafting traditions. The events of the Third Intermediate Period in Egypt forced transformations in trade and the economy, which had a direct impact on religious practices, as well as on funerary technologies. Despite the clear value of such studies, coffins are not usually subjected to a detailed analysis that focuses on construction methods and actions, with few valuable exceptions (for example, Strudwick and Dawson 2016). Scientific analyses must be integrated to complete the examination of the coffin. The joining techniques used for this heavily decorated coffin would not have been visible without CT scans, making the processes of construction nearly impossible to access. The holes on the base of the coffin

were also inaccessible, as the mummy continues to occupy the coffin, hiding these details from a visual examination. The additional material and stylistic studies help complete the picture. The C14 dates make the possibility of reuse much more likely, despite the fact that little clear evidence for such a practice was visible in construction. This further suggests that reuse may be difficult to identify and may be more common than is currently accepted. It is hoped that more interdisciplinary assessments of coffins will be able to add to a corpus of examples, building up a repertoire of tool marks, construction methods, and materials that can be used in combination with the detailed and valuable analysis of style and decoration. As social documents, more complete studies of coffins can help provide access to a wide variety of Egypt's inhabitants, allowing us to see the significance of objects and their embedded function in the lives of individuals.

REFERENCES

Arbuckle, Caroline. 2018. "*A Social History of Coffins and Carpenters in Ancient Egypt.*" PhD dissertation, University of California, Los Angeles.

Arbuckle MacLeod, Caroline, and Kathlyn M. Cooney. 2019. "The Layered Life of JE26204: The Construction and Reuse of the Coffins of Henuttawy." *Journal of Egyptian Archaeology* 105 (2): 285–96.

Arbuckle MacLeod, Caroline, Elsbeth Geldhof, Marissa Stevens, and Kathlyn M. Cooney. 2016. "The Life of the Egyptian Coffin: Preliminary Report." In *Backdirt: The Annual Review of the Cotsen Institute of Archaeology*, 32–37. Los Angeles: Cotsen Institute of Archaeology Press.

Capart, Jean, Alan H. Gardiner, and Baudouin van de Walle. 1936. "New Light on the Ramesside Tomb-Robberies." *Journal of Egyptian Archaeology* 22 (2): 169–93.

Carter, Howard. 1923. *The Tomb of Tut-Ankh-Amen*. London: Cassell.

Cartwright, Caroline R. 2016. "Wood in Ancient Egypt: Choosing Woods for Coffins." In *Death on the Nile: Uncovering the Afterlife of Ancient Egypt*, edited by Helen Strudwick and Julie Dawson, 78–79. London: Fitzwilliam Museum and D. Giles Ltd.

Cooney, Kathlyn M. 2007. *The Cost of Death: The Social and Economic Value of Ancient Egyptian Funerary Art in the Ramesside Period*. Leiden: Nederlands Instituut voor het nabije oosten.

Cooney, Kathlyn M. 2011. "Changing Burial Practices at the End of the New Kingdom: Defensive Adaptations in Tomb Commissions, Coffin Commissions, Coffin Decoration, and Mummification." *Journal of the American Research Centre in Egypt* 47: 3–44.

Cooney, Kathlyn M. 2014. "Ancient Egyptian Funerary Arts as Social Documents: Social Place, Reuse, and Working towards a New Typology of 21st Dynasty Coffins." in *Body, Cosmos, and Eternity: New Research Trends in the Iconography and Symbolism of Ancient Egyptian Coffins*, edited by Rogério Sousa, 45–66. Oxford: Archaeopress.

Creasman, Pearce Paul. 2013. "Ship Timber and the Reuse of Wood in Ancient Egypt." *Journal of Egyptian History* 6 (2): 152–76.

Daressy, Georges. 1909. *Cerceuils des Cachettes Royales*. Cairo, Egypt: Imprimerie de l'Institut Francais d'Archeologie Orientale.

Davies, W. Vivian. 1995. "Ancient Egyptian Timber Imports: An Analysis of Wooden Coffins in the British Museum." In *Egypt, the Aegean, and the Levant: Interconnections in the Second Millennium* BC, edited by W. Vivian Davies and Louise Schofield, 146–56. London: British Museum Press.

Dawson, Julie, Jennifer Marchant, and Eleanor von Aderkas. 2016. "Egyptian Coffins: Materials, Construction, and Decoration." In *Death on the Nile: Uncovering the Afterlife of Ancient Egypt*, edited by Helen Strudwick and Julie Dawson, 75–111. London: Fitzwilliam Museum and D. Giles Ltd.

Eisenberg, Ronald L. 2004. *Jewish Traditions: A JPS Guide*. Philadelphia: Jewish Publication Society.

Gale, Rowena, Peter Gasson, Nigel Hepper, and Geoffrey Killen. 2000. "Wood." In *Ancient Egyptian Materials and Technology*, edited by Paul T. Nicholson and Ian Shaw, 334–71. Cambridge: Cambridge University Press.

Graves-Brown, Carolyn. 2015. *Egyptology in the Present: Experiential and Experimental Methods in Archaeology*. Swansea: Classical Press of Wales.

Ikram, Salima, and Aidan Dodson. 1998. *The Mummy in Ancient Egypt: Equipping the Dead for Eternity*. London: Thames and Hudson.

Janssen, Jac J. 1975. *Commodity Prices from the Ramesside Period: An Economic Study of the Village of Necropolis Workmen at Thebes*. Leiden: E. J. Brill.

Killen, Geoffery. 1994. *Egyptian Woodworking and Furniture*. Princes Risborough, UK: Shire.

Lemonnier, Pierre. 1992. *Elements for an Anthropology of Technology*. Ann Arbor: Museum of Anthropology, University of Michigan.

Niwiński, Andrzej. 1988. *21st Dynasty Coffins from Thebes: Chronological and Typological Studies*. Mainz am Rhein, Germany: Verlag Philipp von Zabern.

Niwiński, Andrzej. 1989. "The Solar-Osirian Unity as Principle of the Theology of the 'State of Amun' in Thebes in the 21st Dynasty." *Journal of the Near Eastern Society "Ex Oriente Lux"* 30 (1987–88): 89–106.

Niwiński, Andrzej. 1992. "Ritual Protection of the Dead or Symbolic Reflection of His Special Status in Society? The Problem of the Black-Coated Cartonnages

and Coffins of the Third Intermediate Period." In *The Intellection Heritage of Egypt: Studies Presented to László Kákosy by Friends and Colleagues on the Occasion of His 60th Birthday*, edited by Ulrich Luft, 457–71. Budapest: Chaire d'Égyptologie.

Parkes, Phil, and David Watkinson. 2010. "Computed Tomography and X-Radiography of a Coffin from Dynasty 21/22." In *Decorated Surfaces on Ancient Egyptian Objects: Technology, Deterioration, and Conservation*, edited by Julie Dawson, Christina Rozeik, and Margot M. Wright, 58–66. London: Archetype.

Peet, T. Eric. 1930. *The Great Tomb Robberies of the Twentieth Egyptian Dynasty, being a Critical Study, with Translations and Commentaries, of the Papyri in Which These Are Recorded*. 2 vols. Oxford: Clarendon.

Raven, Maarten J. 1982. "Corn-Mummies." *Oudheidkundige mededelingen uit het Rijksmuseum van Oudheden te Leiden* 63: 7–38.

Roundhill, Linda S. 2004. "Conservation Treatment Considerations for an Egyptian Polychrome Wood Coffin." *AIC Objects Specialty Group Postprints* 11: 89–102.

Seiler, Roger, and Frank Rühli. 2015. "The Opening of the Mouth: A New Perspective for an Ancient Egyptian Mummification Procedure." *Anatomical Record* 298 (6): 1208–16.

Serpico, Margaret. 2000. "Resins, Amber, and Bitumen." In *Ancient Egyptian Materials and Technology*, edited by Paul T. Nicholson and Ian Shaw, 430–74. Cambridge: Cambridge University Press.

Śliwa, Joachim. 1975. *Studies in Ancient Egyptian Handicraft: Woodworking*. Krakow, Poland: Krakow University.

Strudwick, Helen, and Julie Dawson, eds. 2016. *Death on the Nile: Uncovering the Afterlife of Ancient Egypt*. London: Fitzwilliam Museum and D. Giles Ltd.

Strudwick, Helen, and Julie Dawson, eds. 2019. *Ancient Egyptian Coffins: Past, Present, Future*. Oxford: Oxbow Books.

Taylor, John H. 1999. "The Burial Assemblage of Henutmehyt: Inventory, Date, and Provenance." In *Studies in Egyptian Antiquities: A Tribute to T.G.H. James*, edited by W. Vivian Davies, 59–72. London: British Museum Occasional Papers.

Taylor, John H. 2003. "Theban Coffins from the 22nd to the 26th Dynasty: Dating and Synthesis of Development." In *The Theban Necropolis: Past, Present, and Future*, edited by Nigel Strudwick and John H. Taylor, 95–121. London: British Museum Press.

Taylor, John H. 2010. *Egyptian Mummies*. Austin: University of Texas Press.

Wendrich, Willeke. 1999. *The World According to Basketry*. Leiden: Leiden University, Center for Non-Western Studies.

Wendrich, Willeke. 2012. *Archaeology and Apprenticeship: Body Knowledge, Identity, and Communities of Practice*. Tucson: University of Arizona Press.

6

The significance of wood in ancient Egypt is not frequently recognized. Nor does timber regularly enter into discussions of Egyptian coffins. This is, in part, related to the understandable reticence of museum curators to allow sampling, a necessary procedure to permit reliable species identification and the study of dendrochronological details; however, the analysis of timber used in coffins, such as those evaluated here, offers great opportunity to extract important information, including for chronological, environmental, and behavioral matters (e.g., Creasman 2015a, 2015b; Dean 1996). In the process of the examination of coffins EX1997-24.2A and B and EX1997-24.4A and B, wood samples were taken and analyzed by a team of experts using microscopy and dendrochronological methods. The results provide significant insight into access to resources in the Third Intermediate Period, the status of the objects' owners, and changes in construction methods and technologies. This chapter therefore demonstrates the necessity and value of timber analysis and the vital part it plays in the holistic examination of ancient Egyptian coffins.

Coffin Timbers and Dendrochronology

The Significance of Wood in Coffins from the Denver Museum of Nature & Science

CAROLINE ARBUCKLE MACLEOD,
CHRISTOPHER H. BAISAN,
AND PEARCE PAUL CREASMAN

TIMBER AND TREES IN EGYPT

It is usually assumed that throughout the pharaonic period, quality timber resources in Egypt were consistently at a premium, owing to the modern (nineteenth–twenty-first-century) belief that local

DOI: 10.5876/9781646421381.c006

trees were scarce, as they appear to be today (Deglin 2012, 85; Gale et al. 2000, 334; Lucas 1962, 429). The question of how much and what quality timber was actually available, however, has not been thoroughly addressed (see Creasman 2013, 154–55; 2015b, 46–49 for discussion), and the situation may not have been as dire as is often suggested (e.g., Ward 2000, 15). The sheer volume of artifacts composed of available native species provides some perspective, if not evidence, that more local wood was available than is usually supposed. Yet the high frequency of timber reuse suggests that in no period was so much of the resource available for the society as a whole that the Egyptians could be wasteful (Creasman 2013, 155).

Of the native trees available during the pharaonic period, some genera produced strong, hard wood that was superior for crafting smaller objects; some were good for ornamental needs; some provided for medicinal needs; and some produced long lengths suitable for spanning roofs and the like but were poor for any sort of tailoring (e.g., palms). What Egypt seems to have lacked was a large number of trees capable of providing long, straight, sturdy timbers that could be precisely shaped for large worked objects, especially those needed to withstand immense weights or other stresses (e.g., ship hulls and masts, support timbers for stone structures). For these materials Egypt often turned to its neighbors, most commonly to import conifers (e.g., *Cedrus* sp., *Cupressus* sp., *Juniperus* sp., and *Pinus* sp.; see Creasman 2014, 87; Liphschitz 2007). Desire for imported prestige materials may have played a significant role in obscuring the matter of domestic versus imported timber supply and relative need (Creasman 2015b, 48–49).

When Egypt was prosperous and trade relations with the Near East were stable—during the heights of the Old, Middle, and New Kingdoms, for instance—cedar wood was plentiful for royal uses. During these times, even the wealthy non-royals could arrange access to foreign timber to build large coffin assemblages. Those who could not afford the imported resources made use of what grew in Egypt: most commonly sycamore fig (*Ficus sycormorus*), acacia (*Vachellia* spp. [formerly *Acacia* spp.]),[1] and tamarisk (*Tamarix* spp.) (Cichocki et al. 2004; Creasman 2014, S88). Local sidder/Christ's

1. As of 2013, the acacias of Africa have been reclassified from the genus *Acacia* to *Vachellia* and others (Kyalangalilwa et al. 2013). While the work has not been completed for all of the known Egyptian variants (e.g., Mahmoud 2010, 27–30), the most common taxa have been renamed as such: *Acacia nilotica* is now *Vachellia nilotica* and *Acacia tortilis* is now *Vachellia tortilis*. The work has been confirmed by taxonomic collaboratives, such as the Integrated Taxonomic Information System (see www.itis.gov) and the Catalogue of Life (www.catalogueoflife.org).

thorn (*Ziziphus spina-christi*), date palm (*Phoenix dactylifera*), and dom palm (*Hyphaene thebaica*), as well as imported ebony (*Dalbergia melanoxylon*), were also used in considerable amounts (Březinovà and Hurda 1976; Cartwright 2016; Creasman 2015b; Gale et al. 2000, 340–48). In all periods, when local woods were used, large objects such as coffins were typically composed of smaller and shorter pieces joined together, sometimes using ingenious methods. During periods when Egypt's economy was less prosperous and trade routes were destabilized, new wooden constructions were primarily limited to the use of local trees (see chapter 5).

During the Third Intermediate Period, the era during which the coffins of the Denver Museum of Nature & Science were created, burial practices experienced perceptible shifts, corresponding with increasing international tensions and an economic downturn. The ever-present desire for a well-provided burial did not disappear, but the materials to create and the means to finance elaborate assemblages were no longer readily available (see chapter 2). Observation of the archaeological remains of the 21st and 22nd Dynasties suggests that available timber resources could not meet demand: Reuse of burial objects, in whole or in part, occurred to an extent that had not previously been seen in Egypt. Coffins and other wooden objects were extensively recycled, either taken apart for materials or simply redecorated for their new owners (Cooney 2011). Compared to other times in Egyptian history, Third Intermediate Period coffins seldom contain cedar wood; when they do, it has been reused from earlier contexts. When cedar was available, the coffin makers seem to have frequently reserved it for specific elements of the burial materials considered particularly important, such as the face, while creating the remainder of the coffin from local timbers (see chapter 5).

Scientific identification of the genera or species of woods used and the information that can be revealed by such identification are only recently being addressed and remain frustratingly uncommon in coffin studies (Cartwright 2016; Davies 1995; Taylor 1999). For example, when cedar is found (regardless of the period), it is usually suggested that the owner had privileged access to resources of some kind (e.g., Ward 2000, 20–21), whether this be fresh trade/tribute, royal storehouses, or elite tombs. Conversely, if a coffin is built from several different types of wood, pieced together like a puzzle, it is usually interpreted as a sign of resource stress, in either the raw material or the commodity used to obtain the raw materials. However, in specific instances, diversity of material reflects not a lack of ability/resource but rather an acknowledgment by the builder of the valuable inherent properties of specific woods, due to their various strengths and anatomic structure (Cartwright 2016). It is not the

piecing together of multiple woods but evidence for the reuse of materials and a decline in the quality of craftsmanship that should therefore be illustrative of economic distress (see chapter 5).

In Egypt, the ritual significance of an item or species must also be considered. Certain trees and tree by-products had connections to certain gods (Incordino and Creasman 2017; Manniche 1989). Use of certain woods, then, may have contributed to the ritual efficacy of an item, especially the coffin. For instance, sycomore fig was commonly associated with Hathor and Nut, goddesses connected to the rebirth of Osiris, god of the afterlife, and thus to the rebirth of the mortal dead (Goyon 1972, 241; Koemoth 1994, 203, 206; for the ancient perspective of sycomore fig in general, see Weeks 2003). With its symbolic association with the dead and its local availability, sycomore fig became a wood commonly used for coffins, especially during the Third Intermediate Period when more valuable cedar was not accessible. It is interesting that one of the most readily available sources of native timber became greatly valued for its use in the burial for symbolic reasons. At some unknown date, the prevailing opinion regarding the use of common (read: less prestigious) sycomore fig in a coffin must have tipped, as it ultimately became a desirable commodity for this purpose.

WOOD IDENTIFICATION
METHODS

In many cases, sampling of an artifact for additional analysis can be unobtrusive, and the information gathered can lead to a greater understanding of the object and the society from which it derives. The data obtained are (potentially) worth a small sacrifice: such sampling is far less destructive to the object than archaeological excavation (or looting) is to the site from which it came. When sampling the wood from coffins for the purposes of identification, small fragments can be taken from areas where damage is already present or from within joints or mortises, where the sampling would remain effectively invisible for an object on display. The size of the sample required for species identification varies depending on the methods involved, but it is often possible to find sufficiently diagnostic material in a sample that is just a few millimeters in width and length.

Several acceptable standard procedures and sets of terminology have been developed for the purposes of wood identification. Those offered by the International Association of Wood Anatomists, intended primarily for modern woods, were used in this case. A checklist of anatomical features was

prepared for both hardwoods and softwoods, and this can be used to identify elements and compare the sample features to those of a reference collection (InsideWood Working Group 2004; Richter et al. 2004; Wheeler et al. 1989). The checklists and procedures were adapted for historical wood, especially to account for the effects of aging and degradation (Cartwright et al. 2011, 49). It is standard practice that three sections of the wood in question need to be visible for proper identification: the transverse, radial longitudinal, and tangential longitudinal. Each section has the potential to provide different anatomical information.

Two general methods can be used to gain access to the planes of reference. If samples are relatively large and in good state of preservation, thin sections can be prepared for analysis and examined using transmitted light microscopy. In this process, thin sections of approximately 15μ in width are cut either by hand using a scalpel or razor blade or, preferably, by a microtome. They are then mounted on a glass slide and examined under the microscope. Again, it is necessary to be able to cut thin sections for each plane, so samples need to be large enough to ensure that at least three such sections can be obtained. A sample that is at least 25 mm × 25 mm × 50 mm is preferable (Cartwright et al. 2011, 51). When a sample of such size cannot be obtained or the wood has deteriorated so badly that a clean thin section cannot be cut, a scanning electron microscope (SEM) can be employed.

The SEM method allows irregular or small surfaces to be examined at high magnification. Using this method, positive identification can be reached with samples only a few millimeters long and wide (Cartwright et al. 2011, 51). In addition, the images created by the SEM are detailed and clear, allowing identifications to be verified and shared. Increasing the reference collection images for ancient woods is an area of need and can help improve the reliability of identifications in general. Online databases, such as InsideWood, for instance, would greatly benefit from the addition of numerous images related to the anatomy of Egyptian and Levantine timbers, which are not currently well represented. The primary limitation to SEM identification is the cost and size of the equipment necessary, as well as maintenance and immobility. Transmitted light microscopy is similar and more portable.

Both microscopy methods were used to analyze the samples collected from the Denver Museum of Nature & Science (DMNS). Transmitted light microscopy was used for primary analysis of the samples, which required the creation of thin sections according to the procedures outlined above. Scanning electron microscopy was performed on smaller samples and, where necessary, to verify identifications. For the latter, uncoated specimens were mounted

with carbon tape on stubs and examined using a variable pressure FEI NOVA 230 Nano SEM at Low Vacuum (LV) with a Low Vacuum Detector (LVD). The accelerating voltage was set at 10 kV, chamber pressure was 50 pa, and working distance fluctuated between 7–7.7 mm, depending on the sample size. Under these conditions, clear anatomical features were visible.

Once the anatomical features are exposed by any method, the sample features are compared with reference collections. Several sources of reference material are available to assist with the identification of woods found in Egypt (Cartwright 2001; Cartwright et al. 2011; Crivellaro and Schweingruber 2013; Fahn et al. 1986; Gale and Cutler 2000; InsideWood Working Group 2004; Neumann 1989); however, as noted, the images of woods from Egypt provided by these references are limited. Due to the variability in wood anatomy, it is preferable to have a modern reference collection on hand, as many features are not visible in the available databases. As additional studies such as this are completed, we can add to this corpus and build on our understanding of anatomical variation and the use of timber in Egypt.

Analysis

Four samples were obtained from coffin lid EX1997-24.4B, where slight areas of damage and well-preserved tenons and dowels permitted the extraction of multiple specimens. Two samples were taken from the sides of the coffin, belonging to the largest pieces used for construction; one was taken from the coffin's upper right shoulder and another from the left. A loose tenon and dowel were also taken from the area of the coffin's left shoulder for sampling; they were then returned to the coffin. Another dowel was taken from coffin base EX1997-24.4A for comparison.

The samples taken from the larger timbers of the coffin lid EX1997-24.4B were determined to be the same species of wood: *Ficus sycomorus* (sycomore fig; figure 6.1). The two samples taken from a tenon and a dowel on lid EX 1997-24.4B and the dowel from coffin base EX1997-24.4A were found to be *Vachellia nilotica* (formerly classified as *Acacia nilotica*; still commonly termed acacia, or gum arabic tree).[2]

An entire tenon with bark was collected from the coffin lid EX1997-24.2B, from the coffin's right side waist mortise. Eight specimens were collected for

2. The preceding specimens were identified by Caroline Arbuckle MacLeod, with the assistance and advice of Caroline Cartwright, senior scientist at the British Museum, for which she is grateful.

Figure 6.1. *Cross-section of* Ficus sycomorus *sample taken from the right shoulder of coffin lid EX1997-24.2B. C. Arbuckle MacLeod.*

dendrochronological purposes from the timbers of EX1997-24.2 (six specimens from four different boards from the coffin base; two specimens from the boards of the lid) and are identified below (see table 6.1).

The tenon with bark remaining from the lid of EX1997-24.2B was identified as *Tamarix* sp.[3] The eight dendrochronological specimens were identified as *Ficus sycomorus*.[4]

3. Likely *Tamarix aphylla*. This specimen had bark and was identified by Michael C. Wiemann, botanist of the Forest Products Laboratory of the US Forest Service (personal communication, May 9, 2016).
4. Identified at the Laboratory of Tree-Ring Research, University of Arizona, by Creasman and Baisan.

TABLE 6.1. Taxonomic identifications for EX1997-24.2 and EX1997-24.4

DMNS Catalog Number	Field Specimen Number	Identification
EX1997-24.4B	Sample 1: R shoulder	*Ficus sycomorus*
EX1997-24.4B	Sample 2: L shoulder	*Ficus sycomorus*
EX1997-24.4B	Sample 3: L dowel	*Vachellia nilotica* (see n. 1)
EX1997-24.4B	Sample 4: L tenon	*Vachellia nilotica* (see n. 1)
EX1997-24.4A	Sample 5: Base dowel	*Vachellia nilotica* (see n. 1)
EX1997-24.2A	Dendro 1	*Ficus sycomorus*
EX1997-24.2A	Dendro 2a	*Ficus sycomorus*
EX1997-24.2A	Dendro 2b	*Ficus sycomorus*
EX1997-24.2A	Dendro 3a	*Ficus sycomorus*
EX1997-24.2A	Dendro 3b	*Ficus sycomorus*
EX1997-24.2A	Dendro 4	*Ficus sycomorus*
EX1997-24.2B	Tenon 1 (with bark)	*Tamarix* sp.
EX1997-24.2B	Dendro 01	*Ficus sycomorus*
EX1997-24.2B	Dendro 02	*Ficus sycomorus*

Interpretation

Ficus sycomorus is the most common taxa used for the construction of coffins throughout the history of ancient Egypt (Davies 1995). The coffins EX1997-24.2 and EX1997-24.4 are no exception. What is interesting, if not atypical, is the use of different species of wood for the dowels and tenons. As noted in chapter 5, both tamarisk and acacia are dense and durable woods. Acacia specifically is reputed as difficult to work with hand tools.[5] Its strength may also be the reason it is commonly found as a material used for tenons and dowels in Egyptian woodwork (Gale et al. 2000, 335). The softer sycomore fig wood is not ideal for joint pegs, as their deterioration could impede the function of the object (Cartwright 2016). After generations of constructing coffins and other wooden items, the practice of using denser, stronger woods for structural elements such as dowels and tenons became commonplace in

5. One anecdote serves as a powerful confirmation of this long-held understanding: during a collection event in Egypt's Wadi el-Gemal National Park in 2015 (NSF award #1427574), Creasman and Baisan, with three other collaborators, collected several specimens of living acacia (with the kind permission of Superintendent Mohamed Gad and many others). It took five men using a sharp handsaw in alternating intervals more than 30 minutes to obtain a single section of acacia only 15 cm in diameter.

ancient Egypt. There would, of course, have been ample small pieces around a woodshop as larger pieces were cut and shaped.

DENDROCHRONOLOGY OF EX1997-24.2A AND B
METHODS

Eight 12 mm cores were collected with a simple hollow bit and standard battery-powered drill for the purpose of dendrochronological evaluation (figures 6.2 and 6.3). Specimen location was selected with the fundamental goal of preventing any damage to the coffin's artistic compositions. That is, specimens were taken only in places that would not change the nature of the coffin while on display or its value as an object of art. While these locations may not have been ideal from a purely dendrochronological perspective, it was a compromise in order to obtain data. The process of specimen collection was recorded as digital video so it can be used to inform and advise the custodians of other potentially useful items in the construction of the much-needed tree-ring chronologies for Egypt. In this regard, the DMNS coffin was an exceptionally successful test case for recruitment of future collaborators. Long-established methods for collection and analyses were employed (e.g., Douglass 1941; Stokes and Smiley 1968), the archaeological applications of which have been thoroughly detailed (Bannister 1963; Dean 1978), as have their specific utility and potential for Egyptology (Creasman 2014, 2015a, 2015b).

Scholars who conduct tree-ring–based research ("dendrochronologists") study tree rings as natural chronometers and recorders of change in the environment around where they grew (Creasman 2012). Tree rings provide a view on pre-industrial cultures and their associated lands that is otherwise unattainable. The methodology is often compared to the assembly of a complex jigsaw puzzle: pieces, collected from many sources, are arduously fitted together over a period of years (often decades) to build up a chronology that yields annual precision for past events and processes. Dendrochronology is the only geochronological or archaeological dating method that is accurate to the calendar year; its precision is presently unrivaled in the archaeological sciences.

The natural growth pattern of many, although not all, species of trees makes dendrochronology feasible: one growth ring added in one calendrical year. Tree-ring research is undertaken not by counting rings but rather by comparing the patterns of varying ring widths among a sufficiently large group of specimens, each specimen requiring a sufficient number of rings for comparison (Bannister 1963). ("Sufficient" is a relative term and is dependent on the totality of conditions for each case study.) A variety of environmental and

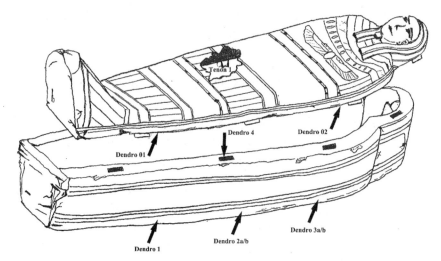

FIGURE 6.2. *Locations of dendrochronological specimen collection. M. Koutkat.*

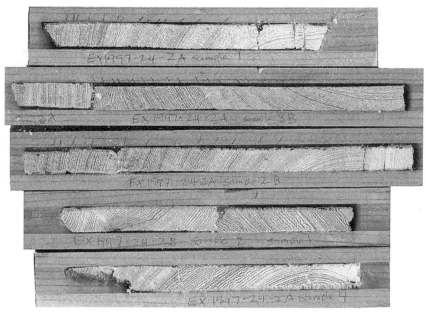

FIGURE 6.3. *Dendrochronological specimens collected and prepared for analysis. C. H. Baisan and P. P. Creasman.*

human conditions can influence the width of the rings and can often be identified as a result. Growth slowed by some degree of drought or cooler temperatures, for example, results in narrower rings. Individual trees growing in similarly sensitive sites during overlapping periods produce comparable patterns (Dean 1997). This allows for meaningful comparison among specimens from different trees. Overlap of patterns between specimens of differing age, in turn, allows for the construction of long-term chronologies by means of cross-dating—the most essential aspect of dendrochronology (Douglass 1941).

ANALYSIS

As no master chronology[6] exists in sufficient length for any wood used with frequency by the ancient Egyptians, the initial goal of this collection was not to provide a calendrical date for the coffin. The specimens were collected as part of an ongoing chronology-building effort, so it may be possible in the future to provide a precise calendrical date for the death of the wood used in this as well as in other Egyptian objects. Beyond the chronological implications of building a tree-ring chronology, the specimens themselves hold important information regarding past natural and human phenomena. There is much about human behavior in direct relation to the environment that can be learned through the study of wood and its uses (e.g., Creasman 2013). Notably, tree rings serve as proxy records for environmental conditions, such as drought, and will likely be the key to evaluating environmental theories of dynastic change (Bell 1971, 1975; Butzer 2012; Moeller 2005; Touchan and Hughes 2009). However, for these environmental records to be derived for Egypt, native taxa, not the imported varieties, must be analyzed; tree rings reflect the conditions where they grew, which is not necessarily where they are recovered.

Coffin EX 1997-24.2 (parts A and B) was the only item sampled for dendrochronological purposes from the collection of the Denver Museum of Nature & Science during the 2016 effort. As the largest and most robust coffin in the collection, it provided the greatest opportunity for sampling while ensuring the continued integrity of the artifact itself. Few Egyptian coffins have ever been sampled for dendrochronological study, largely due to such concerns. The

6. A master chronology is a series of tree-ring measurements or graphs, unique to a time and place (and often a species or genera), that has been determined to represent known calendar dates for a time and place, as it is linked to the present day through a living tree. This specific series, or set of tree-ring patterns, is used as the data to which all other suspected and undated specimens for that time and place are compared to determine and assign calendar dates; it is the "backbone" of tree-ring dating (Allaby 1998).

artistic corpus suggests that the coffin dates from the 25th, possibly the 26th, Dynasty, which is a specific period of interest in the chronology-building effort. Furthermore, as most coffins of the period under focus are built of native taxa, the specimens collected could be incorporated into a parallel effort to evaluate the fundamental dendrochronological utility of Egypt's native trees, which is understudied (Creasman 2014, S87–S88) but now actively being undertaken (e.g., Creasman et al. 2017; Manning et al. 2014; Peters et al. 2017).

INTERPRETATION

Foremost, it bears repeating that useful, good-quality dendrochronological specimens were obtained with standard tools and methods from the coffin without causing any unintended or inadvertent alteration to the objects. That is, the only change to the nature or appearance of the coffin was where and as expected: the small holes created by the hollow drill bit. With professional care, even the most delicate painted coffins can be dendrochronologically sampled.

With comparatively few specimens and no extant master chronology to which to compare them, the information derived is inherently limited for now. Still, several interesting observations can be made from this modest sample set. For example, the coffin samples demonstrate bands of parenchyma that resemble the pattern found in modern long-lived sycamore figs of Egypt (the pattern is different in short-lived [e.g., thirty years or less] modern sycamore figs). This pattern, being similar to the modern long-lived comparative material, suggests that these timbers derived from trees that were already old before being harvested for use in the coffin, perhaps a century or more in age. In addition, the slow growth near the pith (center) of the coffin samples suggests that the timbers were originally branch wood rather than stem (trunk) wood. Initial growth in the main stem appears quite rapid in modern sycamore figs. Pruning branches to use for carpentry (i.e., to turn them into lumber/timber) preserves the main plant for other uses and new branch wood can be harvested at intervals, extending the longevity of the native resource. This practice is known from ancient Egypt (Gale et al. 2000, 353) and is seen in several reliefs, perhaps most famously in those from the 18th Dynasty temple of Hatshepsut at Deir el-Bahri (Naville 1898, pl. 70). It is also possible that an old tree was felled in its entirety and the branches were removed for use afterward, as shown in several Egyptian tombs, including the 4th Dynasty tomb of Sekhemkara at Giza (Hassan 1943, fig. 60), the 12th Dynasty tomb of Khnumhotep II at Beni Hassan (Kanawati and Evans 2014, pl. 120; Newberry 1893, pl. 29), and several of the New Kingdom.

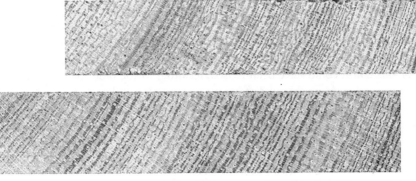

FIGURE 6.4. *Cross-dating specimens from EX1997-24.2A: Dendro 2b and 3b. C. H. Baisan.*

Critically, the coffin specimens exhibit parenchyma bands that define, more or less clearly, a repeating cycle of growth, probably annual. It is not possible at present to distinguish what causes this banding: annual Nilotic floods or cool/cold temperatures in the winter are most likely, but this remains only speculation at present. A terminal parenchyma band is not, however, apparent. Further research needs to be conducted on modern living sycomore figs in Upper and Lower Egypt to identify the cause(s), confirm the resolution, and evaluate whether terminal parenchyma are present. Interestingly, even without obvious terminal parenchyma, the bands of two specimens (EX 1997-24.2A specimens 2b and 3b) exhibit matching patterns and almost certainly originated from the same tree (figure 6.4). Such inter-tree cross-dating is a critical step forward in evaluating the utility of the species for tree-ring research.

DISCUSSION

There is little in the dendrochronology or artistic decoration that suggests that the wood of coffin EX1997-24.2 has been reused, agreeing with the suggestion in chapters 5 and 9 that by this point in the Third Intermediate Period, the political situation had become more stable and local woods could again be used to construct new funerary objects. The carbon 14 data provide a valuable additional perspective. Resulting dates are as follows: coffin lid EX1997-24.2B, 778–543 BCE; coffin base EX1997-24.2A, 775–542 BCE; and the tenon with bark from lid EX1997-24.2B, 791–550 BC. All are at the 95.4 percent confidence interval. In total, the evidence suggests that the coffin was created from new materials in the 25th–26th Dynasties, which aligns with the artistic/stylistic analysis.

The second coffin under consideration is a different case. Coffin lid EX1997-24.4B, 1047–925 BCE; tenon from lid EX1997-24.4B, 911–822 BCE; and dowel from base EX1997-24.4A, 927–831, are similarly dated at the 95.4 percent confidence interval. These dates raise the possibility that the sycomore fig used for this coffin could have been reused, resulting in the older dates, while the dowels and tenons were made from new materials in a late 21st or early 22nd Dynasty workshop. The artistic decoration (such as it remains) is consistent with this later date (see chapter 9). In addition to reuse, it is also possible that the sycomore fig had been cut and stockpiled well before the tenon and dowels were produced or that the sycomore fig lost considerable edge material in its conversion to usable timber. The later dates of the joinery materials and some kind of human intervention fully explain the divergence in dates and comfortably place the final construction of the coffin in the later 21st or early 22nd Dynasties, which aligns with the artistic/stylistic analysis.

The dendrochronological and wood identification analyses alone provide an engaging glimpse into the ancient world. These analyses combined with other lines of evidence are significantly more powerful, as demonstrated above. Despite being undertaken in this limited case study, these analyses have resulted in critical advances on several fronts that offer profound potential as efforts in these areas of study go forward.

REFERENCES

Allaby, Michael. 1998. *A Dictionary of Ecology*. Oxford: Oxford University Press. http://www.oxfordreference.com/view/10.1093/acref/9780198608912.001.0001/acref-9780198608912.

Bannister, Bryant. 1963. "Dendrochronology." In *Science in Archaeology: A Comprehensive Survey of Progress and Research*, edited by Don R. Brothwell and Eric S. Higgs, 162–86. New York: Thames and Hudson.

Bell, Barbara. 1971. "The Dark Ages in Ancient History, I: The First Dark Age in Egypt." *American Journal of Archaeology* 75 (1): 1–26.

Bell, Barbara. 1975. "Climate and the History of Egypt: The Middle Kingdom." *American Journal of Archaeology* 79: 223–69.

Březinová, Drahomira, and Bohumil Hurda. 1976. "Xylotomic Examination of Timber from Ancient Egyptian Coffins." *Zeitschrift für ägyptische Sprache und Altertumskunde* 103: 139–42.

Butzer, Karl W. 2012. "Collapse, Environment, and Society." *Proceedings of the National Academy of Sciences of the United States of America* 109 (10): 3632–39.

Cartwright, Caroline R. 2001. "*Cedrus libani* under the Microscope: The Anatomy of Modern and Ancient Cedar of Lebanon Wood." *Archaeology and History in Lebanon* 14: 107–13.

Cartwright, Caroline R. 2016. "Wood in Ancient Egypt: Choosing Woods for Coffins." In *Death on the Nile: Uncovering the Afterlife of Ancient Egypt*, edited by Helen Strudwick and Julie Dawson, 78–79. London: Fitzwilliam Museum and D. Giles Ltd.

Cartwright, Caroline R., Lin Rosa Spaabæk, and Marie Svoboda. 2011. "Portrait Mummies from Roman Egypt: Ongoing Collaborative Research on Wood Identification." *British Museum Technical Research Bulletin* 5: 49–58.

Cichocki, Otto, Max Bichler, Gertrude Firneis, Walter Kutschera, Wolfgang Müller, and Peter Stadler. 2004. "The Synchronization of Civilizations in the Eastern Mediterranean in the Second Millennium BC: Natural Science Dating Attempts." In *Tools for Constructing Chronologies: Crossing Disciplinary Boundaries*, edited by Caitlin E. Buck and Andrew R. Millard, 83–108. London: Springer.

Cooney, Kathlyn. 2011. "Changing Burial Practices at the End of the New Kingdom: Defensive Adaptations in Tomb Commissions, Coffin Commissions, Coffin Decoration, and Mummification." *Journal of the American Research Centre in Egypt* 47: 3–44.

Creasman, Pearce Paul. 2012. "Long-Term Preservation of Dendroarchaeological Specimens: Problems and Practical Solutions." *Conservation and Management of Archaeological Sites* 14 (1–2): 349–58.

Creasman, Pearce Paul. 2013. "Ship Timber and the Reuse of Wood in Ancient Egypt." *Journal of Egyptian History* 6 (2): 152–76.

Creasman, Pearce Paul. 2014. "Tree Rings and the Chronology of Ancient Egypt." *Radiocarbon* 56 (4): *Tree-Ring Research* 70 (3): S85–S92.

Creasman, Pearce Paul. 2015a. "Exposing Ancient Egyptian Shipbuilders' Secrets." In *Egyptology in the Present: Experiential and Experimental Methods in Archaeology*, edited by Carolyn Graves-Brown and Wendy Goodridge, 13–37. Swansea: Classical Press of Wales.

Creasman, Pearce Paul. 2015b. "Timbers of Time: Revealing International Economics and Environment in Antiquity." In *There and Back Again—the Crossroads II: Proceedings of an International Conference Held in Prague, September 15–18, 2014*, edited by Jana Mynářová, Pavel Onderka, and Peter Pavúk, 45–58. Prague: Charles University, Faculty of Arts.

Creasman, Pearce Paul, Hayat Touchane, Christopher H. Baisan, Hussein Bassir, Rebecca Caroli, Noreen Doyle, Hannah Herrick, Magdi A. Koutkat, and Ramzi Touchan. 2017. "An Illustrated Glossary of Arabic-English Dendrochronology

Terms and Names." *Palarch Journal of the Archaeology of Egypt/Egyptology* 14 (3): 1–35.

Crivellaro, Alan, and Fritz H. Schweingruber. 2013. *Atlas of Wood, Bark, and Pith Anatomy of Eastern Mediterranean Trees and Shrubs.* Berlin: Springer.

Davies, W. Vivian. 1995. "Ancient Egyptian Timber Imports: An Analysis of Wooden Coffins in the British Museum." In *Egypt, the Aegean, and the Levant: Interconnections in the Second Millennium* BC, edited by W. Vivian Davies and Louise Schofield, 146–56. London: British Museum Press.

Dean, Jeffrey S. 1978. "Tree-Ring Dating in Archaeology." In *University of Utah Anthropological Papers: Miscellaneous Collected Papers* 24, edited by Jesse Jennings, 129–63. Salt Lake City: University of Utah Press.

Dean, Jeffrey S. 1996. "Dendrochronology and the Study of Human Behavior." In *Tree Rings, Environment, and Humanity: Proceedings of the International Conference, Tucson, Arizona, 17–21 May 1994*, edited by Jeffrey S. Dean, David Meko, and Thomas W. Swetnam, 461–69. Tucson: Radiocarbon, Department of Geosciences, University of Arizona.

Dean, Jeffrey S. 1997. "Dendrochronology." In *Chronometric Dating in Archaeology*, edited by Royal E. Taylor and Martin J. Aitken, 31–64. New York: Springer.

Deglin, Flavie. 2012. "Wood Exploitation in Ancient Egypt: Where, Who, and How?" In *Current Research in Egyptology 2011: Proceedings of the Twelfth Annual Symposium Which Took Place at Durham University, United Kingdom, March 2011*, edited by Heba Abd El Gawad, Nathalie Andrews, Maria Correas-Amador, Veronica Tamorri, and James Taylor, 85–96. Oxford: Oxbow Books.

Douglass, Andrew E. 1941. "Crossdating in Dendrochronology." *Journal of Forestry* 39 (10): 825–31.

Fahn, Abraham, Ella Werker, and Pieter Baas. 1986. *Wood Anatomy and Identifications of Trees and Shrubs from Israel and Adjacent Regions.* Jerusalem: Israel Academy of Sciences.

Gale, Rowena, and David Frederick Cutler. 2000. *Plants in Archaeology: Identification Manual of Vegetative Plant Materials Used in Europe and the Southern Mediterranean to c. 1500.* Otley, UK: Westbury and Royal Botanic Gardens, Kew.

Gale, Rowena, Peter Gasson, Nigel Hepper, and Geoffrey Killen. 2000. "Wood." In *Ancient Egyptian Materials and Technology*, edited by Paul T. Nicholson and Ian Shaw, 334–71 Cambridge: Cambridge University Press.

Goyon, Jean-Claude. 1972. *Rituels funéraires de l'ancienne Égypte.* Paris: Éditions du Cerf.

Hassan, Selim. 1943. *Excavations at Giza, vol. 4: 1932–1933.* Cairo, Egypt: Government Press.

Incordino, Ilaria, and Pearce Paul Creasman, eds. 2017. *Flora Trade between Egypt and Africa in Antiquity.* Oxford: Oxbow.

InsideWood Working Group. 2004. *Inside Wood Database.* Raleigh: North Carolina State University. http://insidewood.lib.ncsu.edu/search.

Kanawati, Naguib, and Linda Evans. 2014. *Beni Hassan, vol.* 1: *The Tomb of Khnumhotep II.* Australian Centre for Egyptology Reports 36. London: Aris and Phillips.

Koemoth, Pierre. 1994. *Osiris et les arbres: contribution à l'étude des arbres sacrés de l'Égypte ancienne.* Liège: Centre Informatique de Philosophie et Lettres.

Kyalangalilwa, Bruce, James S. Boatwright, Barnabas H. Daru, Olivier Maurin, and Michelle van der Bank. 2013. "Phylogenetic Position and Revised Classification of *Acacia* s.l. (Fabaceae: Mimosoideae) in Africa, Including New Combinations in *Vachellia* and *Senegalia.*" *Botanical Journal of the Linnean Society* 172 (4): 500–523.

Liphschitz, Nili. 2007. *Timber in Ancient Israel: Dendroarchaeology and Dendrochronology.* Institute of Archaeology Publications Monograph 26. Tel Aviv: Tel Aviv University.

Lucas, Alfred. 1962. *Ancient Egyptian Materials and Industries.* London: Histories and Mysteries of Man Ltd.

Mahmoud, Tamer. 2010. *Desert Plants of Egypt's Wadi El Gemal National Park.* Cairo: American University in Cairo Press.

Manniche, Lise. 1989. *An Ancient Egyptian Herbal.* London: British Museum Publications.

Manning, Sturt, Michael W. Dee, Eva M. Wild, Christopher Bronk Ramsey, Kathryn Bandy, Pearce Paul Creasman, Carol B. Griggs, Charlotte L. Pearson, Andrew J. Shortland, and Peter Steier. 2014. "High-Precision Dendro-14C Dating of Two Cedar Wood Sequences from First Intermediate Period and Middle Kingdom Egypt and a Small Regional Climate-Related 14C Divergence." *Journal of Archaeological Science* 46: 401–16.

Moeller, Nadine. 2005. "The First Intermediate Period: A Time of Famine and Climate Change?" *Ägypten und Levante* 15: 153–67.

Naville, Edouard. 1898. *The Temple of Deir el Bahari, vol.* 3: *End of Northern Half and Southern Half of the Middle Platform.* London: Egypt Exploration Fund.

Neumann, Katharina. 1989. *Forschungen zur Umweltgeschichte der Ostsahara.* Köln: Heinrich-Barth-Institut.

Newberry, Percy E. 1893. *Beni Hasan, vol.* 1. London: Kegan Paul, Trench, Trübner.

Peters, Erin, Caroline Roberts, and Pearce Paul Creasman. 2017. "Recent Research on the 'Carnegie Boat' from Dahshur, Egypt." *Journal of Ancient Egyptian Interconnections* 17: 99–103.

Richter, Hans Georg, Dietger Grosser, Immo Heinz, and Peter E. Gasson, eds. 2004. "IAWA List of Microscopic Features for Softwood Identification." *International Association of Wood Anatomists Journal* 25: 1–70.

Stokes, Marvin A., and Terah L. Smiley. 1968. *An Introduction to Tree-Ring Dating.* Chicago: University of Chicago Press.

Taylor, John H. 1999. "The Burial Assemblage of Henutmehyt: Inventory, Date, and Provenance." In *Studies in Egyptian Antiquities: A Tribute to T.G.H. James, edited by W. Vivian Davies,* 59–72. London: British Museum Occasional Papers.

Touchan, Ramzi, and Malcolm K. Hughes. 2009. "Dendroclimatology in the Near East and Eastern Mediterranean Region." In *Tree-Rings, Kings, and Old World Archaeology and Environment: Papers Presented in Honor of Peter Ian Kuniholm, edited by Sturt W. Manning and Mary Jaye Bruce,* 65–70. Oxford: Oxbow.

Ward, Cheryl A. 2000. *Sacred and Secular: Ancient Egyptian Ships and Boats.* Archaeological Institute of America Monographs New Series 5. Philadelphia: University Museum, University of Pennsylvania.

Weeks, Kent R. 2003. "The Sycamore Fig." In *Hommages à Fayza Haikal,* edited by Nicholas Grimal, Amr Kamel, and Cynthia May-Sheikholeslami, 305–13. Le Caire: Institut français d'archéologie orientale.

Wheeler, Elisabeth A., Pieter Baas, and Peter E. Gasson, eds. 1989. "IAWA List of Microscopic Features for Hardwood Identification." *International Association of Wood Anatomists Journal* 10: 219–332.

7

Compositional analysis made possible by technological innovation is revolutionizing the study of ancient objects. This is particularly true of X-ray fluorescence—commonly known as XRF—a spectrographic analysis method that can be used to help determine the chemical makeup of pigment and other inorganic surface treatments on ethnological and archaeological specimens. Our study's use of spectrography technology for pigment analysis adds to the collective insights of research teams that are turning to advanced analysis methods to study ancient Egyptian mortuary specimens.

Portable X-Ray Fluorescence (pXRF) Analysis of Egyptian Mortuary Practices

A Case Study

Farrah Cundiff, Bonnie Clark, and Keith Miller

PIGMENTS AND THEIR ANALYSIS

This study was primarily focused on determining which pigments were used to create the colors we see today on the surface of Egyptian coffins and mummies.

A study in pigment analysis must include a careful look at four interrelated and interdependent entities: *element*, *pigment*, *paint*, and *color*. The following brief definitions outline the differences and similarities among them.

- An element is a single substance that cannot be further broken down chemically.

- A pigment is a colorful substance that can consist of one or more elements; it can be either organic or inorganic.

- Color is the visual appearance of a pigmented substance.

DOI: 10.5876/9781646421381.c007

- Paint is a decorative paste or liquid often made by mixing a pigment-bearing powder with a wet binder like water or oil. The color of a paint derives from its pigments.

To illustrate the relationship among these four phenomena, we can describe an analysis involving the pigment *orpiment*. The elements arsenic and sulfur combine to form the compound *arsenic sulfide*, which, in a certain chemical form, is known as the pigment *orpiment*. Orpiment's color is a bright golden yellow. A bright yellow paint can be made from a mixture of powdered orpiment and water.

The color of a pigment and thus of a paint can change over time due to oxidation or other degradation, so a visual analysis of color is not the most accurate method of identifying the ingredients ancient craftspeople used to make decorative paints. Instead, pigments must be identified through their elements, by using technology like XRF. Based on the XRF spectra of a paint sample, researchers can begin to assess which ancient paint recipe—using the elements detected, in the amounts detected, and accounting for chemical change over time—could have produced the visual color seen in the present.

Exact conclusions about paint ingredients are not always possible using a single spectrography method because these technologies are specialized to interpret one aspect of a material's makeup (Liritzis and Zacharias 2011). However, findings from one spectrographic method can be supported by those of other methods to strengthen the accuracy of pigment analysis conclusions.

The existing literature on pigment analysis of ancient Egyptian funerary decoration reveals common recipes for paint mixtures, which tend to be consistent across time and geography in the ancient Egyptian dynasties. Several pigment analysis studies using XRF technology have been completed for ancient Egypt and have served as important comparative resources (see Calza et al. 2007; Klys et al. 1999; Nicholson and Shaw 2000; Scott et al. 2009). In addition, Nicholson and Shaw's (2000) survey textbook is a rich compendium of information on ancient Egyptian material analysis, compiled from many more studies that benefited from a variety of materials analysis technologies. This text was a valuable source that we used to help shape our study's expectations, predictions, and questions.

XRF TECHNOLOGY

X-ray fluorescence takes advantage of the fact that when materials are exposed to X-rays, their atomic structure is temporarily destabilized by the excitation of

electrons. At the end of exposure, atoms in the material return to their stable configurations, but when doing so, energy is released in the form of light, a process known as fluorescence. The characteristic energy of the fluorescence is specific to the elements out of which materials are made. The information about how an atom fluoresces after exposure to an X-ray can be determined through spectroscopic techniques, which record that energy as a spectrum. Modern XRF instruments contain components that both irradiate objects with X-rays and capture the spectral energy subsequently produced. Analytical software in these instruments can also (with proper calibration appropriate for the material analyzed) convert spectral data into quantitative information (Schlotz and Ulig 2006). For metals, quantitative information is provided as the percentage of material analyzed. In geological (or soils) mode, XRF instruments typically express element concentrations in parts per million, or ppm.

Not all materials are amenable to XRF study. The lightest elements—those typical in organically derived materials—are not detectable by current XRF instruments. Likewise, the heaviest elements cannot be studied using XRF, but they are rarely found in artifacts. Finally, items that are under 10 mm in their smallest dimension or less than 2 mm thick cannot be analyzed predictably by current XRF technology (Shackley 2011, 9).

Despite these limitations, XRF has a number of virtues to recommend it for the analysis of material culture. First, it is non-destructive; the disturbance to materials is temporary. This means XRF analyses can be completed while maintaining complete preservation of specimens. Second, information is derived almost instantaneously from the instrument. Thus, testing regimens can be modified during analysis. This is important for situations like the present study, when access to materials is temporally limited. Third, there is a family of XRF instruments that are portable. Portable XRF (or pXRF) can be used on large or immobile specimens such as coffins, which cannot fit into an instrument's analytical chamber.

HYPOTHESES

The most common type of pXRF analysis in Egyptian mummies and coffins—our main focus of study—is of pigments used in sarcophagi, coffins, and cartonnage (Calza et al. 2007; Scott et al. 2009). Analyses of pigment composition can lead to a better understanding of resources and techniques employed by craftspeople in the past. In addition, the presence or absence of certain pigments, along with radiocarbon analysis and stylistic studies, can contribute to chronological information regarding the date of manufacture.

TABLE 7.1. Common paint mixtures and their elements and colors in ancient Egyptian funerary decoration (according to Calza et al. 2007; Kłys et al. 1999; Lee and Quirke 2000; Nicholson and Peltenburg 2000; Scott et al. 2009)

Element	Pigment	Color	Medium	Material Note
Calcium	—	White	Paint	Bone or chalk
Iron	Ochre, hematite	Tan, light brown	Ground layer	Mud
Calcium, sulfur	—	Off-white	Ground layer	Gypsum
Iron	Ochre, hematite	Brick red, muted orange, dusty yellow, buff	Paint	Clay
Copper	Egyptian blue, green frit, malachite	Bright green, vibrant royal blue	Paint	Synthetic
Arsenic	Orpiment	Intense golden yellow	Paint	—

Based on the paint recipes outlined by pigment analyses in the literature we reviewed—paired with our own preliminary knowledge of the coffins we would be testing—we expected to be able to find the pigments Egyptian blue, green frit, malachite, iron oxides like ochre clays and hematite, and orpiment. Since Egyptian coffins are typically carved from wood and then covered in some type of plaster ground layer (Lee and Quirke 2000), we also hoped to identify ground layers such as chalk, bone white, mud, or gypsum. To determine whether these were the substances used to paint the Denver Museum of Nature & Science (DMNS) coffins, we planned to test for iron, arsenic, copper, and calcium (table 7.1).

Alongside our primary interest in testing pigments and ground layers, we had three additional testing interests:

1. Two of the materials commonly used in the ancient Egyptian embalming process are coniferous tree resin and bitumen, a geological product derived from organic remains. Both resin and bitumen contain some compounds in common, but if bitumen is used, one can expect to detect a specific set of trace elements: vanadium, nickel, and molybdenum (Kłys et al. 1999; Serpico and White 2000). We believed that these elements may be found in black-coated specimens in our study.

2. The identification or characterization of amulets included in mummy wrappings does not yet have an established baseline of similar studies, but we felt XRF could have useful applications in this area. Metallic amulets

included in mummy wrappings should produce a significantly different spectrum than items of *faience*, which are silica and copper-rich, glass-like ceramics (Nicholson and Peltenburg 2000). The success of these types of analyses, however, is very dependent on the depth of the amulet placement. Both the X-rays themselves and the energy resulting from fluorescence are dissipated the further the instrument is from the target. Portable XRF instruments are designed to be used in direct contact with the item analyzed. We expected that any readings of high metallic or silica content in our samples, which fell out of the expected range for pigments and ground layers, could indicate the composition of an amulet and would be worth noting.

3. The specimens we would be testing had undergone a pigment analysis in 1997 using scanning electron microscopy (SEM). Like XRF, SEM can also be used to derive compositional analysis. Other examples of a combination of XRF and SEM analyses can be found for a range of items (Eveno et al. 2014), including the study of Egyptian mortuary specimens (Calza et al. 2007; Scott et al. 2009). The 1997 SEM test's data and interpretive report were available to us from the museum archives where the specimens are held, and we were interested to find where our datasets might support or differ from one another.

METHODS

TEAM

On April 19, 2016, two faculty members from the University of Denver, Bonnie Clark (anthropology) and Keith Miller (chemistry), conducted analytic research of the Egyptian mortuary specimens at the Denver Museum of Nature & Science, alongside several other research teams whose findings are detailed throughout this volume. Clark and Miller used a portable X-ray fluorescence instrument (pXRF) to test the chemical composition of the specimens in the DMNS collection. Graduate research assistant Farrah Cundiff (archives and cultural heritage management) joined the pXRF team to compile test data and provide specialized research into ancient pigments.

SPECIMENS

Seven large specimens were available for testing in 2016: three coffin lids, two coffin bases, and two mummies. One mummy was too fragile to test using pXRF, so testing was performed on only six of the available specimens:

1. Mummy with black coating (EX1997-24.1)
2. Mes's coffin base (EX1997-24.2A)
3. Mes's coffin lid (EX1997-24.2B)
4. 21st Dynasty coffin base (EX1997-24.4A)
5. 21st Dynasty coffin lid (EX1997-24.4B)
6. Ankhefenkhonsu's coffin lid (EX1997-24.5)

INSTRUMENT

The instrument used was an Olympus Delta Premium (DP6000, 4-watt X-ray source; Rh anode; 8–40 keV; Olympus Scientific Solutions, Waltham, MA) portable XRF (figure 7.1). The instrument is capable of using different beam configurations to optimize the analysis of elements in different materials (matrices).

The pXRF was equipped with both alloy ("Alloy Plus") and soil ("Soil Explorer") calibration modes; only the Soil Explorer mode was used in this study. As with all such instruments, elements need to reach a threshold for the instrument to detect them. The thresholds for the instrument used in this study are delineated in table 7.2.

Primarily, the instrument was held by the analyst through each test, which used all three of the beams for maximum analytical potential (figure 7.2). When possible, the unit was used in a holster, which allowed it to rest on the specimen or on a table for better stability. In a few cases, the testing location was fragile or hard to reach. In those instances, only one or two beams were used to reduce the amount of time for the test. In these situations, the beam used was chosen based on primary elements of interest (for example, beam 2 reveals arsenic, which is important to look for in yellow pigments).

PROCEDURE

All pXRF instruments have a face that needs to be placed in contact with the material to be analyzed. Within that face is an "analytical window" where X-rays are released and spectral energy is recorded (see figure 7.1). This affects methodology because all the material exposed to this window will be analyzed. Ideally, testing areas should be chosen where materials of interest exist across the area to be covered by the window and should be relatively flat. In the case of our instrument, that window is 1.7 cm across and 2 cm high. Prior to analysis, the team made a target of inert plastic sheeting. Gridded into 1 centimeter squares with the analytical window cut out, it was designed to protect the specimens during testing. It also helped us plan testing locations and document them photographically.

FIGURE 7.1. *pXRF device face and analytical window*

TABLE 7.2. Instrument detection limits for the elements analyzed in this study expressed as parts per million (ppm) (according to Innov-X Systems, Inc. n.d.)

Element	Detection Limit	Element	Detection Limit	Element	Detection Limit
S	150–300	Fe	10	Zn	3–5
Ca	25–40	Ni	10–20	As	1–3
V	7–15	Cu	5–7	Mo	1–3

On the day of the testing, we began by visually inspecting all of the specimens and working with Dr. Michele Koons and the other specialists present to identify priority areas for testing. Each coffin piece was to have its different paints, any exposed wood, unpainted plaster, and significant black deposits tested.

To better capture visual data about the area tested, at least one photograph was taken of the tested area with the target in place, and at least one photograph was taken with a handheld digital microscope (figure 7.3). The photographs captured both sample context and location, as well as the surface conditions of the tested area. The microscopic photographs tended to be at a magnification

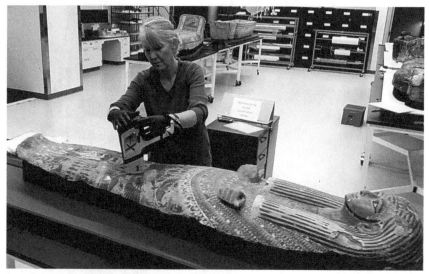

FIGURE 7.2. *Dr. Bonnie Clark using pXRF device on Ankhefenkhonsu's coffin (EX1997-24.5)*

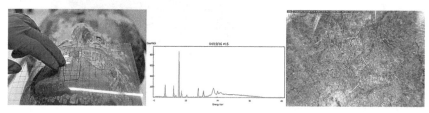

FIGURE 7.3. *21st Dynasty coffin lid (EX1997-24.4B), blue-green sample between eyes (pXRF15). Three types of imaging were captured at each sample spot, shown* left to right: *a photo of the location of the test target, a fluorescence spectrum, and a magnified image of the test area.*

of between 60× to 70×, covering a surface area of just under 8 mm. Figure 7.3 demonstrates the various imaging captured at each pXRF sample spot.

As recommended by leaders in the field (e.g., Shackley 2011), our testing began and ended by using our instrument on an established standard material, one whose composition has been tested independently and repeatedly. By comparing the results of an instrument to those expected for the standard, one can assess the quality of the calibration and the consistency of the testing over the period of the instrument's use. We chose as our standard NIST Standard Reference Material (SRM) 2711 (Montana soil). It has certified levels for many of the elements in which we were particularly interested, including arsenic,

copper, calcium, vanadium, and nickel. Our results on the standard were in line with established composition and were consistent at both the beginning and the end of our testing time. A total of forty-three locations were sampled on the seven specimens (figure 7.4).

RESULTS

Test spectra revealed iron, arsenic, copper, and calcium in samples of paint and ground layer on the three coffins we tested, which was in line with our expectations. We acknowledge that there have been various conservation efforts to the coffins and mummies in the past, but to our knowledge, none of the known treatments used would have affected the results we present here. Sulfur, vanadium, nickel, molybdenum, and zinc were notable elements found in other samples, and these findings require expanded discussion below.

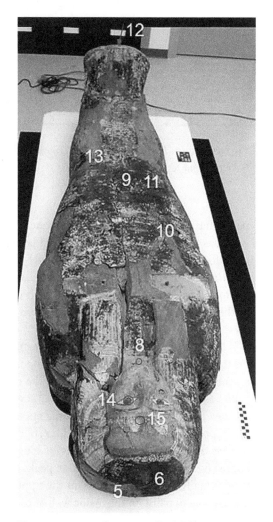

FIGURE 7.4. *21st Dynasty coffin lid (EX1997-24.4B). Distribution of pXRF tests across one of the specimens. Test numbers are sequential for all the specimens.*

21ST DYNASTY COFFIN (EX1997-24.4)

The 21st Dynasty coffin is a set that includes a lid and a base (figure 7.4). In addition to the fact that much of the painted design of the coffin is covered with a thick black substance, around 50 percent of the paint has come off. The

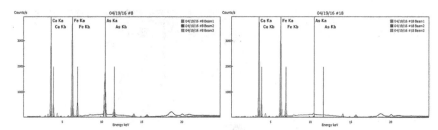

Figure 7.5. *21st Dynasty coffin lid (EX1997-24.4B), yellow samples on throat and head (pXRF08 and pXRF18)*

paint that is present and visible includes red, yellow, green, blue, black, and white, as well as tan and white ground layers, often in very small shapes that are difficult to capture alone in the pXRF device's field.

Calcium: All samples on the 21st Dynasty coffin reveal high amounts of calcium. In fact, this high calcium reading is detected by pXRF in most samples in the study, suggesting that it comes from a universal material present across all specimens.

Yellow: Yellow on the figure's throat tested high for iron and arsenic; yellow on the top of the head is primarily composed of iron with a trace amount of arsenic (figure 7.5). On the outside of the coffin's base, at the top of the head, yellow is high only in iron (figure 7.6).

Arsenic: We noted that trace arsenic appeared on the lid and base in the following paint samples: yellow, red, blue, blue-green, and black substance.

Blue: Spectra from four samples of blue paint tested on the 21st Dynasty coffin (figures 7.7–7.10) showed large peaks over copper. Three of these samples were visually blue: a raised dot on the upper leg area, a spot between the eyes, and an area of paint on the inside wall of the base. The fourth sample, tested on the lower abdomen, was covered in the black substance that partially obscures the design on this coffin. Unexpectedly, this test revealed a high amount of copper, very similar to the results of the areas that appear blue.

Red: Tests of red samples showed major peaks over iron.

Black: A test of black paint on the lid identified high iron.

Mes's coffin (EX1997-24.2)

Mes's coffin lid is covered in a dedication in hieroglyphs to a man named "Mes" (figure 7.11) (for translation and interpretation of inscription, see chapter

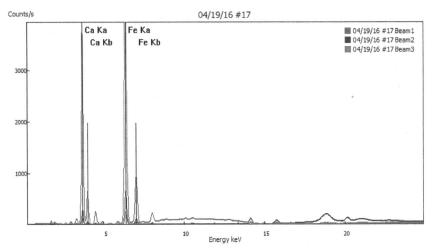

FIGURE 7.6. *21st Dynasty coffin base (EX1997-24.4A), yellow sample head (pXRF17)*

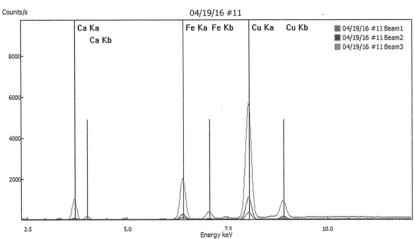

FIGURE 7.7. *21st Dynasty coffin lid (EX1997-24.4B), black substance sample on abdomen (pXRF11)*

9, this volume). The interior of the base is decorated with a large image of Ptah-Sokar-Osiris, a deity with the head of a falcon (chapter 9). The coffin lid and base are well preserved, but the colors have a distinctly dull, muted quality. Paint colors include white, light green, red, dusty yellow, tan, pale blue, and black, over what seem to be tan and white ground layers.

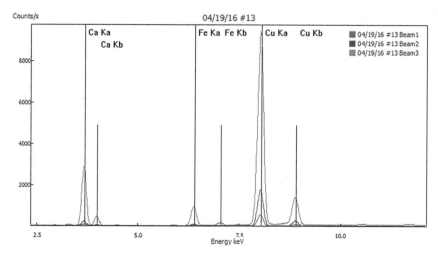

Figure 7.8. *21st Dynasty coffin lid (EX1997-24.4B), blue sample on leg (pXRF13)*

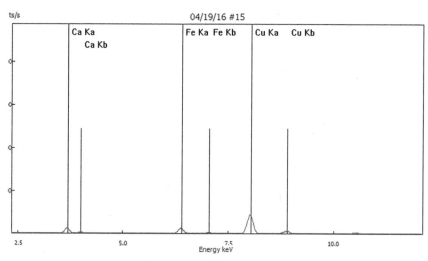

Figure 7.9. *21st Dynasty coffin lid (EX1997-24.4B), blue sample between eyes (pXRF15)*

Calcium: Most pXRF readings across the entirety of Mes's coffin show substantial amounts of calcium, regardless of color or location. Calcium is also relatively higher across all readings on this coffin's base.

Red: Samples from both the body of the falcon-headed god inside the base and the mid-leg area on the lid show similar spectra with prominent iron content and trace copper (figures 7.12 and 7.13).

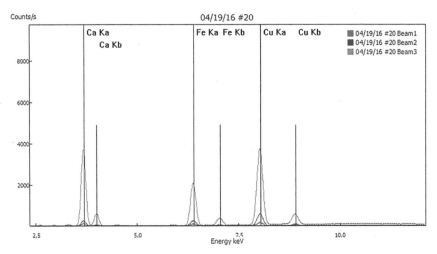

FIGURE 7.10. *21st Dynasty coffin base (EX1997-24.4A), blue sample on inside wall of base (pXRF20)*

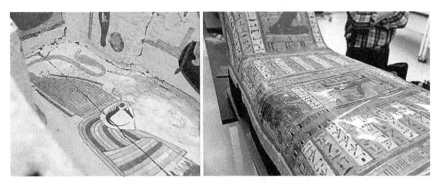

FIGURE 7.11. Left to right: *Mes's coffin base (EX1997-24.2A) and lid (EX1997-24.2B). Plastic targets laid over red and white sample areas.*

Yellow: Two yellow paint samples in the mid-leg area on the lid and inside the base on the falcon-headed god's crown tested high in iron.

Arsenic: XRF detected trace arsenic on Mes's coffin lid in the following samples: green, red, yellow, blue, and tan. Arsenic was not detected on the sides of the lid or on the base.

Green: pXRF results from a mid-leg green sample yielded a high amount of copper and a significant amount of iron, with trace tin.

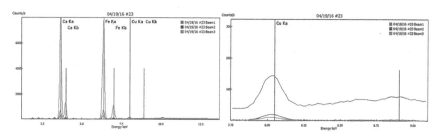

FIGURE 7.12. *Mes's coffin base (EX1997-24.2A), red sample on falcon-headed god (pXRF23)*

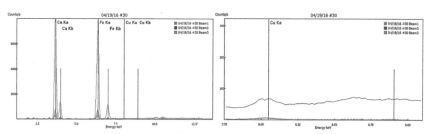

FIGURE 7.13. *Mes's coffin lid (EX1997-24.2B), red sample on legs (pXRF30)*

MUMMY WITH BLACK COATING (EX1997-24.1)

This mummy has well-preserved linen wrappings and a thick, gritty-looking black substance coating the top surface of the body. She was previously associated with Mes's coffin but does not belong with it (see chapter 2). Radiology testing in 2016 and in previous years shows a metal object over the mummy's chest, off-center toward the mummy's right side, guessed to be an amulet of some kind (see chapter 4). The radiology tests also show multiple layers of linen wrappings with a harder layer, presumably of the same black substance, halfway between the outer surface and the body (see chapter 4).

Zinc: The area of the amulet registered a high amount of zinc (figure 7.14). This was tested on the surface of the black coating over the center-right chest area.

Black Coating: Two samples of the black substance on the mummy—over the chest and over the legs—generated XRF spectra with small peaks over molybdenum, vanadium, and nickel (figure 7.15). These sample areas also registered as two of the higher instances of sulfur among all data in the study: 50,475 ppm and 45,505 ppm, respectively (figure 7.16).

ANKHEFENKHONSU'S COFFIN (EX1997-24.5)

Ankhefenkhonsu's coffin, also known as the scribe's coffin, is so-called due to the inscriptions on the lid dedicating the coffin to an honored Egyptian

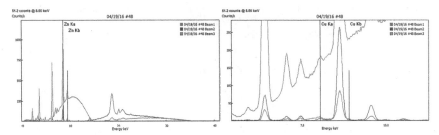

FIGURE 7. 14. *Mummy with black coating (EX1997-24.1), region over amulet (pXRF48)*

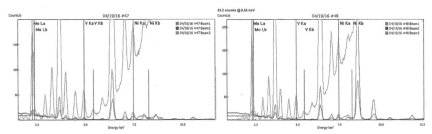

FIGURE 7.15. *Mummy with black coating (EX1997-24.1), black substance samples (pXRF47 and 48). Test spectrum shows positive reading for the molybdenum, vanadium, and nickel combination cited by Kłys and colleagues (1999) as markers of bitumen.*

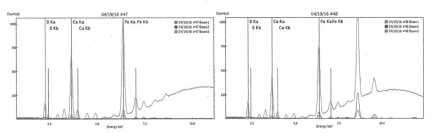

FIGURE 7.16. *Mummy with black coating (EX1997-24.1), black substance samples (pXRF47 and 48). Test spectrum shows positive reading for sulfur, cited as marker of bitumen.*

scribe, Ankhefenkhonsu of Thebes (see chapter 9, this volume). The coffin consists of a lid only. The lid is covered in finely detailed symbols and script and is very well preserved. Today, the colors of its decoration appear to be black, a blackish-green (dark green, almost black), light green, red, and yellow (figure 7.17).

Calcium: Most of our samples on Ankhefenkhonsu's coffin registered high amounts of calcium. A tan-colored sample we suspected to be ground layer also showed a significant peak over iron.

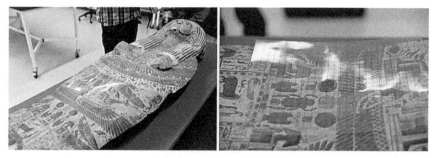

FIGURE 7.17. *Ankhefenkhonsu's coffin (EX1997-24.5).* Left to right: *Areas appearing to be black on the body of the figure are actually a blackish-green color under light. The plastic target is aligned over a blackish-green dot (pXRF38) over the pelvis.*

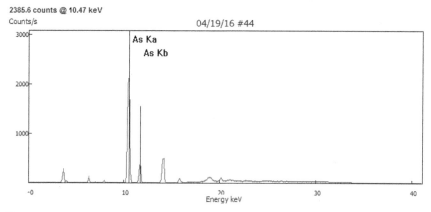

FIGURE 7.18. *Ankhefenkhonsu's coffin (EX1997-24.5), black sample on left iris (pXRF44). Arsenic reading.*

Yellow: The figure's left hand and left eye both tested very high for arsenic, with less prominent readings of iron and sulfur. XRF readings of arsenic are 42,255 ppm on the left hand and 17,644 ppm on the left eye, the two highest arsenic readings in the study by at least three orders of magnitude. Each tested yellow area also showed sulfur and iron. The left eye is painted black, and with visual inspection (figures 7.18 and 7.19), it was possible to see the color yellow through chips in black paint.

Green and Blue: XRF analyses showed a strong copper presence on a raised green-black circle over the pelvis (figure 7.20), on a raised light green circle over the pelvis (figure 7.21), and on the tall light green crown of a seated

FIGURE 7.19. *Ankhefenkhonsu's coffin (EX1997-24.5)* (left image), *black sample on left iris (pXRF44)* (right image). *Test location and microscopic view of layered paints.*

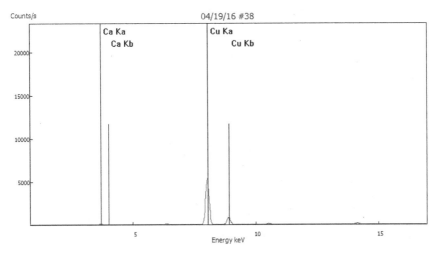

FIGURE 7.20. *Ankhefenkhonsu's coffin (EX1997-24.5), dark green sample over pelvis (pXRF38)*

figure over the pelvic region (in chapter 9, this is identified as the "seated figure of Osiris wearing the white crown") (figure 7.21). The concentrations of copper in these samples are 300 percent to 600 percent higher than any other copper reading in this study. Close visual inspection revealed that bright blue paint shows through chips in a green-black dot over the thighs, and bright red paint shows through chips in the surface of a light green dot over the pelvis (figure 7.22).

Arsenic: We detected trace arsenic in every sample from Ankhefenkhonsu's coffin lid: light green, dark green, red, yellow, black, bare wood, and mud plaster.

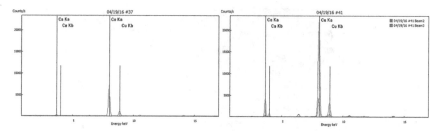

FIGURE 7.21. *Ankhefenkhonsu's coffin (EX1997-24.5), light green samples of dot and Osiris's crown over pelvis (pXRF37 and 41)*

DISCUSSION

Positive tests for iron, arsenic, copper, and calcium helped us identify some of the pigments and ground layers we had expected (ochre, orpiment, Egyptian blue, and mud plaster or chalk), but not all (green frit, malachite, and bone white were not identifiable with our methods and available samples; hematite and gypsum were not substances we found to be present on these specimens).

21ST DYNASTY COFFIN (EX1997-24.4)

Ground Layer: The high amount of calcium in multiple samples on this coffin probably comes from a clay or chalk ground layer beneath the paint. Its universal presence across the samples in this study indicates a similar ground layer on all of the coffins.

Yellow: The two primary sources of yellow in ancient Egyptian decoration are orpiment, an arsenic sulfide, and ochre, an iron oxide clay (Lee and Quirke 2000). They differ in rarity and appearance, with ochre far more common (2000). As for the difference in their appearance, Lee and Quirke (2000, 116) write: "The buff or dull yellow given by ochre can often be distinguished from bright orpiment . . . Orpiment has a laminar structure, creating a scintillating effect quite unlike the matte surface of ochre." Although orpiment was less common than ochre, Lee and Quirke (2000) cite several instances of their use together: layers of ochre over orpiment and of orpiment over ochre; also, mixtures of the two together have been identified in previous pigment analyses of Egyptian decoration.

Yellow samples tested on this coffin appear to be made of two different compositions of pigments: a mixed paint of ochre and orpiment and a paint of ochre only. This finding aligns with the studies discussed in chapter 8, in which a loose sample from this same coffin (3604) was found to contain orpiment.

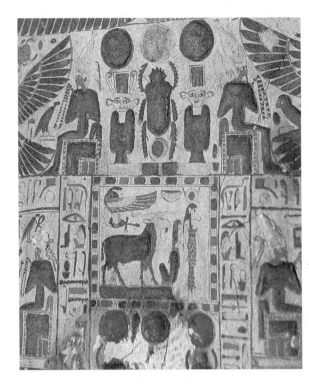

FIGURE 7.22.
Ankhefenkhonsu's coffin (EX1997-24.5), view of light green dot over pelvis with red color beneath surface and dark green dot over thighs with blue color beneath surface

Both orpiment and ochre and variations therein are evident on all three coffins tested in this study, leading us to conclude that yellow was a color that could be highly variable either within one design or between funerary workshops and possibly also due to coffin reuse (Cooney 2017) during the time period represented by the coffins in this study.

Arsenic: An Egyptian coffin would have been susceptible to insects eating the wood or paints made with organic pigments. There were at least six types of arsenic-based pesticides in use by field collectors and museum staff for the prevention of this kind of damage in anthropology specimens during the nineteenth and twentieth centuries (Goldberg 1996). They include paintable liquids (such as arsenic trichloride) and dusting powders (such as arsenic trioxide and sodium arsenite). The coffins examined in this study were all collected from the field and then housed in museums during the time when arsenic would have been a popular preservation substance.

Although arsenic-bearing orpiment has been found layered beneath ochre in yellow paints (Lee and Quirke 2000, 115), arsenic as a pesticide is another

possibility that provides a stronger explanation for the presence of small amounts of arsenic in non-yellow color samples on the coffin. The historical use of arsenic as a preservative in museum contexts provides a plausible scenario in which the 21st Dynasty coffin acquired a layer of trace arsenic inside and out that is not due to an orpiment-based yellow paint.

Blue: The manufacture of Egyptian blue requires heating a group of naturally occurring substances, including copper, to induce a chemical change that creates a synthetic pigment not commonly found in nature. Although this is the most common blue pigment found in ancient Egyptian decoration (Lee and Quirke 2000), the manufacture process made this paint rare and expensive, likely to be found only on the coffins of high-ranking or wealthy people.

The high copper readings of blue paint on this coffin indicate that the pigment utilized for this object was Egyptian blue.

Red: Red samples with high iron content are likely made of an iron-rich clay or mud, that is, ochre.

Black: Iron detected in the area of black paint on the lid is probably from the ground layer and not the black paint. Hematite-black is not likely as the iron is not very strong, and the black paint does not have the shimmering quality that is characteristic of hematite coloring (Lee and Quirke 2000). A carbon-based or charcoal pigment—which would be invisible to XRF—seems the most likely source of the black color.

Mes's Coffin (EX1997-24.2)

White Ground Layer: Most pXRF readings across the entirety of Mes's coffin show substantial amounts of calcium, regardless of color or location. We believe this ubiquity is due to calcium having been applied in a ground layer across the whole coffin before paint was applied. Calcium is also relatively higher across all readings on the base of this coffin. White ground layer and white paint may have been applied more thickly to create a bright matte background color for the motifs on the interior of the base. It is not clear from the XRF data whether the white ground layer and white paint are different materials.

Yellow: Iron-rich yellow samples appear to be made of a yellow ochre.

Arsenic: As was the case on the 21st Dynasty coffin's surface, we believe arsenic's presence across Mes's coffin's lid, in colors not typically associated with orpiment, could be due to an arsenic-based preservative coating. Arsenic's presence on the top of the coffin and not the sides or bottom supports the possibility that an arsenical pesticide powder was dusted across the coffin's top surface.

Green: Known sources of copper-bearing green on Egyptian coffins include green frit, malachite, copper chloride, chrysocalla, Paris green, and verdigris (Lee and Quirke 2000; Scott et al. 2009). Materially, these pigments are made with similar elemental ingredients to Egyptian blue (Lee and Quirke 2000; Nicholson and Peltenburg 2000; Scott et al. 2009), which makes distinguishing blue from green an impossible task using only XRF for analysis.

A number of variables affect the appearance and elemental makeup of ancient green paints. Scott and colleagues (2009, 923) write that the identification of a green color's source pigments requires ruling out a number of possible copper compounds and ascertaining whether the green color is a degradation product of a different shade of green.

XRF tests show that the color green on Mes's coffin is due to a copper-based pigment. We cannot provide an exact source of the light green on Mes's coffin; we can only conclude that green earth can be ruled out as the pigment on this coffin because green earth does not contain copper (Lee and Quirke 2000; Scott et al. 2009).

Ankhefenkhonsu's Coffin (EX1997-24.5)

Tan Ground Layer: The sample we expected to be ground layer may be made of a calcium- and iron-rich mud or clay, based on high calcium and iron readings at that point. However, its iron content and tan coloring may indicate that it is actually a faded ochre paint.

Yellow: Yellow paint on Ankhefenkhonsu's coffin is very high in arsenic with minor amounts of sulfur and iron, and prior literature indicates that this is orpiment or a mixture of orpiment and ochre. In each sample, the amount of iron is too low to determine whether it is present primarily in a ground layer or whether orpiment was layered over a coat of yellow ochre (Lee and Quirke 2000). The amount of sulfur in these samples helps indicate orpiment as the pigment because orpiment is an arsenic sulfide. The high concentration of arsenic found on Ankhefenkhonsu's coffin would have made a powerful visual effect on the scribe figure's eyes and hands, but at least one vibrant yellow area was painted over: the left eye is painted black.

Green and Blue: In addition to the close chemical similarity between green and blue copper-based paints, described above, the literature on these pigments in ancient Egyptian decoration shows that what looks like a green color today is sometimes the degraded appearance of paint that was originally blue. Known degradation patterns of Egyptian blue inform us that it can degrade to a green, dark blue, or black color (Lee and Quirke 2000, 110).

In our study samples, dark green and light green colors read very high in copper and must have been painted in a bright blue or green copper-based paint. In fact, one dark green dot on the coffin figure's pelvis has a bright blue color showing through chips in the paint. It could be that this is Egyptian blue degraded into dark green. Another possibility is provided by the studies found in chapter 8, namely, that in at least one instance on this coffin, thin varnish applied over the pigment darkened the visual appearance of the pigment.

Meanwhile, a light green spot on the navel has cracked, and this chipped area reveals a red color beneath the light green. We do not know of a common degradation from red to light green, so we conclude that an originally red navel dot may have been painted over in a green or blue color that itself may have degraded. This over-painting technique is also found in the iris of this coffin's figure and indicates that at some point in time, at least two colors or significant body areas were over-painted on this coffin.

Arsenic: As with the 21st Dynasty coffin and Mes's coffin, it is very possible that the trace arsenic detected all over Ankhefenkhonsu's coffin lid comes from a pesticide.

Speculative Interpretations

Black Coating: The authors of chapter 8 provide a more in-depth discussion of the differences between varnish and resin. They also provide the results of analysis of one small sample (3610) that came from the black coating of the mummy with the amulet (EX1997-24.1). The authors of chapter 8 definitively rule out the presence of bitumen in sample 3610, which came from an unknown location on the mummy. Some of their tests suggest the presence of varnish, and they definitively identified organic compounds. Our testing complicates this picture.

Although the organic elements in the embalming substances of bitumen and resin are too light for pXRF used in this study to detect, prior researchers have established that there are certain inorganic elements that are not. Specifically, XRF can detect vanadium, molybdenum, nickel, and sulfur. We tested two known locations on this mummy with our pXRF, tests that covered a larger area than the 3610 sample and captured the full depth of the coating. pXRF spectra of the black coating in our study showed significant sulfur as well as trace molybdenum, vanadium, and nickel.

The distinctive combination of the trace elements molybdenum, vanadium, and nickel was not detected in any of our other tests. Found in combination they are often interpreted as diagnostic of bitumen as an embalming treatment (Kłys et al. 1999; Serpico and White 2000). In the context of a coated mummy,

this combination of elements is very unlikely to derive from any other material. Sulfur is also consistent with bitumen (Nissenbaum and Buckley 2013; Serpico and White 2000). Sulfur readings in test areas on this mummy were significantly higher than other samples in our study, and we interpret the reason to be the black coating dominating the sample areas. These findings lead us to believe that the black substance on this mummy is bitumen, used in the mummification process for this individual.

In their overview of the use of resins, beeswax, and bitumen in Egyptian mummification, Serpico and White note that use of these substances varies between mummies and through time. But most critical for the case at hand, "Samples taken from the different areas of a single body or from its wrappings may also vary in composition or in the ratio of these components" (Serpico and White 2000, 466). Thus, we do not feel that our interpretation contradicts the findings of chapter 8 for sample 3610. Taken in combination, these analyses suggest that in creating the coating on this mummy, Egyptian funerary workers utilized more than one technique and one material. This finding strikingly echoes the results of our pigment analysis.

Amulet: An interest of this study was to test the area of the amulet on the mummy's chest to try to capture any possible fluorescence from the amulet materials. Radiology tests on the mummy have established that the amulet is located 36 mm from her chest surface (see chapter 4). The penetration depth of analysis for the pXRF instruments depends on both the energy of the fluorescence photons and the matrix of the analyzed material. Fluorescence photons from zinc are lower-energy photons and thus would not be expected to travel more than 6–7 mm (Schlotz and Ulig 2006, 46) under ideal detection conditions. Because the amulet is located deeper than the pXRF can reasonably measure, it is unlikely that the fluorescence photons that were detected originated from the pXRF's beam directly hitting the amulet. But there may be another explanation, one that does have to do with the amulet. Experimental mummification following the techniques expected for the individual we tested resulted in a significant rise in the pH of mummified human flesh, from a neutral 7 to a moderately alkaline pH of 10 (Papageorgopoulou et al. 2015, 978). That pH level is just the sort of atmosphere in which zinc will slowly but consistently corrode (de la Fuente et al. 2007). It is possible that if the amulet were high in zinc and this individual was mummified using natron or other salt-rich materials (which is very likely), the zinc could begin to corrode. Resulting corrosion such as zinc chloride could leach into surrounding linen wrappings. Therefore, one source of the high zinc reading could be the layers of linen wrapping below the black coating.

Zinc is not a commonly used metal in ancient Egypt, but it has been found as a component of natural copper ores in Egypt (Ogden 2000), and the mummy's amulet spectra does show a small peak over copper (figure 7.16). However, the proportion of zinc (2%–3%) found in ancient Egyptian ores does not match the proportion found in the amulet sample (Ogden 2000). Further research and testing is needed on this object to ascertain its material makeup and the possibility of its leaching into its surrounding environment.

1997 SEM Pigment Analysis: In 1997, the Denver Museum of Nature & Science conducted a pigment analysis on Mes's coffin and the 21st Dynasty coffin. Loose and manually removed paint flakes from both coffins were sent to the US Geological Survey (USGS) center in Denver for testing using scanning electron microscopy (SEM) (Cuevas 1998; Meeker 1997). The carbon-coated samples were tested there with a JEOL 5800LV microscope "at 20keV at a working distance of 10mm" (Meeker n.d.). Reports imply that multiple test modes were used, but only "BSE" mode is named (Meeker n.d.).

Differences in testing technology (SEM versus XRF) and sampling (precise locations of SEM sampling are unknown) make it impossible to directly correlate the data gathered by researchers in 1997 and 2016. However, SEM and pXRF are similar in their ability to highlight the presence of single elements in a sample; and, importantly, SEM can detect lighter elements than XRF (such as carbon, oxygen, and sodium), which makes SEM a potentially helpful complement to an XRF study.

In several instances, SEM data clearly supported our own findings in pigment and ground layer analysis. On the 21st Dynasty coffin, we determined that the ground layer was a clay rich in iron and calcium. The SEM data support this, and those researchers proposed that gypsum, lime, salt, barium sulfate, and bone could have been additional components of the ground layer (Cuevas 1998; Meeker n.d.). We identified that black paint's high iron reading on the 21st Dynasty coffin must come from the ground layer and not the paint; SEM data corroborated this with a much higher amount of carbon than iron in their black sample, leading those researchers to propose that the black paint was made of carbon black or charcoal (Cuevas 1998; Meeker 1997). In red samples on the 21st Dynasty coffin, SEM tests support our findings that red paint on this coffin was made with an iron-rich clay or mud, that is, ochre (Cuevas 1998). On Mes's coffin, both of our teams concluded that the red paint is made with ochre (Cuevas 1998; Meeker n.d.). We concluded that the green paint on Mes's coffin is made with a copper-based pigment. SEM data support this, and those researchers suggested that copper carbonate or malachite could have pigmented the paint (Cuevas 1998; Meeker n.d.).

In other samples, the differences in detectable elements and paint sampling, combined with not knowing the SEM testing mode, made comparison more ambiguous. Where we found significant amounts of arsenic in yellow paint samples on the 21st Dynasty coffin, the SEM test did not detect any (Cuevas 1998). Where we found enough iron to comfortably identify ochre in yellow paint samples on Mes's coffin, the SEM test picked up major amounts of sulfur, leading those researchers to conclude that free sulfur was the pigment (Cuevas 1998). These comparisons did not directly support our data, but they did demonstrate that certain pigments (such as yellow) might be more varied than we could detect with pXRF. They also demonstrated that there could be unknown surface treatments on the coffins that further testing might elucidate.

LIMITATIONS

Because of concerns for their material integrity and accessibility, the analysis of items in museum collections is often opportunistic, and this work is no different. We took advantage of a day with these specimens, but more time could certainly have yielded more data. In addition, comparisons of our results with those of the analysis in chapter 8 are hampered by the limited provenience data on the samples analyzed by Price and colleagues. Similarly, our comparison of SEM data gathered from the same specimens has limited reliability because of the lack of information on the SEM research, which we only had knowledge of through brief historical documentation. The SEM results do help establish a wide boundary around the possible pigments used on two of the coffins in our study, but they could not directly strengthen our findings.

FUTURE RESEARCH

The high zinc readings resulting from X-ray fluorescence of the chest of the mummy with the black coating (EX1997-24.1) do not have an explanation supported by prior research and literature on ancient Egyptian mummification, metal use, or amulet manufacture. Any analyses to further test the pH or zinc content of the wrappings just below the coating would be invasive and thus not appropriate for a museum dedicated to the preservation of its collections. However, there appears to be little existing research about the pH of mummy wrappings and their potential effects on metallic objects included in them. This could be an area for future study of similar mummified individuals if the opportunity arose for non- or minimally destructive analysis.

Future studies on Ankhefenkhonsu's coffin could include confirming the composition of dark green, light green, and black paints on the coffin, with attention given to over-painting and copper pigment degradation.

CONCLUSION

This study's major findings were:

- Yellow is a highly variable paint color in ancient Egyptian funerary decoration. Differences exist both within and between each of the coffin sets.

- Some of the visible colors on Ankhefenkhonsu's coffin are likely the result of degradation over time, the application of a varnish, over-painting, or some combination. What appears black or dark green could once have been much brighter blues or greens made of pigments with very high copper content. Other colors on this coffin appear to be painted over—bright yellow covered with black, red covered with light green, and blue covered with dark green.

- The mummy with the amulet appears to have been treated with bitumen, likely used in combination with resin (see chapter 8).

- The amulet seen in CT scans on the mummy's chest may be the source of zinc readings in the wrappings above the amulet, and future research can help orient this unexpected finding in the existing body of knowledge on metal and amulet use in Egyptian mummification.

- It is possible that the 21st Dynasty coffin, Mes's coffin, and Ankhefenkhonsu's coffin were each treated with an arsenical pesticide.

Our results fulfilled goals to better understand funerary workshop techniques and resources, ancient Egyptian decorative paint, and what material the mummy's chest amulet might be.

The depth of information we learned speaks to the strengths of performing a materials analysis on objects with unknown or incomplete provenance. By studying materials through their primary sources—in this case, their elemental composition—we can approach the study of historical practices from a perspective that is less obstructed by what is known and more focused on what can be known. pXRF data helped us pinpoint elements and thus construct a new understanding about the materials we assumed we might find through a bottom-up approach to historical and artistic analysis. We hope the knowledge shared in this case study leads to a fuller understanding of the practices, resources, and techniques of ancient Egyptian craftspeople.

ACKNOWLEDGMENTS

The authors would like to acknowledge the Honors Program at the University of Denver (DU) for funding the rental of the pXRF unit used in this study and the National Science Foundation for its support of integrating materials science into pedagogy at DU (CCLI Grant #736977). We are especially grateful to Michele Koons, who kindly invited Clark to be a part of this exciting opportunity and also patiently shepherded this work to publication. Miller and Clark were assisted in data collection by Helena Kapuni-Reynolds and Julia Strunk, then MA students in the DU Department of Anthropology.

REFERENCES

Calza, Cristiane, Marcelino J. Anjos, Maria Izabel M.S. Bueno, Sheila Mendonça de Souza, Antonio Brancaglion Jr, Tânia A. Lima, and Ricardo Tadeu Lopes. 2007. "XRF Applications in Archaeometry: Analysis of Marajoara Pubic Covers and Pigments from the Sarcophagus Cartonnage of an Egyptian Mummy." *X-Ray Spectrometry* 36 (5): 348–54. doi:10.1002/xrs.982.

Cooney, Kathlyn. 2017. "Coffin Reuse: Ritual Materialism in the Context of Scarcity." In *The First Vatican Coffins Conference, 19–22 June, 2013: Conference Proceedings*, edited by Alessia Amenta, 101–12. The Vatican: Gregorian Museums.

Cuevas, Ephraim A. 1998. "Evaluation of SEM X-Ray Spectra: Egyptian Mummy and Coffin DMNH." Report, Denver Museum of Natural History, Denver, CO.

de la Fuente, Daniel, Juan G. Castaño, and Manuel Morcillo. 2007. "Long-Term Atmospheric Corrosion of Zinc." *Corrosion Science* 49 (3): 1420–36. doi:10.1016/j.corsci.2006.08.003.

Eveno, Myriam, Elisabeth Ravaud, Thomas Calligaro, Laurent Pichon, and Eric Laval. 2014. "The Louvre Crucifix by Giotto: Unveiling the Original Decoration by 2D-XRF, X-Ray Radiography, Emissiography, and SEM-EDX Analysis." *Heritage Science* 2 (1): 1–9. doi:10.1186/s40494-014-0017-y.

Goldberg, Lisa. 1996. "A History of Pest Control Measures in the Anthropology Collections, National Museum of Natural History, Smithsonian Institution." *Journal of the American Institute for Conservation* 35 (1): 23–43. doi:10.2307/3179936.

Innov-X Systems, Inc. n.d. "Delta HHXRF Analyzers: Limits of Detection (LODs)." Chart. http://www.xrfrentals.com/images/documents/delta_detectable_elememts.pdf.

Kłys, Małgorzata, Teresa Lech, Janina Zięba-Palus, and Józefa Białka. 1999. "A Chemical and Physicochemical Study of an Egyptian Mummy 'Iset Iri Hetes' from the Ptolemaic Period III–I BC." *Forensic Science International* 99 (3): 217–28. doi:10.1016/S0379-0738(98)00192-3.

Lee, Lorna, and Stephen Quirke. 2000. "Painting Materials." In *Ancient Egyptian Materials and Technology*, edited by Paul T. Nicholson and Ian Shaw, 104–20. Cambridge: Cambridge University Press.

Liritzis, Ioannis, and Nikolaos Zacharias. 2011. "Portable XRF of Archaeological Artifacts: Current Research, Potentials, and Limitations." In *X-Ray Fluorescence Spectrometry (XRF) in Geoarchaeology*, edited by M. Steven Shackley, 109–42. New York: Springer. doi:10.1007/978-1-4419-6886-9_6.

Meeker, Greg. 1997. "Mummies Exhibit: Samples." Report. Department of the Interior, United States Geological Survey, Washington, DC, November 14.

Meeker, Greg. n.d. "Preliminary Observations on Data Collected from DMNH Egyptian Paint Samples." Report. Department of the Interior, United States Geological Survey, Washington, DC.

Nicholson, Paul T., and Edgar Peltenburg. 2000. "Egyptian Faience." In *Ancient Egyptian Materials and Technology*, edited by Paul T. Nicholson and Ian Shaw, 177–94. Cambridge: Cambridge University Press.

Nicholson, Paul T., and Ian Shaw, eds. 2000. *Ancient Egyptian Materials and Technology*. Cambridge: Cambridge University Press.

Nissenbaum, Arie, and Stephen Buckley. 2013. "Dead Sea Asphalt in Ancient Egyptian Mummies—Why?" *Archaeometry* 55 (3): 563–68. doi: 10.1111/j.1475-4754.2012 .00713.x.

Ogden, Jack. 2000. "Metals." In *Ancient Egyptian Materials and Technology*, edited by Paul T. Nicholson and Ian Shaw, 148–76. Cambridge: Cambridge University Press.

Papageorgopoulou, Christina, Natallia Shved, Johann Wanek, and Frank J. Rühli. 2015. "Modeling Ancient Egyptian Mummification on Fresh Human Tissue: Macroscopic and Histological Aspects." *Anatomical Record* 298: 974–87. doi: 10.1002 /ar.23134.

Schlotz, Reinhold, and Stefan Ulig. 2006. *Introduction to X-Ray Fluorescence (XRF): Guide to XRF Basics*. Madison, WI: Bruker AXS, Inc.

Scott, David A., Sebastian Warmlander, Joy Mazurek, and Stephen Quirke. 2009. "Examination of Some Pigments, Grounds, and Media from Egyptian Cartonnage Fragments in the Petrie Museum, University College London." *Journal of Archaeological Science* 36 (3): 923–32. doi:10.1016/j.jas.2008.12.011.

Serpico, Margaret, and Raymond White. 2000. "Resins, Amber, and Bitumen." In *Ancient Egyptian Materials and Technology*, edited by Paul T. Nicholson and Ian Shaw, 430–74. Cambridge: Cambridge University Press.

Shackley, M. Steven, ed. 2011. *X-Ray Fluorescence Spectrometry (XRF) in Geoarchaeology*. New York: Springer. doi:10.1007/978-1-4419-6886-9.

8

It is rare that researchers in the analysis of ancient
materials explicitly address the procedural concerns
necessary for working with both destructive and non-
destructive methods. This chapter is an investigation of
four samples taken non-invasively from several coffins
housed at the Denver Museum of Nature & Science
(DMNS). The samples became separated from the
coffins during their thorough inspection and conser-
vation, as often happens in such studies. This there-
fore provided the opportunity to compare destructive
analyses with non-destructive analyses, as discussed in
chapter 7, without additional invasive sampling and
the added risk of altering the integrity of the origi-
nal object. In this examination, the authors sought to
identify the materials present in the samples as a way
of contributing to the discussion of how the coffins
were decorated. Furthermore, this chapter discusses
the usefulness and limitations of both destructive and
non-destructive analytical techniques and the proce-
dural concerns that must be considered when such
methods are applied.

Destructive techniques include, for example, gas
chromatography combined with mass spectrom-
etry (GC/MS), the taking of samples for microscopy,
and X-ray diffraction (XRD), as all of these involve
removing original material from an object and then
destroying that sample. While such methods often
result in impressive findings (Barnard 2012; Hamm et al.
2004; Serpico 2004; Stern et al. 2008), there are many

*Considerations in the
Technical Analysis
of Ancient Egyptian
Material Remains*

*Destructive and Non-
Destructive Methods*

Robyn Price,
Vanessa Muros, and
Hans Barnard

DOI: 10.5876/9781646421381.c008

139

techniques available to researchers that do not require altering the artifact in any way. Such non-destructive methods include various examination and documentation techniques, such as UV-induced visible fluorescence (UVIVF) and reflectance transformation imaging (RTI) (Alvrus et al. 2001; Piquette 2016; Thum and Troche 2016).

We seek to make accessible some of the possible methods for the analysis of all types of samples, including those that were intentionally sampled as well as those, like ours, which were gathered opportunistically from fragments that became separated from an object. Before any sampling should be considered, it is necessary first to understand how one's research question would be served by such an approach. Justifying invasive methods requires fully understanding the implications of one's research study. Thus the significance and application of a study that requires altering irreplaceable materials should be considered before embarking on any invasive or destructive technical analysis. The size of the sample to be taken, the methods chosen for analysis, and the procedure to be followed all depend on the questions asked. For example, to identify wood, ideally a sample of 0.5 cm^3 must be taken, while X-ray diffraction typically requires only a small scraping.

To use samples most efficiently and regardless of the research question, multiple methods of analysis should be employed so the greatest amount of information might be extracted from the material. Furthermore, different techniques often complement one another or reveal gaps in the data that can be filled by other methods. A well–thought-out procedure is thus required before any analysis is undertaken, as once the sample is destroyed, it can no longer be used. Thus conducting non-destructive analysis first, such as portable X-ray fluorescence (pXRF) spectroscopy or polarized light microscopy (PLM), is advisable before, for example, they are dissolved for GC/MS. In addition, it is important to continually assess the results of each technique, as it can become apparent that further non-destructive methods need to be employed to answer the original research questions.

MATERIALS AND METHODS

In early 2018, four samples were sent to the authors by DMNS. The samples had been collected from the storage containers of the artifacts under study in this publication and were not taken intentionally from any of the objects. Two of the samples (originally labeled 3610 and 3612) contained fragments of the black material applied to the exterior of the coffins and a mummy, and one of the primary goals of our analysis was to determine if this material

TABLE 8.1. General information provided by DMNS on the samples

Sample Number	Sample Description	Original Object Number	Object Description
3604	Yellow/red pigment with varnish	EX1997-24.4	Coffin (1077–943 BCE)
3607	Blue pigment with varnish	EX1997-24.5	Coffin, stylistically dates to 21st Dynasty
3610	Bitumen from mummy	EX1997-24.1	Mummy (894–825 BCE)
3612	Piece of coffin lid with bitumen	EX1997-24.4.B	Coffin (1077–943 BCE)

was bitumen.[1] Identifying thick black layers as bitumen is a common practice in Egyptology, despite a lack of scientific identification (see Clark et al. 2016, n1–3, 5). In fact, the term *mummy* comes from the Arabic word *mum*, which means "bitumen," as it was long thought that this substance was used to preserve ancient bodies (Clark et al. 2016, 2). As the other primary goal of this study, we sought to identify the materials that made up the samples labeled 3604 and 3607, which were expected to be various types of pigments and varnish (table 8.1).

Complications in the identification of materials are not limited to bitumen but also occur in the differentiation between varnish and resin. A resin is typically understood to be a viscous, lipid-soluble mixture of both volatile and non-volatile terpenoid or phenolic secondary compounds, which secrete from particular plants (Langenheim 2003, 23). This term can also be used to refer to a synthetic organic material that forms a crystalline or amorphous solid or viscous liquid (Gettens and Stout 1966). Varnish is a hardened substance made from the combination of a resin, a solvent, and sometimes an oil; it typically takes the form of a thin coating or film. It is generally transparent and can be applied to painted surfaces to protect them and to create various surface effects, such as gloss (Langenheim 2003, 375).

It is important to be clear about the terms used to describe various substances, as both words and materials elicit very specific identifications. Using terminology such as bitumen, varnish, or resin incorrectly or without adequate support can cause confusion among researchers, resulting in conflicting narratives and the diffusion of bad data. Thus a secondary goal of this chapter is

1. We retained the numbers with which the samples were labeled when they arrived to be sure of limiting any confusion in communication among the authors, museum staff, and future analyses.

to highlight the need for accurate labels of materials. For instance, one should use "thick black substance" when the analysis has not been done rather than offering "bitumen" as the final verdict until further study can be completed for material verification.

The ensuing report is organized by the procedures followed to analyze these samples. Thus this chapter suggests the order of methods for analysis of samples, beginning with non-destructive analyses and ending with the complete destruction of the samples. In each section, we cover what the methods employed accomplished, the problems and limitations associated with them, how we used them to study our samples, and the results we gleaned with each particular method. Many of the methods build off one another and we suggest that none of them be used in isolation, as information gathered from a particular step might inform the interpretation of results in later studies.

STEP 1: NON-DESTRUCTIVE ANALYSIS: VISUAL INSPECTION

The first step in any technical analysis is the visual inspection of the original object. Various simple examination techniques, such as the use of ultraviolet (UV) or infrared (IR) light, can be used to achieve a general understanding of the materials present (both modern and ancient) and the methods of manufacture. This initial observation, in combination with the research questions, will determine from where samples should be taken, if at all. Consequently, this visual examination provides context for the samples, which is instrumental to the interpretation of the data resulting from any analysis. The type of samples taken, their number, and their size all depend on the research goals and the analytical techniques that will be used.

As stated previously, the samples examined for this study were not taken intentionally, so only the general context of the object from which the samples derived was known. While this allowed for a less invasive study, it did limit the possible interpretations. We therefore began with a visual inspection of the samples to understand what types of materials we were dealing with, what research questions we could ask, and what analytical techniques could be applied. All samples were examined using a Meiji EMZ binocular microscope at 7×–45× magnification. This helped determine the surface layers, colors, construction techniques, inclusions, stratigraphy, and condition. The samples were then photographed using a Keyence VHX-1000 digital microscope to document the features and layers we had observed using the binocular microscope.

Based on this visual examination of the samples, we were able to make various preliminary observations, which helped determine the later steps. For

FIGURE 8.1. *Sample 3604 (EX1997-24.4A or B): (A) painted side; (B) reverse of sample showing earthen plaster layer.*

FIGURE 8.2. *Sample 3607 (EX1997-24.5A): (A) painted side; (B) reverse of sample showing fine, light-colored plaster layer*

example, sample 3604 had at least two distinct layers (figure 8.1A, B). The top layer was light yellow and seemingly translucent, like a resin or varnish. It was unclear whether yellow pigment was mixed into the resin or situated below this top layer. Below all this was a cream-colored surface, which, under initial scrutiny, could not be fully differentiated from the lower, coarser plaster layer that had quartz grain inclusions.

Sample 3607 consisted of only three very thin layers (figure 8.2A, B). Above the cream-colored ground layer, which seemed finer than the ground layers of the other samples, there was a blue coarse pigment layer. The top of this pigment layer was a different color, more green or green-brown in hue rather than the bright blue of the pigment. At first, it seemed to be part of the blue pigment layer and somehow discolored, not a separately applied layer of pigment. It was not initially clear if this top discoloration was due to the alteration of

FIGURE 8.3. *Sample 3610 (EX1997-24.1): (A) one side of dark resinous-looking material; (B) detail of surface showing reddish-brown fibrous or stringy-looking areas*

the blue pigment itself, a result of the application of a resinous coating, or due to the aging and alteration of the binding media used to apply the pigment (Scott 2016b).

The next sample, 3610, was a fragment of dark resinous material, possibly bitumen or resin. It seemed almost vitreous in areas, with an overall shiny appearance. Upon closer visual inspection, some sections on the surface of the sample seemed reddish-brown and fibrous (figure 8.3A, B). Bitumen is black in appearance and is characterized typically as matte and as exhibiting craquelure (Sease 1994). Thus this initial visual examination suggested to us that the sample may have been a resin or a gum rather than bitumen.

Sample 3612 was found detached by a shoulder of coffin EX1997-24.4B, whose radiocarbon dates showed a range of 398–260 BCE (see chapter 2). Our inspection of this sample showed it had several layers (from the top): (1) a black resinous material; (2) a coarse-grained blue pigment layer; (3) a thin preparatory layer between the paint layer and underlying support material, which is typically identified as a ground layer; (4) a coarser layer of plaster, likely earthen-based with wood fragments; and (5) an even coarser earthen plaster layer with quartz grains and other inclusions, including wood pieces (figure 8.4A, B). This sample also had a clear, likely synthetic resin on one end that appeared to be from a recent repair adhesive.

STEP 1A: NON-DESTRUCTIVE ANALYSIS: ULTRAVIOLET LIGHT

After initial examination with a microscope, the samples were examined using ultraviolet light to observe the UVIVF of the materials present in the samples. UV light is often used as a diagnostic tool to examine artifacts for the

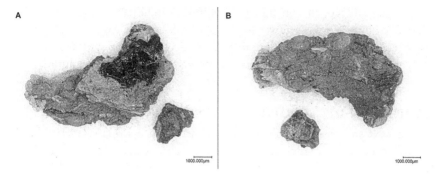

FIGURE 8.4. *Sample 3612 (EX1997-24.4A): (A) painted side; (B) reverse of sample showing earthen plaster layer.*

presence of organic binders, certain pigments, and any repairs or restoration materials. The UV light is absorbed by certain materials and reflected as visible fluorescence, and the color of this fluorescence can be indicative of certain classes of materials (de la Rie 1982).

The samples were all examined using a handheld UV lamp (λ max$_{\text{exc}}$ = 365 nm) to look for surface and material differences and whether the colors observed could be used to identify the material components. Although we could identify some difference in the materials, there were limitations to the examination. For example, the small size of the samples made it difficult to see which areas fluoresced, a phenomenon that can indicate the presence of binding media. Furthermore, although some fluorescence was observed on the samples, the colors observed did not help determine what the material might be. For example, a UV lamp can distinguish between bitumen, which does not fluoresce, and natural resins, which should. We found that the possible sample of bitumen, sample 3610, fluoresced yellow-orange in areas showing what appeared to be small orange fibers. Although indicative of not being bitumen, there are several materials that fluoresce an orange or yellow-orange color, such as shellac and natural resins like pine pitch (Measday 2017). This fluorescence, however, was inconclusive in terms of secure material identification. In chapter 3, Southward and Fletcher used UV light in their investigation of mummy EX1997-24.1, from which sample 3610 originated. They noted that parts of the mummy fluoresced "bright turquoise-blue" and then inferred that this color is indicative of a restoration treatment applied to the mummy sometime before 1982. The visual analysis of the complete object therefore helped clarify the history of our sample, although the secure identification of the material in our sample remains ambiguous.

Similar to this conclusion drawn by Southward and Fletcher, a clear resin that fluoresced blue in UV light was found in sample 3612 (EX1997-24.4.A—base) at its edge under magnification, likewise indicating that a synthetic resin or polymer had been applied during a previous conservation intervention.

STEP 2: NON-DESTRUCTIVE ANALYSIS: PXRF

The next step was to analyze the samples using a Bruker Tracer III-SD pXRF spectrometer, which can provide general information on the elemental composition of the materials present. XRF analysis (also discussed in chapter 7) is an elemental analysis technique based on the principle that when a high-energy electromagnetic beam (in this case produced by an X-ray tube) is directed toward an atom and absorbed, electrons from the inner orbital shells are knocked out. After this happens, an electron from an outer shell moves in to take the place of the displaced electron. Energy is released when an electron moves from an outer to an inner shell in the form of a photon and this energy difference is emitted as fluorescence. The X-ray photon that is emitted during this process will have a characteristic energy of a particular element, which allows it to be identified (Liritzis and Zacharias 2011).

Although XRF is a good tool for determining composition and identifying materials, there are limitations (Liritzis and Zacharias 2011; Shackley 2011; Shugar 2013). The method works best for materials that are homogeneous. Because it analyzes everything in the path of the beam, it is difficult to determine, in mixed or heterogeneous materials, which element is contributed by what part of the sample. The beam can penetrate a few millimeters into the sample depending on the parameters chosen, the effects of the matrix and elements present, and any material on the surface. In the case of our samples, in analyzing the pigmented surface, the beam of the pXRF penetrated all the layers present, likely picking up data from not only the ground and pigment layers but from the coarser plaster layers as well. This means that quantification was not possible.

Furthermore, because it is a surface technique, anything on the surface will be detected, such as soiling or any alteration of the surface (Shackley 2011; Shugar 2013). Such changes further compromise the usefulness of the spectrum produced in this analysis. Another difficulty in analyzing the samples with the pXRF instrument resulted from the fact that the samples were small and did not situate themselves well within the large (about 8 mm) detector window. Thus we were limited to analyzing the "top/obverse" and "bottom/reverse" of each sample, as attempting to study particular layers or specific areas was impossible.

These limitations were kept in mind when analyzing our samples and interpreting the data. Realizing that we could only use the pXRF to identify the overall elements present in the samples and appreciating that we would need other techniques in combination with these results to make any significant conclusions, we used parameters that would identify low, mid-range, and high Z elements. Samples were thus analyzed at 40 kV and 11 μA with no filter in air for two minutes. One area was analyzed on each side of the sample (pigment side and plaster side). Data were processed using the S1PXRF software (v. 8.3.) by Bruker AXS (table 8.2). We compared the readings for each side of the sample to check for differences or similarities in peak heights between elements. This was done to understand better which materials or layers contributed to the elements detected. The pXRF results were interpreted and the materials were identified by the elements detected, the observations made through the previous examination techniques, and published literature on the composition of Egyptian pigments and coffin construction (Genbrugge 2010; Mallinckrodt 2014; Scott 2016a).

Sample 3604 had major peaks of calcium and iron when analyzed from the bottom, thus identifying the main constituents of the ground and plaster layer(s). From the obverse, pXRF analysis indicated the presence of arsenic, calcium, and iron as the major elements. A large arsenic peak might suggest that an arsenic-based pigment was applied atop the ground layer or perhaps mixed in with the resin to create a stronger yellow color. An arsenic-based pigment would likely be orpiment (As_2S_3), but realgar (AsS) could also be a possibility.

The painted surface of sample 3607 contained significant amounts of copper and iron. The presence of copper was likely due to the blue pigment, here identified as Egyptian blue ($CaCuSi_4O_{10}$) due to its common use as a blue pigment in ancient Egypt and its relatively large grain size and coarse appearance. Azurite ($Cu_3(CO_3)_2(OH)_2$) was also a possible identification for the blue copper pigment, but this mineral was not commonly used as a pigment in ancient Egypt (Scott 2016b). Another technique, such as XRD, which we completed later in our analysis and is discussed below, was needed to securely identify which copper-containing pigment this sample contained, as pXRF can only identify the individual elements and not the compound or mineral.

The possible sample of resin, 3610, was indeed composed of organic materials. The major element detected was sulfur, with small peaks of lead and bromine, which could come from either the location where this resinous material was once presumably attached to a mummy, the application of a pesticide, or some other modern contamination.

TABLE 8.2. pXRF and XRD results

Sample/ Object Nos.	Area Analyzed	XRF Elements Detected	XRF Results	XRD Results
3604	Painted side (obverse)	Si, S, K, Ca, Ti, Cr, Mn, Fe, Ni, As, Sr, Zr	Major peaks: As, Ca, Fe More S than reverse	Calcite $CaCO_3$ (ICCD PDF#98-000-0022) Quartz SiO_2 (ICCD PDF#98-000-0088) Goethite $FeO(OH)$ (ICCD PDF#98-000-0055) Dolomite $MgCa(CO_3)_2$ (ICCD PDF#99-000-0046) Ankerite $Ca(Fe^{+2},Mg,Mn)(CO_3)_2$ (ICCD PDF#99-000-0123)
3604	Ground/ plaster side (reverse)	Al, Si, S, K, Ca, Ti, Cr, Mn, Fe, Ni, As, Sr, Zr	Major peaks: Ca, Fe Small peak of As	Calcite $CaCO_3$ (ICCD PDF#98-000-0022) Quartz SiO_2 (ICCD PDF#98-000-0088) Amesite Mg_2AlSi (ICCD PDF#99-000-0050) but also some similarities to other alumino-silicate clays
3607	Painted side (obverse)	Si, S, K, Ca, Ti, Mn, Fe, Ni, Cu, As, Pb, Sr, Zr	Major peak: Cu Large peaks: Ca, Fe Equal peaks to reverse: Pb, As	**Blue and green-brown pigment area:** Calcite $CaCO_3$ (ICCD PDF#98-000-0022) Cuprorivaite $CaCuSi_4O_{10}$ (ICCD PDF#99-000-0873) **Blue and red pigment area:** Calcite $CaCO_3$ (ICCD PDF#98-000-0022) Cuprorivaite $CaCuSi_4O_{10}$ (ICCD PDF#99-000-0873) Maghemite $Fe_{2.67}O_4$ (ICCD PDF#99-000-2215)
3607	Ground/ plaster side (reverse)	Si, P, S, K, Ca, Ti, Fe, Ni, Cu, As, Pb, Sr	Major peak: Ca Large peaks: Cu, Fe Equal peaks to obverse: Pb, As	Calcite $CaCO_3$ (ICCD PDF#98-000-0022) Quartz SiO_2 (ICCD PDF#98-000-0088)

continued on next page

TABLE 8.2—*continued*

Sample/ Object Nos.	Area Analyzed	XRF Elements Detected	XRF Results	XRD Results
3610	Organic material fragment	Al, Si, P, S, K, Ca, Ti, V, Cr, Mn, Fe, Ni, Cu, Zn, Pb, Br	Major peak: S Material is organic Small peak: Pb, Br	XRD analysis not conducted on this sample.
3612	Painted side (obverse)	Al, Si, S, K, Ca, Ti, Cr, Mn, Fe, Ni, Cu, Zn, Pb, Br, Rb, Sr, Zr	Major peaks: Fe, Cu, S Equal peaks to reverse: Pb, Br	Calcite $CaCO_3$ (ICCD PDF#98-000-0022) Quartz SiO_2 (ICCD PDF#98-000-0088) Cuprorivaite $CaCuSi_4O_{10}$ (ICCD PDF#99-000-0873) Cuprite CuO (ICCD PDF#99-000-0865)
3612	Ground/ plaster side (reverse)	Al, Si, S, K, Ca, Ti, Cr, Mn, Fe, Ni, Cu, Zn, Pb, Br, Rb, Sr, Zr	Major peak: Fe, Ca Equal peak to obverse: Pb, Br	Calcite $CaCO_3$ (ICCD PDF#98-000-0022) Quartz SiO_2 (ICCD PDF#98-000-0088) Nepheline $NaAlSiO_4$ (ICCD PDF#98-000-0083) but also some similarities to other aluminosilicate clays

The blue pigment of sample 3612 also appears to be Egyptian blue, identified for similar reasons as expressed above for sample 3607. Calcium and iron peaks were also present in this sample, as well as lead and arsenic, which were all present when the sample was analyzed both from the top and from the bottom.

There was also an intense peak for iron in sample 3612, but its source could not be identified. Because the sample was not homogeneous, iron was likely being detected as part of several different materials present in the multiple layers of this sample, such as in the earthen plaster layers. Any surface dust or soiling could also contribute iron. The iron detected in samples 3604 and 3607 could be present for similar reasons, either soiling on the surface or as a component of the plaster layers. In these two samples, the presence of iron-containing pigments in the paint layer, as discovered later using XRD and the microscopic examination of the cross-sections, might also have contributed the iron.

Furthermore, a large sulfur peak was created by the painted side of sample 3612, although it was not clear where this sulfur was located. It is possible that

resin may have been applied or mixed in with the blue pigment, which has now made it appear green-brown. The probability of this conclusion might be further substantiated by our pXRF analysis of the organic material sample (3610), which, among other elements, contained a concentration of sulfur. The lead and bromine peaks for sample 3612 were the same height on both the painted and plaster sides ("obverse" and "reverse"), suggesting it was likely from a contaminant of some kind.

STEP 3: DESTRUCTIVE ANALYSIS: XRD

Once the examination and non-destructive analyses were completed, we decided to subject the samples to various types of destructive analyses, as additional information was required for secure material identifications. The first step was to take a microsample from the samples themselves to characterize the pigments, ground/plaster layers, and any binding media present. This microsample (about 3–4 mm) was taken first before other methods of destructive analysis were undertaken that would either alter or destroy the sample and prevent any further work. By setting aside part of the sample for GC/MS, we could conduct XRD on the microsamples while preserving tiny cross-sections of the overall samples that could undergo further analysis if necessary.

XRD is a technique that identifies materials based on their crystal structure. An X-ray beam is directed at an object. The atomic and molecular structure of the object will cause this beam to diffract in specific ways. By measuring the angle and intensities of the diffracted beam and comparing them to known reference materials, it is possible to identify the minerals or compounds present in the sample. Although XRD often requires only a bit of powder from the material to function, this method works best with very crystalline, inorganic substances (Clearfield et al. 2009).

A Rigaku R-AXIS Spider powder diffractometer was used for the analysis of the pigments, ground, and plaster of the samples. The analysis was performed on each pigment, ground, and plaster layer. Then, the sample was mounted on a glass spindle using Apiezon N grease. Next, the samples were analyzed at 50 kv and 40 mA using a Cu-α target. Data were processed using Rigaku's 2D software and identified using the program Jade 8.3, which contains a database of reference spectra from the International Center for Diffraction Data (ICDD) (table 8.2).

We were able to identify several of the pigments and plaster layers using the ICDD database, although several peaks in each spectra remain unidentified, because of either the limitations of the database or the mixed nature of some of

the samples. The pigments from samples 3604, 3607, and 3612 all appear to be painted on a calcite ground or preparatory layer, as no gypsum was identified in any of the samples examined. The coarse layers beneath these calcite layers also appeared to contain calcite, although it was mixed with some type of clay.

The identification of the yellow pigment from sample 3604 was challenging at first. The XRD results for this sample did not confirm the presence of orpiment, as we suspected would be present due to the identification of arsenic by pXRF. Difficulties in identifying orpiment with XRD have been reported by other researchers, and it is likely due to either the lack of crystallinity or the low concentration of the material in the pigment layer (Scott et al. 2003, 2004).

The blue in sample 3607 was identified securely as Egyptian blue using XRD because cuprorivaite ($CaCuSi_4O_{10}$), a copper calcium silicate, was identified (Lee and Quirke 2000). The discolored green substance on the top of this pigment was not from salts or the degradation of the Egyptian blue into another green form of copper, as neither sodium chloride (NaCl) nor any of the common copper degradation products were present (Lee and Quirke 2000; Scott 2016b). It is more likely that some type of coating, varnish, or binder was added to the top of the pigment and degraded or darkened due to aging, which altered the blue color of the pigment.

In the sampling of 3607 for XRD analysis, we also noticed a small spot of red pigment underneath the blue crystals. This was sampled and analyzed, with the results showing cuprorivaite from the blue pigment, calcite from the ground layer, and maghemite (Fe_2O_3, γ-Fe_2O_3), an anhydrous iron oxide with a red to brown color (Helwig 2007). Maghemite can form from the degradation of another iron oxide compound, magnetite (Northam 2013), the dehydroxylation of clays or the iron oxide hydroxide lepidocrocite (γ-FeO(OH)) (Helwig 2007), or when other iron oxides are heated in a low oxygen environment, often with organic material present (Helwig 2007; Northam 2013). Although not as widely used as other red iron oxides like hematite, it has been found on rock art paintings (Helwig 2007), red earth samples (Helwig 2007; Northam 2013), and a fire-damaged Roman fresco (Helwig 2007).

STEP 4: DESTRUCTIVE ANALYSIS: PLM

With polarized light microscopy, one transmits plane or crossed polarized light through pigment particles to look for specific features that can characterize the particle and help identify the pigment. PLM works well with

all types of materials, including biological, (in)organic, and (non)crystalline compounds. It has been stated that PLM can be more accurate than both a scanning electron microscope (SEM) and Fourier-transform infrared spectroscopy (FTIR) (McCrone 1994). It does, however, require extensive training and much experience, as certain materials can appear to have very similar structures. Thus seeking out multiple characteristics, beyond just purely visual inspection, can help limit the number of possible interpretations.

PLM was used to identify the yellow pigment present in sample 3604, which XRD failed to do. It was suspected that the yellow pigment of this sample was orpiment because pXRF analysis showed the presence of arsenic. For this we prepared a microscope slide with a sample of the yellow pigment from sample 3604, which was dispersed in the mounting medium Cargille Meltmount (refractive index [RI] 1.662). The pigment particles were examined both in plane and with cross-polarized light using an Olympus BX-51 microscope. Some of the characteristics of the pigment particle we were looking for included birefringence (difference in refractive indices of a particle that is dependent on the direction the light passes through it), particle color, shape and relief, and its RI in relation to the RI of the mounting medium (McCrone 1982). Images were taken using a QImaging MicroPublisher 5.0 RTV digital camera and Q Capture Pro v. 5.1 software.

With this method, we confirmed that sample 3604 contained orpiment particles (figure 8.5A, B). The particle was identified based on the following criteria: coarse particle size, anhedral shape, strong birefringence with green and pink-red interference colors, high relief, and an RI higher than 1.662 (Eastaugh et al. 2008; McCrone 1982). A reference sample of orpiment pigment from Cargille's reference pigment set was used for comparison and confirmed the identification. In the microsample we took for this analysis, however, there was only a single orpiment particle found mixed in with yellow ochre. This shows that there was a low concentration of orpiment particles in the pigment, which is likely why it could not be detected by XRD. This also suggests that the yellow ochre pigment, identified as goethite with XRD (table 8.2), contributed to the iron peak in the pXRF results.

STEP 5: DESTRUCTIVE ANALYSIS: CROSS-SECTIONS

The creation of cross-sections from samples is useful for accurately identifying the layering of plaster, ground, and paint layers. Such analysis helps us understand the construction of objects. For example, with our sample, understanding the buildup of layers helps demonstrate how a coffin surface was prepared

Figure 8.5. *Plane polarized light image (A) and cross-polarized light image (B) of a pigment sample taken from 3604. The larger, anhedral-shaped particle was identified as orpiment. The clumps of rounded yellow particles are likely yellow ochre.*

and painted. In addition, prepared cross-sections make it easier to examine the material under UV light, which can reveal any organic components or binding media present in the sample and to which layers such material belongs.

We created cross-sections from the samples left over after some were set aside for GC/MS and some for XRD. We cut each with a scalpel to reveal a flattened edge, removing as little as possible to leave the stratigraphy of the layers intact. Next, these small flattened samples were embedded in Struers EpoFix epoxy resin and polished using aluminum oxide grinding paper and MicroMesh polishing sheets. The samples were ground and polished dry, without the use of water or another solvent for fear of dissolving any organic binding media that might have been present in the samples. In polishing, the goal was to expose the complete stratigraphy of the cross-section.

This method is destructive. Once the samples have been embedded in resin, they cannot be removed, thus limiting what further work can be done. For example, the synthetic resin in which the sample is embedded has the potential to interfere with any further organic material analysis such as FTIR spectroscopy. Cross-sections prepared in this way, however, can help with further analysis should the equipment be available. For example, a SEM coupled with Energy Dispersive Spectroscopy (EDS) can be used to identify inorganic inclusions at particular points in a cross-section. There are also stains that can be used in which the dye will selectively bind to certain organic materials and indicate the presence of, for example, any carbohydrates or proteins in the pigment layer, which might be indicative of the type of binder used (Sandu et al. 2012).

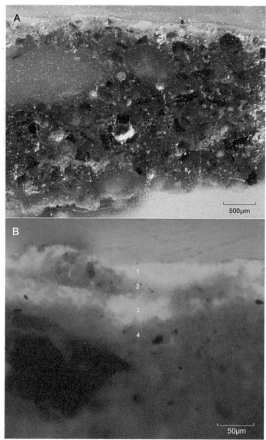

Figure 8.6. *Cross-section of 3604 showed it was made up of at least six layers (A), the top four of which were easier to see under UV light (B). The following layers were identified: (1) possible varnish layer; (2) pigment layer; (3) ground layer that appeared white under UV; (4) a coarser tan plaster layer with small aggregates; (5) a darker, coarser earthen plaster layer with larger aggregates; and (6) a bottom layer of a warmer toned earthen plaster with rounded aggregates.*

We examined our cross-sections using an Olympus BX-51 polarizing microscope with a Reflected Fluorescence System. The cross-sections were examined both in reflected light and using a fluorescence mirror unit for UV-induced visible fluorescence (excitation 330–85 nm, emission 420 nm). Images of the cross-section were taken using a QImaging MicroPublisher 5.0 RTV camera and QCapture Pro software (v. 5.1).

The results of this analysis helped solidify our understanding of the stratigraphy of the layers and allowed us to photograph them. UV light in combination with this method, as mentioned above, helped demonstrate more clearly in which layers the fluorescing compounds were present.

The cross-section of sample 3604 showed it was made up of at least six layers, the top four of which were easier to see under UV (figure 8.6A, B). From

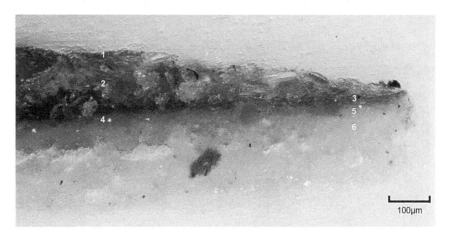

FIGURE 8.7. *Cross-section of sample 3607 showed it contained about six layers: (1) dark brown varnish layer; (2) Egyptian blue pigment layer; (3) red pigment layer; (4) dark layer of an unknown material, which could be varnish, resin, or another pigment layer; (5) yellow to light brown–colored layer, which could be the ground; and (6) layer of light-colored fine plaster.*

the top of the sample, the following layers were identified: (1) possible varnish layer; (2) pigment layer; (3) layer that appeared white under UV, which could be the ground; (4) a coarser tan plaster layer with small aggregates; (5) a darker, coarser earthen plaster layer with larger aggregates, some of which were dark brown; and (6) a bottom layer of a warmer toned earthen plaster with rounded aggregates that appeared to be quartz grains.

Under UV, the top layer of sample 3604 fluoresced a pale yellow-white (figure 8.6B). The reason for this was unclear, although it is indicative of the presence of an organic material due either to the varnish or a binder in the pigment. Since it seemed to be sitting on top of the pigment particles, it was more likely a varnish. The UV photo also assisted with making some of the pigment particles stand out in the pigment layers. Although the pigment particles could not be identified using this method, the coarser particle size of these yellow pigments could suggest that they were orpiment, as opposed to the yellow ochre or goethite particles. Orpiment must be kept coarsely ground when prepared as a pigment; otherwise, a different color effect is produced (Scott 2016b).

Sample 3607, which was extremely thin, showed possibly six layers, which were visible under both reflected and UV light (figure 8.7). We discovered that the blue crystals in sample 3607, which had a greenish-brown layer on top, were not actually altered to green but were more likely topped by a varnish,

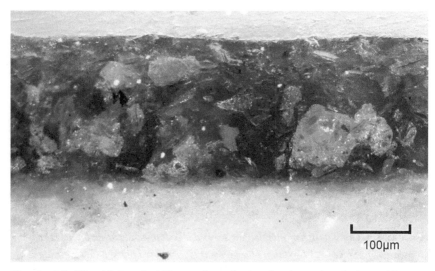

Figure 8.8. *View of the painted layers of sample 3607 showing a clear dark varnish layer on top of the coarse-grained Egyptian blue pigment layer. Some of the dark varnish is found in the pigment particles, which is likely what is causing the color change visible where the paint layer looks more green than blue. Areas where there are losses of the darker top layer on the sample show clear blue pigment below.*

which may have darkened and altered the overall color to a dark green (figure 8.8). Interestingly, a small dark line appeared on one end of the sample, which we visually identified as a red pigment under the microscope. Because the red line did not extend across the entire sample, it likely was not an over-painted area or applied under the blue for an optical effect. Its presence could be due to this sample being taken from an area near a different painted element. As the precise context of the sample is not known, this could not be confirmed. The presence of this iron oxide pigment, identified through XRD, was likely what was contributing to the intense iron peak in the pXRF results.

In this cross-section, we could also see that the Egyptian blue pigment itself was prepared differently than that used in sample 3612. Sample 3612 (figure 8.9A) showed a pigment layer that was not only thinner but consisted of more rounded Egyptian blue particles. The layer also appeared less compact and had larger clear-colored grains, which were likely the glassy phase particles often found in Egyptian blue (Lee and Quirke 200). The paint layer of sample 3607 tended to have elongated Egyptian blue particles within a blue matrix, and the pigment layer was more compact.

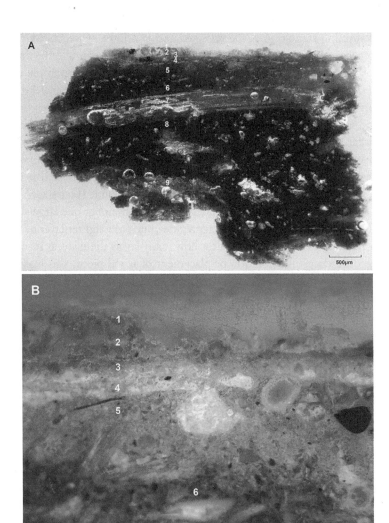

FIGURE 8.9. *Cross-section of sample 3612 showing it is composed of at least six layers. Examination of the section with reflected light (A) and UV light (B) helped clarify the first five layers. From the top: (1) a dark resin or varnish layer; (2) a pigment layer of coarse Egyptian blue particles; (3) a thin dark layer, which could either be another varnish layer or a ground layer; (4) a thin, lighter-colored layer, which could be the ground; and (5) a darker layer with small particles, such as quartz and wood fragments. Below these five layers, the stratigraphy of the sample is not entirely straightforward. It is unclear whether the rest of the sample is just one thick layer containing aggregates that include large pieces of wood or if it is composed of multiple layers.*

In examining sample 3612, the reflected and UV light helped us identify at least six separate layers of construction (figure 8.9A, B). Under UV, the first four to five layers were clearly distinguishable from the top of the sample (figure 8.9B): (1) a dark resin or varnish layer; (2) a pigment layer of coarse Egyptian blue particles; (3) a thin dark layer, which could either be another varnish layer or a ground layer; (4) a thin, lighter-colored layer, which could be the ground; and (5) a darker layer with small particles, such as quartz and wood fragment. Below these five layers, the stratigraphy of the sample is not entirely straightforward. It is unclear whether the rest of the sample is just one thick layer or if it is composed of two to four layers. The possible layers could include (figure 8.9A): (6) a darker layer with aggregates and wood, (7) a layer containing one large sliver of wood, (8) a layer of dark plaster and aggregates, and (9) a lighter layer of plaster and aggregates. As stated, it is not clear how many layers there are, as it could be that the differences in coloration or placement of wood pieces was just coincidental and a result of how the sample was taken or prepared.

Sample 3612, as well as samples 3604 and 3607, also showed a mixing of the varnish and pigment layers (figure 8.9B). It might be possible, then, to suggest that the pigment was applied mixed with the varnish or even that the varnish was applied, should it have been sufficiently liquefied, when the pigment was not yet dry. Alternatively, with the pigment being so coarse and there being very little binder between the grains, it is possible that the varnish flowed between the grains when applied.

STEP 6: DESTRUCTIVE ANALYSIS: GC/MS

GC/MS is a method of analysis that combines gas chromatography and mass spectrometry to identify organic molecules in a sample. The resolving power of gas chromatography is unrivaled by other chemical analytical separation techniques, with stereo-isomers routinely eluding off the column at different times. The accuracy and precision of modern mass analyzers is well below the unit of mass measurement (Da). In combination with the highly reproducible fragmentation of molecules after electron-impact ionization, relating to both the structure and the relative abundance of the fragments, these allow near certain identification of many compounds by electronic comparison with the mass spectra of more than 250,000 known molecules that are available in digital databases. As analysis is performed on molecules in the gas phase, the main limitation of the methods is the thermostability of the analytes. Many derivatization methods have been developed to replace active with more stable moieties, but this requires additional manipulation of the sample,

and it remains difficult to create thermostable molecules with a mass greater than around 600 Da. Another, increasingly less significant limitation is the small injection volume, typically 1 μL, of the prepared sample.

For the biochemical analysis of our samples, approximately 50 mg of each was combined with 2 mL of a mix of chloroform/methanol (2/1, v/v) in clean, marked test tubes. These were vigorously mixed on a vortex mixer (20 s), sonicated in a water bath (20 min), mixed again (20 s), and then centrifuged (1500 × g, 20 min). The supernatants were transferred into a second set of clean marked test tubes. To each of these, 2 μg (20 ng/injection) nonadecanoic acid ($CH_3(CH_2)_{17}COOH$) was added to serve as internal standard (IS). To prevent contamination, nitrile examination gloves were worn throughout sample preparation.

The four samples were dried in a vacuum centrifuge, re-dissolved in 200 μL ethyl-acetate, and transferred into autosampler champagne vials. The samples were then dried in a vacuum again, after which 100 μL benzene was added and then dried to remove the final traces of water. Next, 50 μL of a 2 percent solution of methoxylamine in pyridine was added. The vials were capped and kept at 60°C for 30 minutes to convert keto functions into their methyloxime forms. After the samples were dried in the vacuum a final time, they were re-dissolved in 50 μL ethyl-acetate and 50 μL N,O-bis-trimethylsilyl-trifluoroacetamide (BSTFA) with 10 percent trimethylsilyl-chloride (TMCS) added to convert hydroxyl, carboxyl, and amino functions into their corresponding trimethylsilyl (TMS) derivatives. The vials were then capped and kept at 60°C for 30 minutes to ensure complete derivatization.

For analysis, 1 μL of each sample was subjected to GC/MS. The sample inlet of a GC/MS instrument consists of a gas chromatograph (figure 8.10), which comprises a long, narrow glass column through which a flow of carrier gas is maintained. This column is coated on the inside with a thin layer of a viscous polymer that attracts some of the molecules in the sample. The column is in an oven whose temperature can be carefully controlled. The end of the column is connected to the ion source of a mass spectrometer. Once the sample is on the column, the mobile phase (the carrier gas) and the stationary phase (the coating inside the column) compete for the molecules in the sample. For each molecule, the outcome of this competition depends on the molecular weight of the molecule, the polarity of the molecule, and the temperature inside the column. As the temperature is slowly raised, the various components of the sample leave the stationary phase one by one and travel with the carrier gas to the end of the column and into the electron-impact (EI+) ion source of the mass spectrometer. Ionization is necessary to enable the electromagnetic

FIGURE 8.10. *Schematic overview of the combination of a chromatography* (top) *and a mass spectrometry* (middle) *array into a combined gas chromatography–mass spectrometry instrument* (bottom)

forces in the mass analyzer to manipulate the molecules and measure their mass, but it also results in fragmentation of some of the molecules. This fragmentation is highly reproducible, with the same molecule always breaking into the same fragments in the same relative ratio. This reproducibility allows the comparison of the mass spectrum generated by an unknown compound with known spectra in large digital libraries.

The instrument used for this project was the Thermo Q Exactive hybrid quadrupole-orbitrap GC/MS purchased by the UCLA Pasarow Mass Spectrometry Laboratory through NIH SIG grant 1S10OD018227-01A1. The autosampler injector port (250°C) was connected to a bonded-phase non-polar fused silica capillary column (50 m × 320 μm; 0.25 μm film thickness). The column was eluted with ultra-high-purity helium (constant flow, 1.2 mL/min). The oven was held at 50°C for 3 minutes following injection in split-less mode, then raised 5°C/min to 350°C and kept at that temperature for

another 10 minutes, resulting in a total run time of 63 minutes. The end of the column, a transfer line at 250°C, was inserted into the electron-impact source (200°C, 70 eV) of an orbitrap mass spectrometer scanning from m/z 50–700 (automatic gain control target 1 × 106, maximum inject time 200 msec, resolution 60,000 full-width-at-half-maximum). Data were collected and visualized using Thermo Xcalibur Qualbrowser (version 4.0.27.10) software supplied by the instrument manufacturer and analyzed by comparing unknown spectra with those in the NIST 2014 Mass Spectral Library (Barnard 2012; Barnard and Eerkens 2017; Barnard et al. 2016; Nigra et al. 2015). An orbitrap is an ion trap mass analyzer consisting of an outer barrel-like electrode and a coaxial inner spindle-like electrode that traps ions in an orbital motion around the spindle. The current generated by the trapped ions is detected and converted into a mass spectrum by Fourier transformation of the frequency of the signal.

The output of a GC/MS instrument is a combination of a single chromatogram (current versus time), created by gas chromatography, and many mass spectra (relative abundance versus mass-to-charge ratio), created by the mass spectrometer. Each peak in the chromatogram represents a molecule in the sample, and a mass spectrum can be created for each of these peaks. With specialized software, mass spectra of the unknown compounds in the sample can be compared electronically with the spectra of known compounds in a digital library. This usually leads to the identification, with a high degree of certainty, of many of the components in most of the samples.

None of our four samples contained a broad or distinctive suite of small organic molecules (figures 8.11–8.14). Samples 3604, 3607, and 3612 appeared to contain mostly hexadecanoic and octadecanoic acid, which are common saturated fatty acids and not indicative of their source. These could have been introduced into the samples at any moment, including during handling in modern times. In addition to hexadecanoic and octadecanoic acid, sample 3610 did contain several dicarboxylic fatty acids, including adipic, azelaic, glutaric, pimelic, subaric, and succinic acid, which are likely oxidation products of longer unsaturated fatty acids. Such unsaturated fatty acids are more likely components of the original ancient materials or to have been introduced by their manipulation a significant time ago. This sample also preserved a suite of saturated and mono-unsaturated fatty acids, including dodecenoic, hexacosanoic, lignoceric, tetracosanoic, and petroselinic acid, all present in low abundances (figures 8.14–8.15), as well as glycerol, which once likely combined such fatty acids into mono-, di- or triglycerides (fats). No di- and triterpenoids, indicative for natural resins (Modugno et al. 2006; Stern et al. 2003), or steranes or terpenes, indicative for bitumen (Connan 1999; Harrell and Lewan 2002),

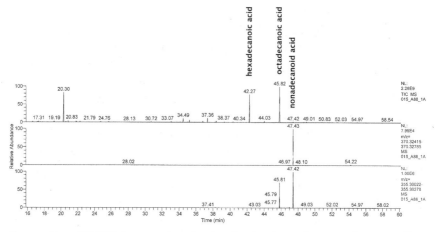

FIGURE 8.11. *GC/MS chromatogram showing the abundance of compounds converted into TMS derivatives by treatment with BSTFA in sample 3604. The chromatographic peak at 47.43 results from 20 ng of nonadecanoic acid added as internal standard.*

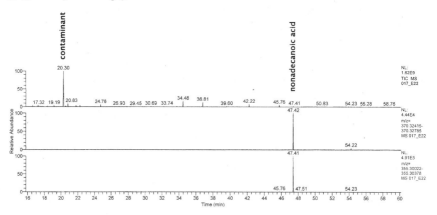

FIGURE 8.12. *GC/MS chromatogram showing the abundance of compounds converted into TMS derivatives by treatment with BSTFA in sample 3607. The chromatographic peak at 47.42 results from 20 ng of nonadecanoic acid added as internal standard.*

were found in any of the samples. In conclusion, no molecular evidence was found that the samples were derived from bitumen or natural resins. Based on these results, three of the samples (3604, 3607, and 3612) appear not to contain organic compounds, which would be expected in common binders or resins, while the fourth (3610) likely comprised unsaturated fatty acids present in, for instance, vegetable oils or animal fats.

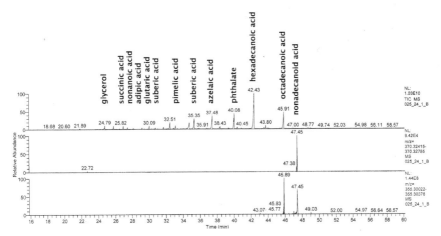

FIGURE 8.13. *GC/MS chromatogram showing the abundance of compounds converted into TMS derivatives by treatment with BSTFA in sample 3610. The chromatographic peak at 47.45 results from 20 ng of nonadecanoic acid added as internal standard. Adipic, azelaic, glutaric, pimelic, subaric, and succinic acid are dicarboxylic fatty acids and likely oxidation products of longer unsaturated fatty acids.*

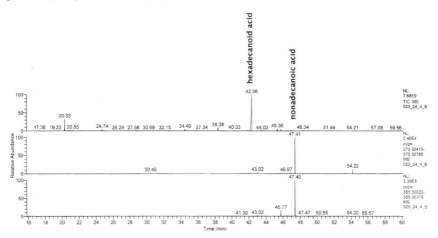

FIGURE 8.14. *GC/MS chromatogram showing the abundance of compounds converted into TMS derivatives by treatment with BSTFA in sample 3612. The chromatographic peak at 47.41 results from 20 ng of nonadecanoic acid added as internal standard.*

The results of the GC/MS analysis are particularly noteworthy as the other techniques we employed, such as examination with UV fluorescence and pXRF, suggested the presence of organic molecules in at least samples 3610

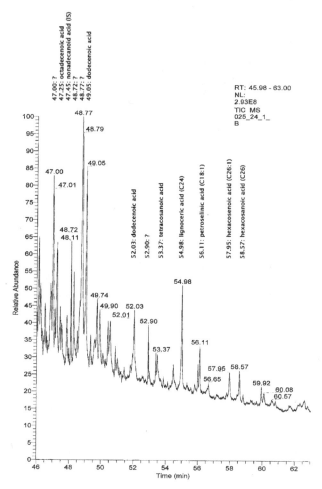

FIGURE 8.15. *Partial GC/MS chromatogram (46–63 min after injection) of sample 3610, showing the compounds that elude after the last large peak (octadecanoic acid). Dodecenoic, hexacosanoic, lignoceric, tetracosanoic, and petroselinic acid are long saturated or mono-unsaturated fatty acids.*

and 3612. These were tentatively interpreted to include resinous materials, but the GC/MS results demonstrated them to be mostly fatty acids. It is possible that the absence of terpenoids from natural resins in three of the four samples is due to the complete degradation of these compounds, the amount of these molecules below the level of detection, or the organic compounds being lost

during the extraction and sample preparation procedures (Hamm et al. 2004). Alternatively, although unlikely and contrary to our earlier suppositions, sample 3610 may not have originally been a resin but rather some organic material exuded from the mummy and its wrappings in antiquity. This interpretation could explain why the sample was largely composed of unsaturated fatty acids and their degradation products (Brettell et al. 2017). Regardless, these results further stress the importance of using multiple techniques for investigation, a thorough understanding of original context and collection history of the object, as well as a rigorous visual examination prior to sampling and analysis.

CONCLUSION

In this chapter we have sought to demonstrate the advantages and limitations of various analytical techniques for mixed organic and inorganic materials. Such an investigation was meant to demonstrate the importance of starting any analysis with a clear research question and procedural plan that exploits any samples collected to their fullest extent. As can be seen by our examples, it is possible that results of certain methods require that other analytical techniques be completed to identify the components fully. For example, we hypothesized that the yellow pigment in sample 3604 contained orpiment, but neither visual inspection nor pXRF nor XRD could confirm this suggestion. While we could have stopped there and concluded that there was no orpiment and that the arsenic must have been a later contaminant, this would have been incorrect. PLM was able to identify with certainty the presence of orpiment particles within a larger matrix of yellow ochre.

Furthermore, it is important to recognize the necessity of recording context when intentionally sampling an object. As noted throughout this discussion, understanding the context of the samples would have improved our ability to make precise, concrete conclusions. Nevertheless, studies like this are useful and can be employed in situations where object sampling is unfeasible. For example, museums are frequently unwilling to allow sampling due to the fragility of objects and the invasive and destructive nature of some of these investigations. Samples, however, can also be created unintentionally during handling or due to imperfect storage conditions and should not be ignored. Although perhaps not acquired under perfect conditions, samples like these are still valuable and can contribute significantly to our understanding of various artifacts while also demonstrating the importance of additional controlled testing. Because these samples were found detached from the original objects by the DMNS conservators when the objects were removed from display in

2016, the exact location on the object from which the samples came is unknown. Nevertheless, we were still able to conduct a number of important analyses to better understand the identification of materials used for coffin construction and mummification, in addition to the technological steps of manufacture.

The limitations we faced did not prevent us from addressing the question posed at the beginning: whether the black material could be identified as bitumen. Despite the previous assumption that bitumen was present, we were able to show that neither sample 3610, from mummy EX1997-24.1, nor sample 3612, from coffin EX1997-24.4, contained bitumen. Although we can tentatively suggest that this material was instead a resin, we remain unable to identify the material definitively. Furthermore, in chapter 7, Cundiff, Clark, and Miller used pXRF on mummy EX1997-24.1 from which sample 3610 originated. In their analysis, they detected significant amounts of sulfur, as well as trace amounts of molybdenum, vanadium, and nickel. The combination of these elements is considered diagnostic of bitumen. As stated in their chapter, it is possible that the application of materials to the mummies might vary across a single surface; and so our tests, which suggest that this material is not bitumen, do not contradict their analysis. Rather, such findings might suggest that more than one material or technique was used in the preparation of the black substance. While it is disappointing that the results are not conclusive, the combination of the two approaches used in these studies demonstrates the necessity of conducting multiple tests at several points on an object, as materials are rarely homogeneous.

The significance of our analyses lies in their ability to demonstrate the often incorrect assumption that any black material covering coffins or mummies is wholly bitumen. Therefore, this substance, its materiality, and its possible trade, technology, and religious connections clearly require further attention and additional, accurate analysis. This project as a whole is meant to demonstrate not only the variety of tools available for the analysis of mixed material samples but also the importance of procedural considerations when working with both destructive and non-destructive methods of analysis. A strong research question and clear procedure, as well as the use of accurate designations in identifying materials, are all crucial elements to the execution of any well-developed research project.

ACKNOWLEDGMENTS

The authors wish to express their sincerest gratitude to the Cotsen Institute of Archaeology, the Pasarow Mass Spectrometry Laboratory, the Nano and

Molecular Archaeology Laboratory, and the Department of Materials Science and Engineering, all at UCLA, and to the UCLA/Getty Conservation Program Training Laboratories at the Getty Villa, as well as to Kym F. Faull, PhD.

REFERENCES

Alvrus, Annalisa, David Wright, and Charles F. Merbs. 2001. "Examination of Tattoos on Mummified Tissue Using Infrared Reflectography." *Journal of Archaeological Science* 28 (4): 395–400.

Barnard, Hans. 2012. "Results of Recent Mass Spectrometric Research of Eastern Desert Ware (4th–6th Centuries CE)." In *The History of the Peoples of the Eastern Desert*, edited by Hans Barnard and Kim Duistermaat, 271–81. Los Angeles: Cotsen Institute of Archaeology.

Barnard, Hans, and Jelmer W. Eerkens. 2017. "Assessing Vessel Function by Organic Residue Analysis." In *The Oxford Handbook of Archaeological Ceramic Analysis, edited by Alice M. W. Hunt*, 625–50. Oxford: Oxford University Press.

Barnard, Hans, Sneha Shah, Gregory E. Areshian, and Kym F. Faull. 2016. "Chemical Insights into the Function of Four Sphero-Conical Vessels from Medieval Dvin, Armenia." *Muqarnas* 33: 409–19.

Brettell, Rhea, William Martin, Stephanie Atherton-Woolham, Ben Stern, and Lidija McKnight. 2017. "Organic Residue Analysis of Egyptian Votive Mummies and Their Research Potential." *Studies in Conservation* 62 (2): 68–82.

Clark, Katherine, Salima Ikram, and Richard Evershed. 2016. "The Significance of Petroleum Bitumen in Ancient Egyptian Mummies." *Philosophical Transactions of the Royal Society A* 374 (2079): 1–15.

Clearfield, Abraham, Joseph Reibenspies, and Nattamai Bhuvaesh. 2009. *Principles and Applications of Powder Diffraction*. Malden, MA: Blackwell.

Connan, Jacques. 1999. "Use and Trade of Bitumen in Antiquity and Prehistory: Molecular Archaeology Reveals Secrets of Past Civilizations." *Philosophical Transactions of the Royal Society of London: Biological Sciences* 354: 33–50.

de la Rie, E. Rene. 1982. "Fluorescence of Paint and Varnish Layers (Part I)." *Studies in Conservation* 27 (1): 1–7.

Eastaugh, Nicholas, Valenntine Walsh, Tracey Chaplin, and Ruth Siddall. 2008. *Pigment Compendium: A Dictionary and Optical Microscopy of Historical Pigments*. Oxford: Butterworth Heinemann.

Genbrugge, Siska. 2010 "Technical Examination of a Ptolemaic Mummy Cartonnage: Analysis and Stabilization of Its Flaking Arsenic Containing Paint Layer." MA thesis, University of California at Los Angeles.

Gettens, Rutherford J., and George L. Stout. 1996. *Painting Materials: A Short Encyclopedia*. New York: Dover.

Hamm, Sandrine, Jean Bleton, and Alain Tchapla. 2004. "Headspace Solid Phase Microextraction for Screening for the Presence of Resins in Egyptian Archaeological Samples." *Journal of Separation Science* 27: 235–43.

Harrell, James A., and Michael D. Lewan. 2002. "Sources of Mummy Bitumen in Ancient Egypt and Palestine." *Archaeometry* 44: 285–93.

Helwig, Kate. 2007. "Iron Oxide Pigments: Natural and Synthetic." In *Artists' Pigments: A Handbook of Their History and Characteristics, vol. 4*, edited by Barbara Berrie, 39–110. Washington, DC: National Gallery of Art.

Langenheim, Jean H. 2003. *Plant Resins: Chemistry, Evolution, Ecology, and Ethnobotany*. Portland, OR: Timber Press.

Lee, Lorna, and Stephen Quirke. 2000. "Painting Materials." In *Ancient Egyptian Materials and Technology*, edited by Paul T. Nicholson and Ian Shaw, 108–11. Cambridge: Cambridge University Press.

Liritzis, Ioannis, and Nikolaos Zacharias. 2011. "Portable XRF of Archaeological Artifacts: Current Research, Potentials, and Limitations." In *X-Ray Fluorescence Spectrometry (XRF) in Geoarchaeology, edited by M. Stephen Shackley*, 109–42. New York: Springer.

Mallinckrodt, Casey S. 2014. "Technical Analysis of a Ptolemaic Child Sarcophagus and the Identification of Ancient and Modern Reuse." MA thesis, University of California at Los Angeles.

McCrone, Walter C. 1982. "The Microscopical Identification of Artists' Pigments." *Journal of the International Institute for Conservation–Canada Group* 7 (1–2): 11–34.

McCrone, Walter C. 1994. "Polarized Light Microscopy in Conservation: A Personal Perspective." *Journal of the American Institute for Conservation* 33 (2): 101–14.

Measday, Danielle. 2017. "A Summary of Ultra-Violet Fluorescent Materials Relevant to Conservation." Australian Institute for the Conservation of Cultural Material. https://aiccm.org.au/national-news/summary-ultra-violet-fluorescent-materials-relevant-conservation.

Modugno, Francesca, Erika Ribechini, and Maria Perla Colombini. 2006. "Aromatic Resin Characterisation by Gas Chromatography–Mass Spectrometry: Raw and Archaeological Materials." *Journal of Chromatography A* 1134: 298–304.

Nigra, Benjamin T., Kym F. Faull, and Hans Barnard. 2015. "Analytical Chemistry in Archaeological Research." *Analytical Chemistry* 87: 3–18.

Northam, Janice K. 2013. "Red Ochre: An Archaeological Artifact." MA thesis, Ball State University, Muncie, IN.

Piquette, Kathryn E. 2016. "Documenting Early Egyptian Imagery: Analysing Past Technologies and Materialities with the Aid of Reflectance Transformation Imaging

(RTI)." In *Préhistoires de l'écriture: iconographie, pratiques graphiques et émergence de l'écrit dans l'Égypte prédynastique*, edited by Gwenola Graff and Alejandro Jiménez Serrano, 87–112. Aix-en-Provence: Presses universitaires de Provence.

Sandu, Irina C.A., Stephen Schäfer, Donata Magrini, Susanna Bracci, and Cecilia A. Roque. 2012. "Cross-Section and Staining-Based Techniques for Investigating Organic Materials in Painted and Polychrome Works of Art: A Review." *Microscopy and Microanalysis* 18 (4): 860–75.

Scott, David A. 2016a. "Egyptian Sarcophagi and Mummies in the San Diego Museum of Man: Some Technical Studies." *Studies in Conservation* 63 (4): 215–35.

Scott, David A. 2016b. "A Review of Ancient Egyptian Pigments and Cosmetics." *Studies in Conservation* 61 (4): 185–202.

Scott, David A., Megan Dennis, Narayan Khandekar, Joy Keeney, David Carson, and Lynn Swartz Dodd. 2003. "An Egyptian Cartonnage of the Graeco-Roman Period: Examination and Discoveries." *Studies in Conservation* 48 (1): 41–56.

Scott, David A., Lynn Swartz Dodd, Junko Furihata, Satoko Tanimoto, Joy Keeney, Michael R. Schilling, and Elizabeth Cowan. 2004. "An Ancient Egyptian Cartonnage Broad Collar: Technical Examination of Pigments and Binding Media." *Studies in Conservation* 49 (3): 177–92.

Sease, Catherine. 1994. *A Conservation Manual for the Field Archaeologist*. Los Angeles: Cotsen Institute of Archaeology Press.

Serpico, Margaret. 2004. "Natural Product Technology in New Kingdom Egypt." In *Invention and Innovation. The Social Context of Technological Change 2: Egypt, the Aegean, and the Near East, 1650–1150* BC, edited by Janine Bourriau and Jacke Phillips, 96–120. Oxford: Oxbow.

Shackley, Michael S. 2011. "An Introduction to X-Ray Fluorescence (XRF) Analysis in Archaeology." In *X-Ray Fluorescence Spectrometry (XRF) in Geoarchaeology*, edited by Michael S. Shackley, 7–44. New York: Springer.

Shugar. Aaron N. 2013. "Portable X-Ray Fluorescence and Archaeology: Limitations of the Instrument and Suggested Methods to Achieve Desired Results." *Archaeological Chemistry VIII* 1147: 173–93.

Stern, Ben, Carl Heron, Lorna Corr, Margaret Serpico, and Janine Bourriau. 2003. "Compositional Variations in Aged and Heated *Pistacia* Resin Found in Late Bronze Age Canaanite Amphorae and Bowls from Amarna, Egypt." *Archaeometry* 45: 457–69.

Stern, Ben, Carl Heron, Tory Tellefsen, and Margaret Serpico. 2008. "New Investigations into the Uluburun Resin Cargo." *Journal of Archaeological Science* 35: 2188–2203.

Thum, Jen, and Julia Troche. 2016. "Visitor as Researcher: Making Archaeology More Accessible with Broken and Unprovenienced Objects." *Advances in Archaeological Practice* 4 (4): 537–49.

9

Artistic and Textual Analyses of the Third Intermediate Period Coffins at the Denver Museum of Nature & Science

Kathryn Howley,
Caroline Arbuckle
MacLeod, and
Pearce Paul Creasman

The traditional approach to the study of Egyptian coffins is based on an examination of their decoration and inscriptions. The combination of significant and subtle changes in style and paleography over time can be used to date coffins with a degree of certainty, often to a specific dynasty or even to the reign of a single pharaoh (cf. Willems 1988; Niwiński 1989). Aligning these studies with scientific analyses, such as carbon 14 dating (see chapter 2), can produce more precise dates for the decoration, allowing stylistic features to be used for comparative chronological study with greater confidence. The combination of multiple dating methods provides a much more stable base on which to ground chronological interpretations. The figures, symbols, and texts illustrated on the surface of the coffin also reveal information about changing religious practices and political transitions. It is possible to see how different deities and funerary texts changed in popularity over time, for instance. In the early Third Intermediate Period (ca. 1069–664 BCE), as noted in the introduction to this volume, Egyptian society was marked with political instability and uncertainty. The coffin became the focus of the funerary arts, and the density and variety of decorations significantly increased. The proliferation of spells and the *horror vacui* demonstrated by the cramped illustrations reflect the discomfort felt by the population at a time of social unrest as they attempted to incorporate as many protective symbols and texts as

DOI: 10.5876/9781646421381.c009

possible (Cooney 2011, 5; Niwiński 1989, 92; Taylor 2010a, 235). By the end of the 22nd Dynasty, however, access to imported, prestigious, and freshly cut timber resources may have been renewed, and decoration techniques became less cramped and complex (Taylor 2003, 103). The additional analyses of wood and construction (in chapters 5 and 6, this volume) complement this image of social and political fluctuations. The following analysis of the decoration of three Third Intermediate Period coffins in the Denver Museum of Nature & Science (EX1997-24.5; EX1997-24.4; EX1997-24.2) provides another vital source of evidence for understanding life and society in Egypt at this crucial point in its history.

COFFIN LID EX1997-24.5: ANKHEFENKHONSU, PRIEST OF AMUN AT KARNAK, 21ST DYNASTY

Artistic Analysis

The lid of coffin EX1997-24.5 is anthropoid in shape, revealing the basic outline of a mummified individual (figure 9.1; for an unedited image of the coffin lid, see chapter 2, figure 2.5). The face and hands are the only elements carved in detail. The shoulders and the subtle representation of elbows and legs, however, are apparent in the overall shape. The background of the lid is yellow, with decorative elements and figures painted in green, blue, black, and red. Much of the figural decoration is raised in plaster. A layer of yellow varnish is still visible on the face, wig, hands, and the area of the knees of this lid. Toward the broken foot end, the decoration is faint or erased entirely, suggesting that it was once subjected to water damage. The shape and decoration of the coffin are typical of those made in Thebes during the 21st Dynasty.

The face of this coffin includes modeled ears protruding from a blue-and-yellow-striped *nemes* wig that terminates in yellow bands, with a lotus flower depicted at the top of the head (figure 9.2). A broad floral and geometric collar stretches from the neck to just below the elbows. The carved hands have been added below the wig, on top of the collar, in the form of clenched fists. Below the collar are horizontal registers of figures followed by vertically composed panels of additional decoration. These panels consist largely of winged goddesses, scarab beetles, solar disks, offering scenes, and hieroglyphic emblems (described below). Virtually all the space has been filled with decoration. Dividing these panels are columns of text written both vertically and horizontally, while additional vertical columns of text line the outer edges of the lower half of the lid, although the decoration toward the feet is heavily damaged.

The modeled ears and red, clenched hands, in addition to the painted black chin strap, indicate that this lid was made for a male owner (see also Taylor 2001, 170). It is likely that a modeled false beard was once present, though it no longer remains. The size and style of the collar, the modeling of only the hands with no reference to the arms, the high concentration of decoration, and the layout of the figural decoration place this coffin lid within Niwiński's type III-a (1988, 69, 76; comparative examples include Vienna 6268; Cairo JE29663; Cairo JE29665). Niwiński (1988, 69) suggests that this style of decoration can be dated primarily to the middle and late 21st Dynasty, under the reign of Pinudjem II and the pontificate of Psusennes.

Region 1 (figure 9.1: 1) is the first register of decoration below the floral collar (figure 9.3). At the center of this register, a central scarab beetle is shown pushing a solar disk upward. Cobras with Isis-knot emblems hanging from their bodies link their tails into this solar disk. Moving outward, there are mirrored arrangements of figures. Toward the proper left of the coffin[1] a mummified figure crowned with a solar disk, likely a representation of a solarized Osiris, sits on a throne. In front of this figure

1. The term *proper left/right* refers to the mummy or coffin's point of view, not the viewer's, and is used to avoid confusion.

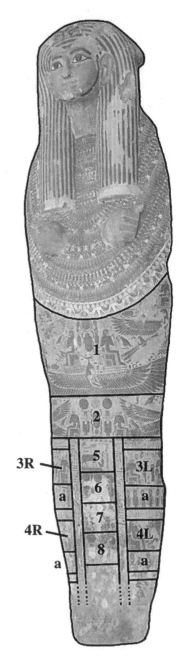

FIGURE 9.1. *Decoration of EX1997-24.5*

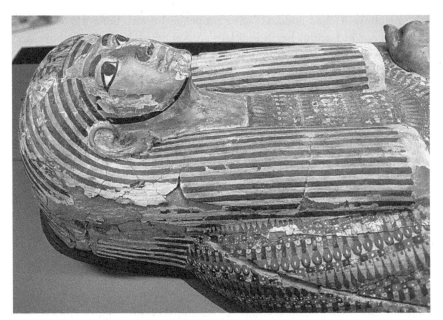

FIGURE 9.2. *Face of coffin lid EX1997-24.5*

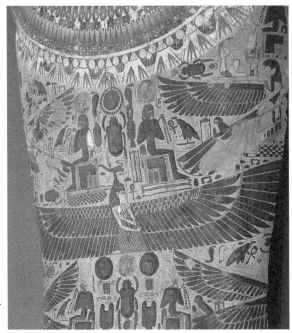

FIGURE 9.3. *Abdomen of coffin lid EX1997-24.5*

is a crouching winged goddess facing proper right with her wings and arms stretched out in front of her. She is labeled Nephthys. In front of, above, and below her wings are smaller figures that include vultures, a symmetrical pair of seated gods (likely representing Osiris), scarabs, jackals, and shrines. These likely serve a protective function and the compositional task of filling space. To the proper right side of the central scarab is a similar arrangement of figures, except that the crouching winged goddess faces proper left and is labeled *ḫntt št3*, an epithet for Isis (see below). The presence of the winged goddesses Isis and Nephthys is related to the Osirian myth cycle. They were believed to have helped protect Osiris after his death and during his rebirth and thus are appropriate figures for the decoration of coffins.

This busy decoration rests on an image of a single kneeling goddess, her wings spread across the front of the coffin. Although the sky goddess Nut usually inhabits this position on Theban coffins of the 21st Dynasty, the scorpion head-dress worn by this figure indicates that she is a different deity. The figure is labeled with a shortened form of the name of Isis, a goddess who was often syncretized with Nut since both were considered mother goddesses (Bergman 1980, 196–97). Although the scorpion is a symbol more often associated with the goddess Selket, Isis often took on the iconography of Selket and therefore also her protective qualities, especially on coffins (Bergman 1980, 197; Goyon 1978; von Känel 1984, 832). Scorpion goddesses were not uncommon on coffins of the Third Intermediate Period (e.g., Gasse 1996, cat. 37, 13), since dangerous animals such as the scorpion were believed to have apotropaic power (Wilkinson 1994).

In region 2 (figure 9.1: 2; visible in figure 9.3), another scarab with a solar disk is depicted in the center, holding a protective *shen* disk between its lower legs. Here, the scarab is framed by a pair of *sistra*, rattles in the shape of the cow-eared goddess Hathor that were used to placate the gods in temple ritual. To either side is a seated figure of Osiris wearing the white crown. On the proper left, another winged goddess facing right crouches before Osiris with her wings outstretched. On the right side of the coffin is another partially broken goddess, facing left. Again, smaller emblems fill the remaining space around these larger figures.

In the damaged, vertically arranged panels of decoration below regions 1 and 2, only a few of the vignettes can be discerned (figure 9.4). It seems likely from what remains that there were originally at least three panels in the outer left and right sections, although only two now remain on each side (figure 9.1: 3R, 3L, 4R, 4L). In these side sections, each panel seems to have contained two seated gods, each receiving offerings from a goddess—Nephthys in 3L and 4L and probably Isis in 3R and 4R. In 3L, a third broken seated royal figure is still

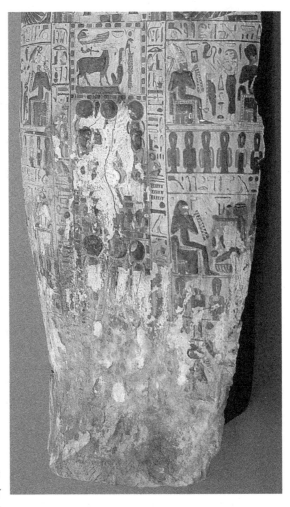

FIGURE 9.4. *Legs of coffin lid EX1997-24.5*

visible. Bands of inscription and friezes of Isis knots (marked with "a" in figure 9.1) separate the panels from each other.

The only complete panel in the center (figure 9.1: 5) shows a ram on a pedestal standing before a crouching demon whose head is depicted in the form of a *maat*-feather. In front of the pedestal is a standing figure of Hathor wearing a horned solar disk crown. Above the ram is an image of a winged cobra holding an *ankh*, the Egyptian hieroglyph meaning life. The ram is likely a reference to Amun, who often appears in ram form. Below this group of figures, the central panels (figure 9.1: 6, 7, 8) are largely destroyed,

but rows of three scarabs holding solar disks can be confidently reconstructed in regions 6 and 8.

The decoration of this lid mixes solar and Osirian motifs, related to the "solar-Osirian unity" that had become central to funerary religion by this time (Niwiński 1989). The emblems that fill the small spaces left between the figures were intended to protect the deceased and the mummy. The offering scenes also helped to ensure that the gods would accept the deceased in the underworld and guaranteed that his rebirth would go smoothly. While the lid in general is an excellent example of classic 21st Dynasty coffin style, the presence of Isis in scorpion guise as the central figure represents an interesting interpretation of the themes of protection that structured coffin decoration at this time.[2]

Textual Analysis

In common with many other coffins of the 21st Dynasty, the use of text on the lid of Ankhefenkhonsu's coffin is limited in comparison to the pictorial decoration. The main sections of text appear in two vertical columns that run from the knees to the ankles, in short horizontal strips that demarcate the vignettes on the side of the legs, and in a long column on the proper right side of the coffin, running along the base edge of the lid from below the broad collar to the ankles. Short labels are also included in the vignettes, naming some of the deities depicted, with single hieroglyphs used to fill empty spaces in the composition and act as protective signs. Increasing the visual integration of the text with the pictorial decoration is the use of the same colors (green, black, and red) for the hieroglyphic writing as for the vignettes: many signs are polychromatic and have their internal details delineated, lending the inscriptions on this lid an appealingly detailed appearance.

Due to damage around the base of the lid, the inscription on the proper left edge of the coffin is no longer present. Water damage at the foot end of the coffin has also obscured the readings of several passages. Despite the damage, enough remains of the text to tell us that this coffin lid belonged to a man named Ankhefenkhonsu. He holds several titles that indicate he was a priest of Amun-Re at Karnak, the largest temple at Thebes. Some of these titles specify the temple itself (*Ipt-swt* in Egyptian), while others, such as "opener

2. The interiors of the lids of all three coffins mentioned in this discussion could not be viewed. Prior to the 2016 study, probably during one of the previous conservation efforts (see chapter 3), the lids had been placed on supportive foam and wood mounts, which cover any possible interior decoration. Museum staff, in discussion with conservators, concluded that the objects were too fragile for these mounts to be removed.

of the doors of heaven," do not contain geographic information but are known only from Theban sources (Ritner 2009, 27). The texts therefore allow us to uncover some of the personal details of the owner of the coffin and confirm stylistic evidence that the deceased lived in Thebes during the 21st Dynasty.

The inscriptions on lid EX1997-24.5 do not relate to the pictorial content of the vignettes (with the exception of the deities' name labels). Rather, the deceased's name and titles are listed, with short formulae used to conveniently fill spaces between vignettes. These inscriptions, although not alluding to any particular religious text, demonstrate the relationship between the deceased and various gods and enumerate offerings to his spirit that would ensure a successful afterlife. The inscriptions thus reflect the identification of the deceased with the divine that characterized the funerary beliefs of this time period (e.g., Taylor 2000, 359; 2010c, 19).

Scene Below Collar: Text in region 1 is restricted to labels that name the deities depicted. As noted above, the winged figure on the proper left of the lid is identified as Nephthys, while that on the right, representing Isis, is given the epithet *ḫntt št3*, "foremost of secrets." This epithet, most common during the Third Intermediate Period, is attested only on coffins and may therefore have had some special funerary significance; although it is most frequently applied to Osiris, other deities (as here) do sometimes bear this title (Leitz 2002–3, 866). The central winged figure is labeled with a shortened writing of the name Isis (Allen 2010, 433). Other textual elements in this scene include repeated use of the shrine hieroglyph and an *ankh* sign before the face of the central figure of Isis. These signs are not necessarily intended to be read but rather are a way to fill the blank spaces of the composition with signs that had a protective function.

Vignettes on Side of Legs: The goddesses offering to the seated god in vignettes 3L and 4L are labeled Nephthys. Those on the right (3R and 4R) are not labeled but are probably to be understood as representing her sister Isis. Individual hieroglyphs representing "West" (i.e., the land of the dead, *imntt*), "underworld" (*dw3t*), "lord" (*nb*), and "tree" (*im3*) appear, again both to fill spaces in the composition and to offer protection.

Vertical Text Columns: The central column of decoration on the legs of the coffin lid is flanked by two columns of text. These inscriptions identify the deceased as Osiris and give his name and titles. The bottom half of the inscription has been damaged and is now illegible.

Right-Hand Column

ḏd-mdw in n [sic] Wsir ḥm-nṯr ḥry-sšt3 n Imn m Ipt-swt
Words spoken by the Osiris, the priest, the chief of secrets of Amun in Karnak

wnn ꜥꜣw nw pt m (?) tꜣ ḏr . . . [*damage*]

The one who opens the doors of heaven, in the land of . . . [damage]

Left-Hand Column

ḏd mdw in Wsir ḥm-nṯr n Imn-Rꜥ nswt-nṯrw

Words spoken by the Osiris, the priest of Amun-Re, king of the gods,

sš . . . nw . . . n pr-Imn ꜥnḫ-[f]-n-ḫnsw . . .

the scribe . . . of the temple of Amun, Ankhefenkhonsu . . . [damage]

Formulae on Right Side of Coffin: These short formulae all begin with the phrase *imꜣḫy-ḫr nṯr-ꜥꜣ*, "honored before the great god," intended to situate the deceased in proper relationship with the divine. The particular god is not specified on this coffin (although Nephthys and Isis are often named on other examples [Aston 2009, 281]), but in each case the formula is followed by an epithet or offering. The brevity of these formulae made them excellent space fillers between vignettes on coffins, and this is where they usually occurred, as indeed they do here. Because of the damage to Ankhefenkhonsu's coffin lid, the ends of these formulae are now lost.

imꜣḫy-ḫr nṯr-ꜥꜣ m-ꜥ (?) nbw d . . .

The one honored before the great god, in the hand of the lords [?] . . .

imꜣḫy-ḫr nṯr-ꜥꜣ ḫꜣ pꜣwt (?) nbt . . .

The one honored before the great god, 1,000 of every offering cake . . .

[imꜣḫ]y-ḫr . . .

The one honored before the great god . . .

Formulae on Left Side of Coffin

imꜣḫy-ḫr nṯr-ꜥꜣ d nbt imnty nfry . . .

The one honored before the great god, may the mistress of the beautiful West give . . .

imꜣḫy-ḫr nṯr-ꜥꜣ w[?] nb dwꜣt . . .

The one honored before the great god . . . the lord of the underworld

Long Column Inscription on Left Edge: This long column of inscription that runs along the left edge of the coffin lid would originally have had a counterpart on the right side of the lid, now lost. The left side edge is also damaged, with approximately half of the left-most signs missing, as well as the end of the column; however, the formulaic nature of the text, in which the name and

titles of the deceased are given along with a wish for offerings for his spirit, means that the inscription is still quite legible.

ꜣḫ ḫwt ḥm-nṯr n Imn-Rꜥ nswt-nṯrw ḥry-sštꜣ m pt . . .
The effective spirit, the priest of Amun-Re, king of the gods, the chief of secrets in [illegible place name]

wnn ꜥꜣw nw pt n ipt swt
The one who opens the doors of the sky in Karnak

mḥ-ib ꜥꜣ n nb=f ꜥnḫ=f-n-ḫn-[sw] mꜣꜥ-ḫrw
One who is greatly trusted by his lord, Ankhefenkhonsu, true of voice

d=sn prt-ḫrw kꜣw ꜣpdw ḫwt nbwt [nfrwt]
May they give invocation offerings: cattle, fowl, and all [good] things

COFFIN EX1997-24.4: 21ST OR 22ND DYNASTY

LID

Coffin lid EX1997-24.4B has been crafted to resemble the mummified form of the deceased (for a full image of the coffin, see chapter 2, figure 2.4). As discussed in chapter 5, the body of the coffin has been carved to include the shape of the head, face, shoulders, and elbows and very slight modeling of the legs. The feet are not modeled but are represented by an angled footboard. Hands had been carved and attached to the coffin, lying flat across the breast, but are no longer extant. The ground of the coffin has been painted yellow, with added figures and decorative elements painted in black, blue, red, yellow, and white. Parts of the coffin have been covered with a layer of varnish followed by a thick black layer that conceals much of the underlying decoration.

The face of the coffin (figure 9.5) has been carved without ears. It is shown wearing a wig and a winged headdress with a large representation of a lotus flower at the forehead. The lappets of the wig are gathered on each side, wrapped in red and yellow bands. An elaborate collar with floral and geometric motifs stretches down below the elbows of the coffin, finishing in florets and lotus flowers. Red leather braces have been painted on top of the collar. The braces cross at the chest and end just short of the collar. These are outlined in yellow and terminate in yellow ends. The flat hands that were once attached on top of the breast are evidenced by the negative impression left in the plaster and paint and by the remaining dowels. Below the collar are the remnants of figural decoration. The figures are shown largely in busy horizontal bands that demonstrate the *horror vacui* common in coffins from the 21st and 22nd Dynasties. Much of the decoration below the collar, however, has either fallen

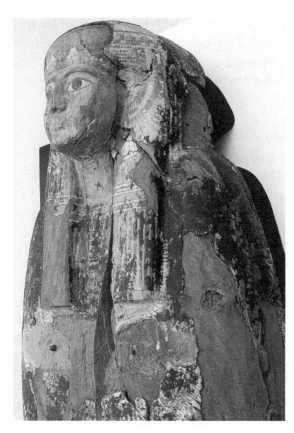

FIGURE 9.5. *Face of coffin lid EX1997-24.4B*

off the coffin or is concealed by the final black coating. Nevertheless, images of red solar disks, scarabs, winged female figures, and bearded males are still partially visible. Some of these details have been applied in raised relief created out of thick plaster and layers of paint. Bands of fragmentary texts are visible in vertical columns down the side edges of the coffin and over the feet.

The lack of added ears and beard, along with the flat hands, indicates that this coffin was made for a woman. The representation of the red braces that cross in front of the chest has given coffins decorated in this style the name "stola coffins" (Van Walsem 1997, 116–17). This, along with the length of the collar and the high concentration of figural decoration, places this coffin firmly within Niwiński's type V (1988, 80; comparative examples include Cairo 26201; Antwerp 79.1.465 AV; Cleveland CMA 14.714). Stola coffins of this type are dated to the late 21st or 22nd Dynasties. The occurrence of diagnostic names on several comparable examples has led Niwiński (1988, 80–81) to suggest a

date for this style of decoration between Psusennes's pontificate and the reign of Osorkon I. The radiocarbon date of the coffin dowels fits within this time period (see chapter 2), suggesting that the decoration of the coffin, along with the final stages of construction, dates to the late 21st or early 22nd Dynasties.

The braces were a significant addition to the development of Third Intermediate Period coffins. Van Walsem (1997) has shown that the earliest representations of stolae are found in the 12th Dynasty and reserved for mummiform deities. The use of the stola on the coffins of individuals in this period thus suggests that the mummy was believed to have obtained divine status (van Walsem 1997, 116–19, 350). It has been suggested that coffin owners in the 21st and early 22nd Dynasties were particularly interested in displaying an array of religious knowledge and that this may even have served as a form of competitive display among the elite. This could be accomplished by including not only scenes from the Book of the Dead, which had been available to non-royal individuals from the beginning of the New Kingdom, but also scenes from the *Amduat* and underworld texts that had once been reserved for royalty (de Araújo Duarte 2014; Taylor 2003, 104).

The damage to the images and the added black layer prevents a full description of the decoration, although a few key elements can be identified. A scarab beetle pushing a solar disk, visible just below the floral collar, is a representation of the god Khepri, the manifestation of the sun god at sunrise. Its presence on the coffins is a reference to the concept of rebirth, a central belief of ancient Egyptian religion. If the deceased individual received the correct funerary rites, he or she would become an "Osiris" and thus be identified with the god of the dead. Osiris was believed to travel through the underworld and unite with Re to be reborn as his manifestation, Khepri, at the beginning of each new day. This rebirth was the goal of each deceased individual (Sousa 2014, 104; van Walsem 1997, 149). Below the scarab is the depiction of a crouching goddess with her wings spread wide across the coffin. Since the top half of this figure is covered by the black layer, it is impossible to see her headdress or any labels that might have accompanied the image; however, she is likely to be Nut, the most common goddess to be depicted in this context (Sousa 2014, 101). Nut was the mother of Osiris. The underworld route through which Osiris traveled was often identified with the body of Nut, who would therefore give birth to Khepri at dawn. Due to this belief, Nut is frequently connected to the coffin. In this manner, the coffin can be seen as a vehicle of rebirth, or the womb of Nut (Taylor 2001, 164; 2010b, 93–98). Below the winged Nut on EX1997-24.4B are partially concealed images of seated Osiride figures, again a reference to the Osirian myth cycle.

Case

The coffin case, EX1997-24.4A, also retains the basic form of a body, with the shape of the head, shoulders, elbows, and legs easily identifiable. As with the lid, much of the blue, red, yellow, white, and black decoration has either worn away or is covered over with the black layers. The visible decoration is divided into two registers (see figure 9.6). The top register consists of a frieze of alternating *uraei* and *maat*-feathers. In the lower frieze are panels of decoration separated by columns of text. As with the lid, the spaces around the figures have been filled with smaller illustrations and designs. Unfortunately, the decoration is very difficult to see in photographs.

The layout of the decoration seen on this coffin case places it within Niwiński's type B. This is the most common type found in 21st and early 22nd Dynasty coffins and therefore offers only a loose dating within this time period (Niwiński 1988, 87, 89); nevertheless, this date range aligns with that provided by the decoration of the lid and the radiocarbon dates.

The *uraei* and *maat*-feather frieze is a variation on a design derived from the representations of kiosks in which kings and gods are shown (van Walsem 1997, 181, type If, fig. 351). The presence of designs derived from architecture and scenes from tomb and temple walls may be a reference to the fact that the coffin took over many of the previous religious functions of the tomb in this period (van Walsem 2014, 19). Other vignettes found on the case also had their origins on tomb and temple walls and thus also helped emphasize the new religious role of the coffin.

The partial concealment of the scenes by the black layer permits description of only a few areas of decoration. Starting from the proper left side, near the foot of the case, the image of Hathor in the form of a cow emerging from the western mountain is visible and is likely a reference to the Book of the Dead spell 186 (figure 9.6; outlined in red). This depiction is found frequently on 21st Dynasty coffins from Thebes (for example, Florence 2157; London BM EA6666; Swansea W1982) and helps suggest that Thebes was the original burial location for this coffin. Liptay (2014) has discussed the symbolism of this episode. Not only does it allow the coffin owner to demonstrate his or her devotion to this powerful protective goddess by referencing her sanctuaries on the western hillside of Thebes, but it also suggests the idea of movement and the passage from the earthly to "otherworldly territories." It also likely alludes to the movement of the coffin itself through the western hills on its way to burial (Liptay 2014, 71–74). To the left of the mountain in this example is also the large hieroglyph *imnetet* "West," leaving no doubt as to the location of these hills and a reference to the land of the dead.

FIGURE 9.6. *Cow goddess (red) and architectural feature (blue), coffin case EX1997-24.4A*

To the proper left, moving toward the head of the coffin, is a three-register representation of an architectural feature, perhaps meant to be an altar or a temple or tomb wall (figure 9.6, outlined in blue). The lowest register consists of a yellow, red, and white-checkered *neb*-basket. The central register is badly obscured by the black layer. On the coffin's right side, however, a very similar vignette has been drawn. In this version, the central register consists of an Isis knot at the center, with a *djed* pillar, *ankh*, *mut* vulture, and a *uraeus* on either side. The top register consists of rows of striped blue, red, and green columns and may represent a cavetto cornice.

Moving to the proper left, again badly obscured, is what appears to be an upright coffin before an offering table. This might be a representation of this coffin itself, receiving the offerings that kept the deceased sustained in the afterlife.

Next to this vignette is another large *imnetet* hieroglyph surmounted by a solar disk. To its right is a winged scarab beetle with another solar disk above its head and a *shen* ring between its back legs. Below the scarab is a representation of a shrine. On either side of this image are two mummified figures with false beards kneeling on *neb*-baskets.

The next visible scene toward the head shows a figure, possibly the deceased, with hands raised in adoration before a second figure seated on a chair atop a plinth. Although there are columns of text labeling this image, they are illegible.

A gap in the black layers at the left shoulder of the coffin shows the heads of two figures beneath a solar disk. Further toward the head are more coffins in front of offering tables and large emblematic hieroglyphs surmounted by solar disks, including *sekhem* and *djed*. The decoration at the very top of the head no longer remains.

Continuing along the coffin's right side, below the head, the case begins with a rather broken area, leading into a series of vignettes showing coffins

FIGURE 9.7. *Coffin stands before seated figures, coffin case EX1997-24.4A.*

or mummified figures standing before seated figures (figure 9.7). In one case, the seated figure appears to be Re or a solarized Osiris, an anthropomorphic figure with a sun disk on his head, while in another, the jackal god Anubis is shown. Once again, these blocks of vignettes are divided by columns of text and large emblematic hieroglyphs.

Just below the coffin's shoulder, a new vignette appears. Although the majority of the image is too badly obscured to interpret, the top of the panel displays two semicircles side by side, consisting of alternating bands of blue, red, green, and yellow. Comparisons with the decoration of other coffins from this period (see, for example, van Walsem 1997, pl. 7) suggest that altars or shrines may be represented here.

Continuing toward the feet is a three-registered image similar to that seen on the proper left side of the coffin. In this version, the bottom register consists of rectangular patterns often seen at the base of walls. Toward the foot of the coffin is a final seated crowned figure before an offering table. Facing this table, the feet of a coffin or mummified figure can be seen. Finally, the decoration is completed by a second representation of the Theban hills and a large *imnetet* hieroglyph.

The interpretation of coffin case EX1997-24.4A is complicated since much of the decoration has been rendered fragmentary by damage from the black coating, but the overall meaning can be understood, if not the specific details. Most coffin cases from this period are decorated with scenes that originated

on tomb and temple walls. The combination of vignettes was usually associated with burial preparations and the tasks that ensured that the deceased would be equipped for their rebirth in the afterlife (de Araújo Duarte 2014; Liptay 2014, 76). This example is no exception. As noted above, the scene of Hathor coming forth from the mountain is related to the geographic location of the burial and the rites with which it was associated. The numerous offering scenes on the coffin most likely aim to ensure that the deceased is equipped with the appropriate objects and to propitiate the gods to ensure that the coffin owner reaches the afterlife safely. The hieroglyphic emblems used include the Isis knot, *djed*, *ankh*, *sekhem*, and *mut*. Each of these emblems also existed in the form of amulets that were used for protection and power (for example, New York MMA 25.3.169, MMA 74.51.4479). The appearance of the signs on the coffin likely had a similar function.

The stola and other profusely decorated yellow coffins are not seen after the introductory years of the 22nd Dynasty (van Walsem 1997, 357), when a rather sudden shift toward much more simplified decoration occurred. At this time, there was a transition to the use of cartonnage as the inner wrapping of the mummy, as opposed to linen wrappings. Cartonnage enabled far more elaborate decoration than linen wrappings, so it was perhaps not considered necessary to have additional complicated decorations on the outer wooden coffins. It is possible that this simplification was a strategic decision instigated by the incoming Libyan rulers to limit the competitive religious display associated with the previous style. This may have helped curtail the power and influence of the Theban priests who were in control of these practices. It is possible that they were also able to reinitiate trade relations with the Levant to once again obtain high-quality raw materials for the coffins and therefore wanted the bare wood to be visible (Taylor 2003, 103; van Walsem 1997, 361–62; see also chapter 5, this volume). Whatever the motivation (and it is likely a combination of elements), by the second half of the 22nd Dynasty most wooden coffins received comparatively little decoration other than the face, wig, and collar, with just one column of text. The decoration on the cartonnage became focused on figures, which grew in size, while the addition of space-filling emblems was drastically reduced. The vignettes were also simplified and seem to be drawn mostly from the Book of the Dead (Taylor 2003, 103–4, 108). These processes represent the end of the competitive display of religious knowledge, almost certainly related to the contemporaneous curtailing of the priesthood of Amun. The stola coffin EX1997-24.4 belonged to the last iteration of the complicated yellow designs.

COFFIN EX1997-24.2A AND B: MES OF THE 25TH DYNASTY

Artistic Analysis

The lid of coffin EX1997-24.2A is anthropoid in shape (figure 9.8; for an unedited image of the coffin, see chapter 2, figure 2.2). The head and face are carved, and the shoulders are defined. The arms and elbows are not shown in either the form of the coffin or its decoration. A subtle distention toward the feet of the coffin suggests the definition of the calves and lower legs. A footboard is present, but the feet are not modeled. The face of the coffin is painted red, with large eyes simply rendered in black and white. The nose and mouth are modeled, as are the ears that protrude from a blue, yellow, and red striped wig. A hole under the chin indicates that a false beard was once present. A floral collar stretches from the neck to the chest of the coffin. Registers of figures and columns of text decorate the lower sections of the piece. The background of the coffin has been painted yellow, and the added decoration is light blue, red, green, yellow, white, and black. The choice of vignettes, style of decoration of the coffin, and the orthography of the text all suggest it should be dated to the 25th Dynasty.

Below the collar in region 1 (figure 9.8) is a winged solar disk, around which two cobras have wrapped their tails. The wings stretch across the

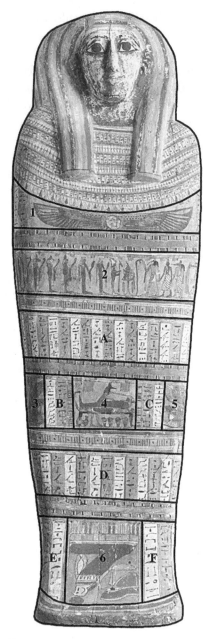

FIGURE 9.8. *Decoration of coffin lid EX1997-24.2A*

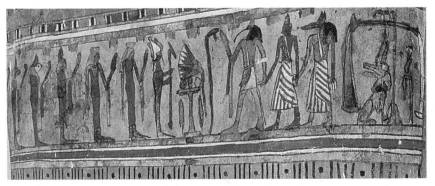

FIGURE 9.9. *Weighing of the heart scene, coffin lid EX1997-24.2A*

chest of the coffin. A decorative frieze separates the winged disk from the next register of figures. Here (figure 9.8, 2) the artist has painted a "weighing of the heart scene," a common vignette from spell 125 of the Book of the Dead (figure 9.9; Hornung 1999, 19). The weighing scales are visible only on the proper left side. Beneath the scale sits a creature called *Ammit* ("the Devourer"), who ate the hearts of those found unworthy. To the viewer's left, the god Anubis is shown. He holds hands with a human figure depicted with red skin, representing the deceased owner of the coffin. Both Anubis and the deceased are wearing white kilts with red stripes. Holding the man's other hand is Thoth. These two gods lead the coffin owner toward an offering table topped with a lotus flower and a row of gods shown in mummified form. The first god is Osiris, lord of the dead. Behind Osiris is a selection of the deities who serve as the tribunal that judges the dead during the weighing of the heart. Spell 125 was a particularly popular choice of text, and the text, accompanying vignette, or both appeared on tomb walls, papyri, amulets, coffins, and other objects from the New Kingdom onward (Stadler 2008, 2). It is often depicted in this manner on coffins from the 25th and 26th Dynasties (Jørgensen 2001, 30, 208; Copenhagen Æ 1522).

Below this central vignette are columns of offering texts, translated below. From these, the name of the coffin owner, *Mes*, can be discerned. Below these texts are three additional vignettes (figure 9.8: 3–5). In the center (figure 9.8: 4) is a depiction that likely derives from spell 154 of the Book of the Dead. The mummy of the deceased is shown lying on a lion-headed couch, beneath which can be seen a group of four canopic jars (figure 9.10). Anubis is attending the mummy, stretching out his hand over the face of the deceased. The spell itself was meant to ensure that the mummy was properly embalmed so

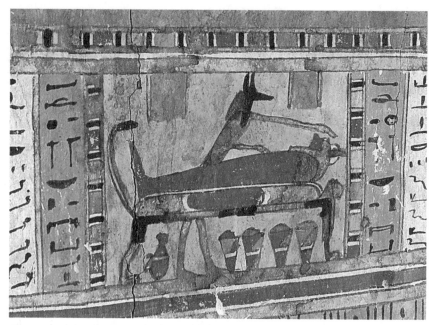

FIGURE 9.10. *Vignette from spell 154, on coffin lid EX1997-24.2A*

the soul could pass successfully into the afterlife. The two vignettes on either side (figure 9.8, 3, 5) show the winged falcon Horus with a sun disk on its head and a *wadjet* eye between his wings. The texts make it clear that this is specifically Horus the Behdedite, the aspect of the god associated with the midday sun and a form of Horus seen frequently on coffins in this period (Jørgensen, 2001: 210; Copenhagen Æ 1522).

Another register of text follows, reaching to the ankles, where the angled footboard begins. The decoration on the footboard (figure 9.8: 6), consisting of an image of a mummified falcon and an additional *wadjet* eye, is inverted when compared with the rest of the illustration so it appears the right way up when viewed by the deceased. On either side of the vignette are additional columns of text that ask Horus the Behdedite for offerings.

In comparison with the coffins from the 21st and early 22nd Dynasties, the decoration on this coffin of Mes is ordered and precise. The emblematic "filler" hieroglyphs and protective symbols are largely gone. While there is still less empty space than seen in the composition of most coffins from the New Kingdom, the *horror vacui* of the early Third Intermediate Period is no longer evident.

Coffin case EX1997-24.2B retains the same basic shape in outline as the lid: the head and the suggestion of shoulders are present, and the sides are straight, leading down to a flat base (for image, see chapter 2, figure 2.2). Both sides of the exterior are decorated in a similar manner. The artist applied a whitewashed background and then added a column of text. The text is oriented as if the coffin were standing on its feet, with the scribe writing vertically starting from the head. On each side, three concentric borderlines were drawn around the columns in yellow, red, and yellow. No other decoration has been applied. The script is written in this manner because the coffins were intended to stand upright during the funeral ritual. In the New Kingdom, coffins were frequently depicted standing, either before mourners or while priests performed the Opening of the Mouth ceremony on them. Coffins from later periods (such as this) even include a built-in pedestal to stabilize the standing coffin. The direction of the text on this coffin case reminds us of the active role coffins played in display and ceremony.

The interior decoration of the coffin case consists largely of three deities with additional hieroglyphs and solar imagery, again on a whitewashed background. On the interior base of the case is a large image of Ptah-Sokar-Osiris, a mummified falcon-headed god who was very popular at the time (Taylor 1989, 56). On the proper left of the coffin is an image of Isis and on the right, Nephthys. At the foot, a protective *shen* ring was drawn, and above the head, the artist has drawn an image of the horizon, the *akhet*. Hieroglyphs near the head read "Behdedite," referencing Horus of Behdet.

Several coffin cases are remarkably similar to this example. That of Neskhonsupakhered in the British Museum (EA47975), for example, has all the same elements. However, for Mes's coffin, the solar symbol at the head is of a solar disk with *uraei*, a standard emblem of Horus of Behdet and probably connected to the "Behdetite" label written elsewhere on the object. The *akhet* above the head is also more crudely drawn than the gods on the coffin base and so may indicate the work of a less experienced artist. Nevertheless, the themes of the coffin case decoration again speak to religious concepts surrounding the rebirth of Osiris and the protection of the deceased in his coffin.

From the decoration alone, the coffin can be dated to between the 25th and 26th Dynasties. Coffins from this period are often constructed from superior materials to those of the 21st and 22nd Dynasties (see chapter 5) and are decorated with Book of the Dead spells 125 and 154, the winged solar disk, and columns of texts whose hieroglyphs are drawn with relatively simple black lines rather than detailed illustrations (Taylor 2003, 113–19; see for comparison,

London EA6672; London EA22814; Copenhagen Æ 1522). The radiocarbon dates for the coffin place its construction between 787 and 556 BCE, supporting the stylistic evidence (see chapter 2). Edoardo Guzzon suggests a specific date of just after 715 BCE based on the coffin's archaeological context (see chapter 2), which would place the coffin squarely within the 25th Dynasty. While style and radiocarbon dates can provide much in the way of general information, this example shows the value of the entire archaeological context and of multidisciplinary study (e.g., Manning et al. 2014), which permits narrower chronological interpretations.

Textual Analysis

The text on coffin EX1997-24.2 consists only of offering formulae and therefore bears no relation to the vignettes on the lid, which show the weighing of the heart and the embalming of the deceased. Instead, the inscriptions link the deceased to Osiris and then enumerate an extensive offering list that will ensure a successful afterlife. The text includes no titles for Mes beyond standard religious epithets, but the names of his mother, Taheryefhes, and father, Horwedja, are included. When originally interred, Mes likely had three coffins: an outer rectangular case known as a *qrsw* coffin, an anthropoid middle coffin (of which this coffin is probably an example), and an inner cartonnage. The religious texts that had come back into fashion in the 25th Dynasty (most often Book of the Dead spells 125 and 154, the vignettes of which are illustrated on this coffin) would have appeared on the outer coffin, while the middle coffin most often bore offering formulae in vertical columns, just as Mes's does (Aston 2009, 281). The writing of the name of Osiris provides further, orthographic support to the dating of this coffin: the use of the divine pennant as a determinative for the god's name, as seen on Mes's coffin, has been convincingly shown by Leahy (1979) not to have been introduced until the 25th Dynasty.

The text on the coffin of Mes is written in a heavily cursive style and in black paint, typical of 25th Dynasty coffins (Taylor 2003, 113–19). It is arranged in four registers on the main body of the coffin lid: flanking the winged sun disk and above, beside, and below the central embalming vignette. Further text appears on the feet in an inverted orientation, an arrangement intended to show the text in the correct position when "viewed" by the deceased. Two further columns of text appear painted on the sides of the case of the coffin, now a faded green color.

COFFIN LID[3]

Texts Flanking the Winged Sun Disk (same on each side)

bḥd.ty nṯr ꜥ3 nb pt di=f ḥtpw

The Behdedite [Horus], great god, lord of the sky, may he give offerings.

Text on Torso, above Embalming Vignette (figure 9.8: A)

ḥtp-di-nsw n wsir ḫnty imnt.t nṯr ꜥ3 nb 3bḏw Gb iry-pꜥ nṯrw wsir wn-nfr ḥḳ3
ḏt di=f pr-ḫrw t ḥ3 m k3w ḥ3 m 3pdw ḥ3 m snṯr ḥ3 m mnḫt ḥ3 m irp ḥ3 m irtt
ḥ3 m ḫt nb[t] nfr[t] wꜥb[t] ḥ3 m ḫt nb[t] nḏm bnr n k3 [n] wsir ms m3ꜥ-ḫrw
nb im3ḫ [ḫ]r nṯr ꜥ3 nb pt s3 ḥr-wḏ3 m3ꜥ-ḫrw nb im3ḫ [ḫ]r . . .

An offering that the king gives to Osiris, foremost one of the West, the great god,
lord of Abydos, [and to] Geb, the prince of the gods, [and to] Osiris *Wennefer*,
lord of eternity. May he give offerings, bread, 1,000 oxen, 1,000 fowl, 1,000
incense, 1,000 linen, 1,000 wine [jars], 1,000 milk [jars], 1,000 of everything
good and pure, 1,000 of everything sweet and delicious to the spirit [of the]
Osiris, Mes, true of voice, lord of honor before the great god, lord of the sky,
son of Horwedja, justified, lord of honor before . . .

Texts Flanking Embalming Vignette (figure 9.8: B and C)

bḥd.ty nṯr ꜥ3 nb pt di[=f] ḥtpw nbw ḏf3w . . .

The Behdedite (Horus), great god, lord of the sky, may [he] give all the offerings
and food . . .

bḥd.ty nṯr ꜥ3 nb pt di=f ḥtpw nbw ḏf3w . . .

The Behdedite (Horus), great god, lord of the sky, may he give all the offerings
and food . . .

Text Below Embalming Vignette (figure 9.8: D)

ḥtp-di-nsw n wsir ḫnty imnt.t nṯr ꜥ3 nb 3bḏw di.f ḥtpw nbw ḏf3w nbw ḥ3 m
ḫt nbt nfr wꜥb, ḫt nb nḏm bnr n k3 [n] wsir ms m3ꜥ-ḫrw (nb) im3ḫ [ḫ]r ꜥ3
nṯr nb pt s3 [n] ḥr-wḏ3 m3ꜥ-ḫrw [nb] im3ḫ [ḫ]r nṯr ꜥ3 nb pt Mwt=f nb[.t]
pr t3-ḫry.f-ḥs m3ꜥ[.t]-ḫrw

An offering that the king gives to Osiris, foremost one of the West, great god,
lord of Abydos. May he give all the offerings and all the food, 1,000 of every-

3. The following translations have been prepared with reference to the notes of Edoardo
Guzzon of the Museo Egizio di Torino, who provided an initial evaluation for the
Denver Museum of Nature & Science (on file at DMNS; Michele Koons, personal
communication, October 17, 2016).

thing perfect and pure, everything sweet and delicious to the spirit [of] the
Osiris Mes, true of voice, [lord of] honor before the great god, lord of the sky,
son of Horwedja, true of voice, [lord of] honor before the great god lord of the
sky, whose mother is the mistress of the house Taheryefhes, true of voice.

Text on Feet (figure 9.8: E and F)

bḥdt nṯr ꜥ3 nb pt di=f ḥtpw nbw ḏf3w nbw ḫt nb[t] nfr[t] wꜥb[t] ḫt nb[t] nḏm
bnr nb (?)

The Behedite (Horus), the great god, lord of the sky. May he give all offerings
and all food, everything good and pure, and everything sweet and delicious

bḥdt nṯr ꜥ3 nb pt di=f ḥtpw nbw ḏf3w nbw ḫt nb[t] nfr[t] wꜥb[t] . . .

The Behdedite (Horus), great god, lord of the sky, may he give all offerings and
all food, everything good and pure . . .

COFFIN CASE

ḥtp-di-nsw n wsir ḫnty imnt.t nṯr ꜥ3 nb 3bd.t di=f ḥtpw nbw n k3 [n] wsir ms
m3ꜥ-ḫrw

An offering that the king gives to Osiris, foremost one of the West, great god,
lord of Abydos. May he give all offerings (to the) spirit (of) the Osiris Mes,
true of voice.

ḥtp-di-nsw n wsir ḫnty imnt.t nṯr ꜥ3 nb 3bd.t [di]=f ḥtpw nbw ḏf3w [n] k3
wsir ms . . .

An offering that the king gives to Osiris, foremost one of the West, great god,
lord of Abydos, [may] he [give] all offerings and food (to the) spirit of the
Osiris, Mes . . .

CONCLUSION

The three coffins from the Denver Museum of Nature & Science provide
an interesting and useful overview of coffin decoration development during
the Third Intermediate Period. During the 21st Dynasty, the Egyptians were
compelled to compress much of the religious function that had previously been
incorporated in the tomb into the decoration of the coffin. The artisans added
as much detail as possible to the decoration of the coffins, filling in every pos-
sible space with protective emblems. In the late 21st to the early 22nd Dynasties,
this practice continued but with the stylistic addition of the mummy braces
creating a specific sub-category termed *stola coffins*. The decoration of these

yellow coffins included structural elements that also referenced the new religious functions of the coffin, alluding to motifs previously more closely associated with the tomb and perhaps temples. During the later 22nd Dynasty, the drive to fill empty space in the composition ceased, and there was a return to a simplified form of decoration, perhaps related to the efforts of a new dynasty of kings to curtail the power and influence of the traditional Theban priesthood, because it was possible to acquire more and better funerary equipment, or both (Taylor 2003, 103; van Walsem 1997, 361–62). The rulers of the 23rd and 24th Dynasties were primarily based outside of Thebes (the source of most extant Third Intermediate Period coffins), and their remains are often difficult to distinguish archaeologically. The few wooden coffins that have been found from these dynasties are transitional in style, with a finely modeled body shape (as seen more frequently with cartonnage body wrappings) but with a move toward discrete pedestals and greater amounts of text (Copenhagen Æ 298; Ikram and Dodson 1998, 236). Finally, during the 25th Dynasty, decorations retained an orderly appearance, but texts became particularly important, perhaps related to the contemporaneous trend for religious archaism. Tracking these changes in coffin styles helps scholars understand the shifts in the interconnected religious and political spheres of ancient Egypt.

A complete analysis of coffins must include a discussion of style and inscriptions. As shown in this chapter, careful assessment of decorative figures and textual inscriptions can provide specific information about the date of the coffin and personal details about its owner. Certain gods, epithets, and symbols were used during specific time periods, so their presence on the coffin is instrumental for dating; however, due to artistic phenomena such as archaism in which artists sometimes adopted styles from earlier time periods, this decorative analysis is best used in combination with other dating methods. Carbon 14 dates can therefore help provide secondary confirmation of the chronological setting implied by stylistic analysis. The changes in the materials used to construct coffins and in the method of construction provide further information about the motivations behind such elaborate decoration. Such multidisciplinary studies greatly increase the utility of coffins as evidence for interpreting the rapid changes Egypt underwent in the Third Intermediate Period.

REFERENCES

Allen, James P. 2010. *Middle Egyptian: An Introduction to the Language and Culture of Hieroglyphs*. Cambridge: Cambridge University Press.

Aston, David A. 2009. *Burial Assemblages of Dynasty 21–25: Chronology, Typology, Developments*. Wien: Verlag der Österreichischen Akademie der Wissenschaften.

Bergman, Jan. 1980. "Isis." In *Band III, Lexikon der Ägyptologie*, edited by Wolfgang Helck and Eberhard Otto, 186–203. Wiesbaden: Harrassowitz.

Cooney, Kathlyn M. 2011. "Changing Burial Practices at the End of the New Kingdom: Defensive Adaptations in Tomb Commissions, Coffin Commissions, Coffin Decoration, and Mummification." *Journal of the American Research Center in Egypt* 47: 3–44.

de Araújo Duarte, Cassío. 2014. "Crossing the Landscapes of Eternity: Parallels between Amduat and Funeral Procession Scenes on the 21st Dynasty Coffins." In *Body, Cosmos, and Eternity: New Research Trends in the Iconography and Symbolism of Ancient Egyptian Coffins*, edited by Rogério Sousa, 81–90. Oxford: Archaeopress.

Gasse, Annie. 1996. *Les sarcophages de la Troisième Période Intermédiaire du Museo Gregoriano Egizio*. Aegyptiaca gregoriana 3. Città del Vaticano: Monumenti, musei e gallerie pontificie.

Goyon, Jean-Claude. 1978. "Hededyt: Isis-Scorpion et Isis au Scorpion." *Bulletin de l'Institut Français d'Archéologie Orientale* 78: 439–57.

Hornung, Erik. 1999. *The Ancient Egyptian Books of the Afterlife*, translated by David Lorton. Ithaca, NY: Cornell University Press.

Ikram, Salima, and Aidan Dodson. 1998. *The Mummy in Ancient Egypt: Equipping the Dead for Eternity*. London: Thames and Hudson.

Jørgensen, Mogens. 2001. *Catalogue Egypt III: Coffins, Mummy Adornments, and Mummies from the Third Intermediate, Late, Ptolemaic, and the Roman Periods (1080 BC–AD 400)*. Catalog. Copenhagen: Ny Carlsberg Glyptotek.

Leahy, Anthony. 1979. "The Name of Osiris Written [unknown]." *Studien zur Altägyptischen Kultur* 7: 141–53.

Leitz, Christian. 2002–3. *Lexikon der ägyptischen Götter und Götterbezeichnungen*. Leuven: Peeters.

Liptay, Éva. 2014. "Representations of Passage in Ancient Egyptian Iconography." In *Body, Cosmos, and Eternity: New Research Trends in the Iconography and Symbolism of Ancient Egyptian Coffins*, edited by Rogério Sousa, 67–80. Oxford: Archaeopress.

Manning, Sturt, Michael W. Dee, Eva M. Wild, Christopher Bronk Ramsey, Kathryn Bandy, Pearce Paul Creasman, Carol B. Griggs, Charlotte L. Pearson, Andrew J. Shortland, and Peter Steier. 2014. "High-Precision Dendro-14C Dating of Two Cedar Wood Sequences from First Intermediate Period and Middle Kingdom Egypt and a Small Regional Climate-Related 14C Divergence." *Journal of Archaeological Science* 46: 401–16.

Niwiński, Andrzej. 1988. *21st Dynasty Coffins from Thebes: Chronological and Typological Studies.* Mainz am Rhein: Verlag Philipp von Zabern.

Niwiński, Andrzej. 1989. "The Solar-Osirian Unity as Principle of the Theology of the 'State of Amun' in Thebes in the 21st Dynasty." *Journal of the Near Eastern Society "Ex Oriente Lux"* 30 (1987–88): 89–106.

Ritner, Robert. 2009. *The Libyan Anarchy: Inscriptions from Egypt's Third Intermediate Period.* Atlanta: Society for Biblical Literature.

Sousa, Rogério. 2014. "Spread Your Wings over Me: Iconography, Symbolism, and Meaning of the Central Panel on Yellow Coffins." In *Body, Cosmos, and Eternity: New Research Trends in the Iconography and Symbolism of Ancient Egyptian Coffins,* edited by Rogério Sousa, 91–110. Oxford: Archaeopress.

Stadler, Martin A. 2008. "Judgment after Death (Negative Confession)." *UCLA Encyclopedia of Egyptology.* Los Angeles: UCLA.

Taylor, John H. 1989. *Egyptian Coffins.* Aylesbury, UK: Shire.

Taylor, John H. 2000. "The Third Intermediate Period." In *The Oxford History of Ancient Egypt,* edited by Ian Shaw, 324–63. Oxford: Oxford University Press.

Taylor, John H. 2001. "Patterns of Colouring on Ancient Egyptian Coffins from the New Kingdom to the Twenty-Sixth Dynasty: An Overview." In *Colour and Painting in Ancient Egypt,* edited by W. Vivian Davies, 164–81. London: British Museum Press.

Taylor, John H. 2003. "Theban Coffins from the Twenty-Second to the Twenty-Sixth Dynasty: Dating and Synthesis of Development." In *The Theban Necropolis: Past, Present, and Future,* edited by Nigel Strudwick and John H. Taylor, 95–121. London: British Museum Press.

Taylor, John H. 2010a. "Changes in the Afterlife." In *Egyptian Archaeology,* edited by W. Wendrich, 220–40. Oxford: Wiley-Blackwell.

Taylor, John H. 2010b. *Egyptian Mummies.* Austin: University of Texas Press.

Taylor, John H. 2010c. *Journey through the Afterlife: Ancient Egyptian Book of the Dead.* London: British Museum Press.

van Walsem, René. 1997. *The Coffin of Djedmonthuiufankh in the National Museum of Antiquities at Leiden I: Technical and Iconographical/Iconological Aspects.* Leiden: Nederlands Instituut voor het Nabije Oosten.

van Walsem, René. 2014. "From Skin Wrappings to Architecture: The Evolution of Prehistoric, Anthropoid Wrappings to Historic Architectonic Coffins/Sarcophagi; Separate Contrasts Optimally Fused in Single Theban 'Stola' Coffins (±975–920 BC)." In *Body, Cosmos, and Eternity: New Research Trends in the Iconography and Symbolism of Ancient Egyptian Coffins,* edited by Rogério Sousa, 1–28. Oxford: Archaeopress.

von Känel, Frédérique. 1984. "Selqet." In *Lexikon der Ägyptologie*, Band V, edited by Wolfgang Helck and Eberhard Otto, 830–33. Wiesbaden: Harrassowitz.

Wilkinson, Richard H. 1994. *Reading Egyptian Art*. London: Thames and Hudson.

Willems, Harco. 1988. *Chests of Life: A Study of the Typological and Conceptual Development of Middle Kingdom Standard Class Coffins*. Leiden: Ex Oriente Lux.

10

Museums are not dusty repositories; rather, they are filled with stories waiting to be uncovered. This collection of chapters and the analyses they present greatly enhance our understanding of the two female mummies and three coffins on display at the Denver Museum of Nature & Science (DMNS). Silent for millennia, their stories are beginning to unravel. From the various analyses presented here, we now know that the two women lived and died 500 years apart. Both received typical mummification practices for the time of their deaths, and neither was buried in the coffin with which she is now associated. Analysis of the materials and techniques used in the construction of the coffins and wrapping of the mummies brings us closer to elucidating ancient Egyptian practices. This, in turn, allows us to view aspects of religious practices, resource choice and procurement, and manufacturing styles and techniques, which advances our understanding of daily life and death in the ancient world.

From a museum perspective, studies such as the ones presented here activate extant collections. They bring new meaning and fresh perspectives to objects that have been in collections for decades, if not centuries. Studies like these are also important reminders that new discoveries do not always need to be made in the field. We can learn new information by revisiting existing collections with new and different techniques. It is no secret that museum collections are often irreplaceable and priceless. The mission of professional

Final Thoughts

Opportunities and Challenges of Research on Exhibited Objects

Michele L. Koons and Caroline Arbuckle MacLeod

DOI: 10.5876/9781646421381.c010

museum staff is to ensure their safety and preservation for generations to come. However, with many of the new scientific technologies, it is getting easier to perform analytical studies on museum specimens with minimal to no intervention. The chapters in this volume highlight minimally to non-invasive techniques that are relatively inexpensive to employ. It is our hope that by describing the methodologies used, similar studies can be performed on other museum collections (Egyptian and beyond) with relative ease. Although we have gained a great number of new insights from these analyses, in this final chapter we wish to acknowledge some of the challenges that arise when studying museum collections.

In addition to being vital to the protection of objects, museums play a key role in communicating an artifact's significance and history and its place within the culture from which it came. Museum spaces are therefore the interface between the academic and the public. Frequently, however, it can be difficult for scholars to gain access to objects, and study requests are often rejected. While at times this is necessary to protect the artifact in question, without careful study, the story of these objects and their owners is inaccessible, and a lack of information can lead to erroneous conclusions that build onto a false impression of what life what like in the societies from which these people and objects derived. The validity of these assertions is clear from the complicated history of the mummies and coffins, as discussed in chapter 2. On the other hand, over-extending access to objects can lead to damage and the loss of both historical information and, if significant, the ability to exhibit the object. Access is also frequently impossible because an object is on display, so a researcher may have to wait until the pieces are not central to an exhibit or are removed for conservation. By collaborating on projects, museums and external researchers can communicate their various concerns more effectively and ultimately arrive at more informed conclusions that do not cause unnecessary damage to objects or significantly interrupt the functioning of the museum; nevertheless, compromises are often necessary.

The DMNS mummies and coffins were removed from display to repaint and install new carpet in the aging gallery. Therefore, the objects were accessible for only a short period of time while the renovations took place. Seizing the opportunity, the museum staff invited scholars to study the mummies and coffins. Once the conservation concerns had been assessed, both mummies and one coffin were taken for CT scans. After they returned to the museum, limited invasive sampling was permitted on the mummies and the three coffins. During the move, as is unavoidable in these circumstances, tiny fragments of the decorative materials became dislodged and were carefully gathered for

analysis. After the researchers collected their data through both visual and minimally destructive means, they returned to their home institutions, and the mummies and coffins were returned to the exhibit.

For the museum, a number of trained staff were required to ensure the protection of the objects for the duration of the time they were off display. Exhibits staff trained in object handling assisted the Colorado Flight for Life team in transporting the mummies from the museum by ambulance to Children's Hospital Colorado. Curatorial and conservation staff also accompanied the mummies on the ride and while in the hospital. Once returned to DMNS, curatorial and conservation staff oversaw the collection of samples for the various analyses to ensure minimal damage.

From the researcher's point of view, it would be ideal to have full and unlimited access to objects. A number of non-destructive and non-invasive preliminary studies would be conducted, followed by minimally invasive sampling of multiple areas to ensure that the analyses would include all possible materials used to create or decorate the object. After these studies were completed, the researchers could take more samples to verify their results or answer additional questions as they arose. Such circumstances, however, are not realistic for objects that are part of popular exhibits and where time constraints are a factor. The time frame in question would require the objects to be removed from their display cases for several weeks while analyses were conducted, causing disappointment for visitors and space constraints on the active conservation laboratory at DMNS. Moreover, the extent of the sampling required to ensure that all materials are represented is significant and is rarely possible without affecting both the aesthetic of the object and its physical integrity. For the present study, researchers, therefore, had to be content with sampling areas that would cause as little alteration to the object as possible and could not return for additional samples since the objects were placed back on exhibit.

The constraints meant it was not possible to collect every last piece of data. For example, the mummies had one opportunity to travel to Children's Hospital for CT scanning. The information gathered in these scans is digitally manipulable in many ways, but scanning technology will surely advance in the coming years. It might be decades before the mummies and coffins make the journey again. Therefore, this was the one opportunity to collect as much data as possible while knowing we could not repeat the procedure if something went awry. In chapter 6, only coffin EX1997-24.2, the one with the thickest base, would permit wood samples large enough for tree rings to be discerned without causing lasting damage to the coffin structure. Therefore, dendrochronological information could not be gathered for any of the other planks used

in coffin construction. In chapter 7, certain questions could not be answered due to the limits of the pXRF. To supplement the data from pXRF, additional analyses were undertaken on pigment and other fragments that became dislodged during the movement of the artifacts, as described in chapter 8. These compromises limited the possible conclusions but helped protect the objects and took advantage of an opportunistic situation. Concerns about the fragility of the objects also meant that the mounts that had been constructed for the objects could not be removed, which caused certain areas to remain inaccessible, as noted in chapters 6 and 9. Despite these limitations, the conclusions discussed in each chapter demonstrate that significant data could be acquired in a manner that maintained the integrity of the objects.

It is our intent not only to encourage cooperation between museums and researchers but also to acknowledge the challenges that arise during such studies. There are practical concerns and limitations that often restrict object analysis, and by acknowledging these challenges, scholars from archaeological and museological disciplines will be better prepared to adjust their approaches and can work together to overcome such hurdles in the future. Overall, by expanding the corpus of holistic mummy studies and publishing these studies in accessible formats and locations, our goal is to provide a how-to manual to organizations interested in scientific analyses of museum specimens with minimal intervention.

The mummies and coffins at DMNS are beloved by museum visitors and have inspired aspiring Egyptologists in the Denver region for decades. The hope is that this volume will be useful not only to specialists in the field but also to anyone with a deep interest in knowing more about the mummies at the museum. We acknowledge the long and mostly unclear journey these mummies made in reaching their current home in Denver. Although it is frustrating to not have all the information we would want because of decades of poor recordkeeping, our goal with this volume is to provide a snapshot of what we do know at this time—all while preserving the integrity of the objects and the human remains. It is our hope that as technology continues to advance, new analyses will come into play and further advance our understanding of these old friends of the Denver Museum of Nature & Science.

CAROLINE ARBUCKLE MACLEOD, PHD, post-doctoral researcher and teaching fellow, University of British Columbia

CHRISTOPHER H. BAISAN, senior research specialist, Laboratory of Tree-Ring Research, University of Arizona

HANS BARNARD, PHD, associate adjunct professor, Department of Near Eastern Languages and Cultures, and associate researcher, Cotsen Institute of Archaeology, UCLA

BONNIE CLARK, PHD, associate professor, Department of Anthropology, University of Denver

PEARCE PAUL CREASMAN, PHD, director, American Center of Research (ACOR); associate professor of anthropology and dendrochronology, University of Arizona.

FARRAH CUNDIFF, MLIS, associate archivist, Clyfford Still Museum

JESSICA M. FLETCHER, owner and object conservator, Fletcher Conservation Services

KARI L. HAYES, MD, pediatric radiologist, Children's Hospital Colorado

KATHRYN HOWLEY, PHD, Lila Acheson Wallace Assistant Professor of Ancient Egyptian Art, Institute of Fine Arts, New York University

STEPHEN HUMPHRIES, PHD, assistant professor of radiology, National Jewish Health

MICHELE L. KOONS, PHD, curator of archaeology, Denver Museum of Nature & Science

KEITH MILLER, PHD, associate professor, Department of Chemistry and Biochemistry, University of Denver

VANESSA MUROS, conservation specialist and lecturer, UCLA/Getty Conservation Program, Cotsen Institute of Archaeology, UCLA

ROBYN PRICE, PHD CANDIDATE, Cotsen Institute of Archaeology, UCLA

DAVID RUBENSTEIN, MD, radiologist, University of Colorado

JUDITH A. SOUTHWARD, conservator, Denver Museum of Nature & Science

JASON WEINMAN, MD, pediatric radiologist, Children's Hospital Colorado

iron oxide, 151, 156
Isis, 27; depictions of, 174, 189; texts about, 177, 178
Isis knots, 175, 183
Italy, 1903 expedition, 22

joinery, wood, in EX1997-24.4, 78

Karnak, Temple of Amun-Re at, 176
Khaemwaset, reused tomb of, 22, *23*
Khepri, 181
Khnumhotep II, tomb of, 104
kings, 21st dynasty, 30
Kushite kings, 30

Lascaux 498HV, 38, 39, 42, 44, 45, 49
Late Period, mummification during, 28; mummy EX1997-24.3, 24, 41, 68
Levant, trade with, 30
Libyans, in Third Intermediate Period, 30, 185
linen, 4, 21, 26, 28, 29, 37, 41, 48; radiocarbon dating of, 7, 20, 24

maat feathers, 62, 182
maghemite, 151
magnetite, 151
malachite, 134
Manco-Johnson, Michael, 53
Mass Spectral Library, 161
McClelland, Andrew, 14
Mes (Mose), 190. *See also* coffin EX1997-24.2
metal foil, with mummy EX1997-24.1, 59, *61*
microphotography, 152, 154
microscopy, 139, 142, 242; of cross-sections, 154–55
Middle Kingdom, mummification during, 27
mixed-energy reconstructions, 56–57
molybdenum, 119; in EX1997-24.1 black substance, 124, 132, 166
mummies, 3–4, 197; analysis/evaluation of, 21, 24–25; CT scanning of, 6–7; samples from, 140–41. *See also* mummy EX1997-24.1; mummy EX1997-24.3
mummification, 17, 21, 31, 59, 67, 68, 197; changing processes of, 26–28, 54
mummy EX1997-24.1, 4, 22, 31, 69; amulet with, 133–34; black substance on, 5, 124, 132–33, 135; and coffin EX1997-24.4, 25–26; condition and conservation treatment,

37–38, 40(table); CT imaging of, 53–54, *55, 57, 58, 59*–66; description of, *14*–15, 17, 21; mummification process, 67–68; pXRF analysis, 116, *125*; radiocarbon dates, 18(table), 20, 21; Sample 3610 from, 141(table), *144,* 145, 147, 149(table), 161, 162, 166
mummy EX1997-24.3, 4, 21, 31; condition and conservation treatment of, 41, 43(table); CT images of, 53, 55, *56, 60, 66–67*; description of, 15–*16*, 17, 24–25; radiocarbon dates, 18(table), *20,* 68
museums, role of, 198
mut vultures, 183
mylar overlays, in documentation, 39, 47, 49–50

National Jewish Health, 17
natron, in mummification, 26–27
Near East, trade with, 94
Neith, 27
Nephthys, 27; depictions of, 174, 177; texts about, 177, 178
Neskhonsupakhered, coffin of (EA47975), 189
New Kingdom, 27, 104, 187, 189
nickel, 119; in EX1997-24.1 black substance, 124, 132, 166
NIST Standard Reference Material (SRM) 2711, analytical use of, 118–19
Niwiński, Andrzej, coffin typology, 172, 180
NMR. *See* nuclear magnetic resonance
non-destructive analysis, 139, 140, 199; pXRF, 146–50; ultraviolet light, 144–46; visual inspection, 142–44. *See also* portable x-ray fluorescence (pXRF)
non-royals, mummification of, 27
Nubia, Kushite kings, 30
nuclear magnetic resonance (NMR), 7
Nut, 96, 174, 181

ochre, in coffin pigments, 128–29, 130, 134
octadecanoic acid, 161
Opening of the Mouth ritual, 86, 189
Open Research Scan Archive (ORSA), 7
organic molecules, in coffin and mummy samples, 161–65
organs: removal of, 27, 59; symbolic protection of, 61
orpiment, 112, 155; on coffin EX1997-24.4, 128–29, 165; on coffin EX1997-24.5, 131

Sea Peoples, Third Intermediate Period, 30
2nd Dynasty, mummification during, 26–27
Second Vatican Coffin Conference, 8
Sekhemkara, tomb of, 104
sekhem hieroglyph, 183
Selket, 174. *See also* Serqet
SEM. *See* scanning electron microscopy
Serqet, 27. *See also* Selket
ships, reused coffin wood in, 74
sidder (*Ziziphus spina-christi*), 76, 94–95
Siemens Healthineers, 55, 57
single-energy imaging, 55–56
sistra, depictions of, 174
social class, 27, 31, 85
solar disk: with scarab, 172, 174, 176, 181;
 winged, 186–87
Solar-Osirian unity, 176
spells, from Book of the Dead, 187–88,
 189–90
stabilization: of coffin EX1997-24.2, 38–39;
 of coffin EX1997-24.4, 42, 44; of coffin lid
 EX1997-24.5, 45–46; of mummy EX1997-
 24.3, 41; staining from, 47–48
stable isotope analysis, diet reconstruction, 7,
 24–25
stola coffins, 180–81, 185, 192–93; holes in,
 87–89
sulfur, 119, 166; in black substance, 124, 133, 147;
 in coffin pigments, 135, 149–50; on EX1997-
 24.5, 126, 131
sycomore fig (*Ficus sycomorus*), 75, 76–77, 84,
 94, 96, 98, 99, 100, 104–5, 106
symbols, symbolism: on coffin lid EX1997-
 24.5, 172, 174; protective, 170–71

Taheryethes, 190
tamarisk (*Tamarix* spp.), 75, 94, 98, 100
teeth: EX1997-24.1, 59; EX1997-24.3, 66
TeraRecon software, 57
texts, 5; on coffin EX1997-24.2, 21, 22, 190–92;
 on coffin EX1997-24.5, 26, 171, 176–79;
 protective, 170–71
Thatcher, John A., 14
Thebes, 176–77; coffins from, 182, 193; priests
 from, 185
Thermo Xcalibur Qualbrowser, 161
thin-section imaging, 55
Third Intermediate Period, 4, 181; coffin
 manufacture during, 5, 28–29, 72, 192–93;

EX1997-24.1 mummy, 21, 37, 67–68; Four
 Sons of Horus figures, 61, 62; mummifica-
 tion during, 27–28; social and political
 change during, 29–31, 74, 89, 95, 170–71
Thoth, 187
3D models, 17, 54, 57, 69
tide line stains, 38, 42
tissue, from EX1997-24.3, 24
Tomb Robbery Papyri, 74
tomb robbing, 25, 31, 74, 85
tombs, reused, 22, 23, 31
tool marks, on coffins, 79–82
touch table, 17
tourist market, 25
trade, in wood, 94–95
translation, of EX1997-24.2 text, 21, 22
transmitted light microscopy, wood identifi-
 cation, 97
treatment histories, 39–44, 49–50
tree-ring dating, 5; coffin EX1997-24.2
 samples, 101–4, 199; sycomore figs, 104–5
trees, tree by-products, and gods, 96
12th Dynasty, 104, 181
21st Dynasty, 177, 182; coffins dating to, 25, 26,
 29, 42, 45, 77, 171, 172, 180–81, 191–93; mum-
 mification, 27–28; sociopolitical changes,
 30–31, 74, 95
22nd Dynasty, 21, 185; coffins dating to, 25, 29,
 74, 180–81; sociopolitical changes, 30–31, 74,
 95; yellow coffins, 192–93
23rd Dynasty, 30
24th Dynasty, 30
25th Dynasty: coffin EX1997-24.2, 22, 38, 105,
 189, 190; coffin manufacture, 29, 193
26th Dynasty: coffin EX1997-24.2, 105, 189;
 mummy EX1997-24.3, 24
2D images, 69

UCHSC. *See* University of Colorado Health
 Science Center
ultraviolet (UV) illumination, 5, 37, 144–46,
 155, 158
underworld, 62, 181
University of Colorado Health Science
 Center (UCHSC), 53
University of Colorado Museum, mummy
 EX1997-24.3, 15
University of Pennsylvania Museum, Open
 Research Scan Archive, 7